MONET AND THE MEDITERRANEAN

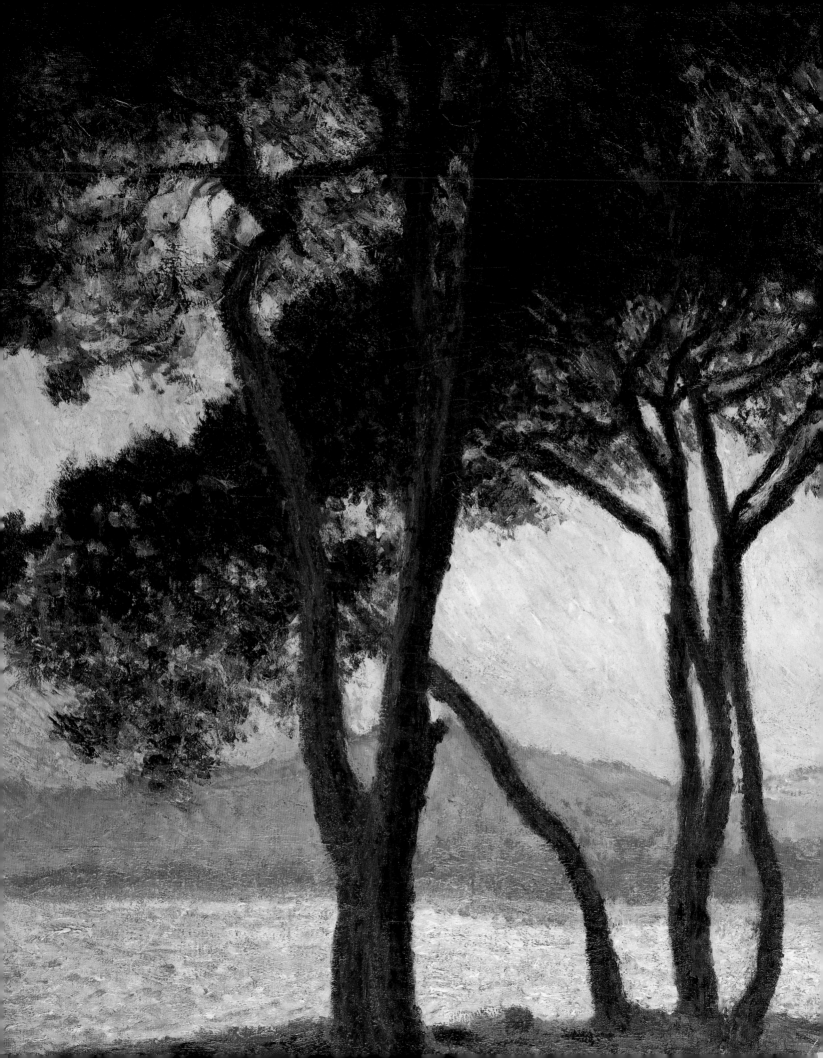

Joachim Pissarro

Published by

Rizzoli

in association with
the Kimbell Art Museum
Fort Worth, Texas

MONET AND THE MEDITERRANEAN

First published in the United States of America in 1997 by
Rizzoli International Publications, Inc.
300 Park Avenue South
New York, NY 10010

This book, albeit independently conceived, has been published in conjunction with
the exhibition *Monet and the Mediterranean*. The exhibition is supported by an indemnity
from the Federal Council on the Arts and the Humanities.

EXHIBITION DATES:

Kimbell Art Museum, Fort Worth
June 8–September 7, 1997

Brooklyn Museum of Art
October 10, 1997–January 4, 1998
The exhibition in Brooklyn is made possible, in part, by a generous grant from
The Florence Gould Foundation.

Front cover: Detail from Claude Monet, *View of Bordighera*, 1884,
The Armand Hammer Collection, UCLA at the Armand Hammer Museum of Art
and Cultural Center, Los Angeles (Plate 3)

Frontispiece: Detail from Claude Monet, *Beach in Juan-les-Pins*, 1888,
Private Collection (Plate 68)

LIBRARY OF CONGRESS CATALOGING-IN-PUBLICATION DATA

Pissarro, Joachim.
Monet and the Mediterranean / by Joachim Pissarro.
p. cm.
An exhibition catalog.
Includes bibliographical references and index.
ISBN 0-8478-1783-0 (hardcover)—ISBN 0-912804-33-5 (pbk.)
1. Monet, Claude, 1840–1926—Exhibitions.
2. Western Mediterranean in art—Exhibitions.
I. Kimbell Art Museum II. Title
ND553.M7A4 1997
759.4–dc20

NOTE TO THE READER:

All works are in oil on canvas, unless otherwise stated.

Designed by Anthony McCall Associates, New York

Printed in Italy

Contents

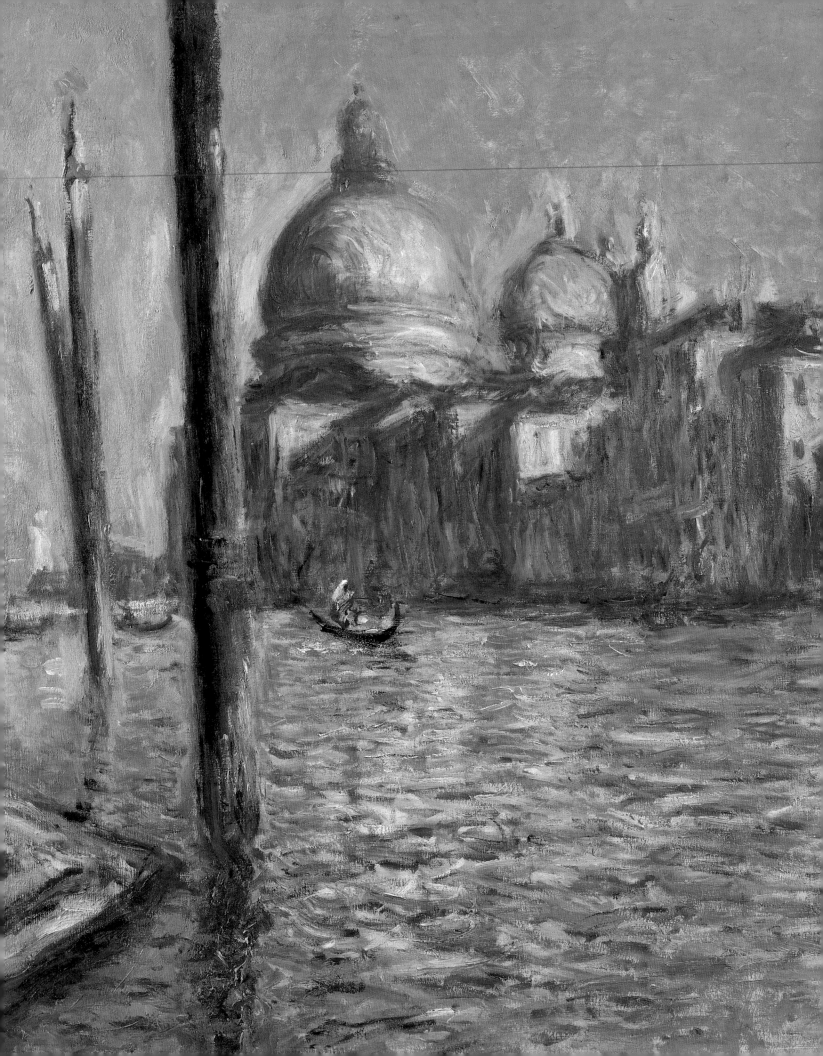

Preface and Acknowledgments

An underlying paradox characterizes Monet studies: while the art of Claude Monet has elicited a greater volume of research, publications, and exhibitions than that of almost any other Western artist (on par, perhaps, with Picasso), it is still possible to discover facets of his work that have remained unexplored until now. This tantalizing situation very much applies to the present exhibition: it seemed only too tempting to bring to the eyes of our public, and to publish, often for the first time in color, the greatest number to date of Monet's Mediterranean works. Indeed, these clusters of paintings, conceived and created together during the course of Monet's three campaigns on the Mediterranean, were primarily intended to be seen and enjoyed as groups, in their togetherness. The primary raison d'être of the project seemed evident: if one readily associates Monet with the obsessive task of "painting light," would it not make sense to look at his works that were produced under the most extreme light —the light of the South? Bordighera and Antibes, on the Italian and French Rivieras, and Venice, each in very distinct ways, provided the artist with the most intense light conditions he could have hoped for, short of traveling to Texas.

Yet, given that we are dealing with Monet, painting light was not simple. First, for an obvious reason, light can be nothing without what is lit: the constantly shifting elements—sea, mountains, canals, and so forth— that constitute Monet's motifs. In addition, the intensity of light is inconstant: light is inseparable from the flux of time. Finally, the fluctuations of light were matched by the vicissitudes of Monet's own psyche, and by his intense need to be heard, seen, and imagined by *others*, while immersed in his search for himself. Monet's sojourns on the Mediterranean, and his ensuing pictorial program, were fraught with unsolvable complexities.

The story of Monet's pursuit of his goal and his often agonizing struggle seemed to justify the effort on our part to reunite works that epitomize many themes inherent in the story of modernism. Many of these paintings, however, had long fallen into oblivion, and this project would likely never have seen completion

without the support, involvement, and understanding of numerous individuals and institutions.

Needless to say, our primary debt goes to those who have consented to make the contents of this exhibition a reality. A list of the lenders who allowed us to publish their names may be found at the end of this volume. Many private and institutional lenders made considerable concessions so that vital pictures could be reunited with their pendants and thus give sense and form to this project: to all of them, our deepest and heartfelt thanks. We owe a deep debt of gratitude especially to the institutions that have sacrificed essential works from their permanent collections in order to ensure a broad representation of Monet's achievements in the South. At the Museum of Fine Arts in Boston, which has generously allowed us to borrow a great number of critical works, we are most grateful to Malcolm Rogers, Theodore E. Stebbins, George T. M. Shackelford, Jim Wright, and Robert Boardingham. At the National Museum and Gallery of Wales, Cardiff, another institution whose contribution was as vital as it was generous, we have to thank Colin Ford and David Alston for their support.

Our sincere thanks also go to museum directors, curators, and conservators who have spared no efforts, often even creating special dispensations, in order to make many pivotal loans available to this exhibition and who have supported this project in numerous ways: at the Stedelijk Museum, Amsterdam, J. H. Sassen, H. C. Bongers, and A. M. Daalder-Vos; at the Rijksmuseum, Amsterdam, Rudi Fuchs and J. P. Filedt Kok; at the Art Institute of Chicago, James N. Wood, Douglas W. Druick, Gloria Groom, and Larry J. Feinberg; at the Cleveland Museum of Art, Robert P. Bergman, Diane De Grazia, and William Robinson; at the Columbus Museum of Art, Irvin M. Lippman and Annegreth Nill; at the Dallas Museum of Art, Jay Gates, Dorothy M. Kosinski, and Kimberly A. Bush; at the Glasgow Art Gallery and Museum, Julian Spalding and Shiona Airlie; at the Indianapolis Museum of Art, Bret Waller and Theresa Harley-Wilson; at the Courtauld Institute Galleries, London, John Murdoch and

Helen Braham; at the Armand Hammer Museum of Art and Cultural Center, UCLA, Henry T. Hopkins and Susan Lockhart; at the Metropolitan Museum of Art, New York, Philippe de Montebello, Gary Tinterow, and Anne Norton; at the Solomon R. Guggenheim Museum, New York, Thomas Krens, Lisa Dennison, and Laura J. Latman; at the Joslyn Art Museum, Omaha, Graham W. J. Beal and Marsha V. Gallagher; at the Musée Marmottan, Paris, Arnaud d'Hauterives and Marianne Delafond; at the Philadelphia Museum of Art, Anne d'Harnoncourt, Joseph J. Rishel, Alison Goodyear, Jennifer Vanim, Conna Clark, and Nancy Wulbrecht; at the Kunstmuseum Saint Gallen, Roland Wäspe and Konrad Bitterli; at the Fine Arts Museums of San Francisco, Harry Parker III, Steven A. Nash, Lynn Orr, and Carl Grimm; at the San Francisco Museum of Modern Art, John R. Lane, Gary Garrels, William Shank, Neil Cockerline, and Jennifer Small; at the Santa Barbara Museum of Art, Robert H. Frankel, Robert Henning, Jr., and Barbara Luton; at the Bridgestone Museum of Art, Tokyo, Kazuo Ishikure and Katsumi Miyazaki; at the Toledo Museum of Art, David W. Steadman, Lawrence W. Nichols, and Patricia Whitesides; at the Musée des Beaux-Arts de Tournai, Serge Le Bailly de Tilleghem; at the Norton Museum of Art, West Palm Beach, Christina Orr-Cahall and David F. Setford; at the Sterling and Francine Clark Art Institute, Williamstown, Michael P. Conforti, David Stopford Brooke, and Martha Asher; at the Von der Heydt-Museum Wuppertal, Sabine Fehlemann and Brigitte Moller; and at the Kunsthaus Zürich, Felix Baumann, Christian Klemm, and Romy Storrer.

Tracing the whereabouts of many of these works has been one of the more taxing aspects of this project: without the kind resources of many individuals, it would have been impossible to secure some critical loans. I owe a special debt of gratitude here to Paul Hayes Tucker, who has given liberally of his time and knowledge, and to Daniel Wildenstein, who made great efforts on behalf of the Kimbell Art Museum to obtain important loans; also, my deepest thanks to Hélène David-Weill for

8

immeasurable help and to Marc Blondeau, who provided access to several crucial works very seldom exhibited. In Japan, the cooperation of Marie Myoko Oyake proved to be invaluable. I am also very obliged to Sarah Ackley, William Acquavella, Noel Allum, Alexander Apsis, Frances F. L. Beatty, K. M. Bunt, Anne Bury, Jacquie Cartwright, Patrick Cooney, Desmond L. Corcoran, Eileen Costello, Andrea Crane, Daniele Crippa, Susan Cross, Alain Disch, Jacques Durand-Ruel, Jean Edmonson, Roberta Entwistle, Günter Esser, Roger L. Evans, Stamos J. Fafalios, Richard L. Feigen, Michael Findlay, Stephen Floersheimer, Diana Fraser, Yoshiko Fujii, Larry Gagosian, Margaret Gergeres, Franck Giraud, Arne Glimcher, Caroline Durand-Ruel Godfroy, Patrick Goetelen, Anthony Goldschmidt, Fadredin Golestaneh, Robert Gordon, Lindsey Gruber, Hitoshi Hachiro, Chieko Hasegawa, Masaaki Hasegawa, Tokushichi Hasegawa, Ay-Whang Hsia, Hans Humm, Takako Ichinose, Takatomo Ii, Naoya Inoue, Ron Y. Ishii, Antoinette Jackson, Laura Klar, Kiyotaka Kori, Yasunari Kumon, Max Lahyani, Caroline Lang, Marc and Pierre Larock, Anne London, Robert Lorenzson, John Lumley, Katherine MacLean, Alice F. Mason, Julia May, Katsumi Miyazaki, Ryuichiro Mizushima, Takao Mori, Masatsugu Nagamatsu, Peter Nathan, David, Ezra, and Giuseppe Nehmad, Philip Niarchos, David Norman, Harunobu Okada, Mizuho Okada, Katia Pissarro, Lionel Pissarro, Simon de Pury, Jussi Pylkkänen, Stanford Z. Rothschild, Jr., James Roundell, Arlene Rumbough, Rivka Saker, Arnold A. Saltzman, Manuel and Robert Schmit, Tetsuji Shibayama, Noritsugu Shimose, Takeshi Shindo, Sharon Simpson, Claire Durand-Ruel Snollaerts, Esperanza Sobrino, Sidsel Maria Sondergaard, Jacqueline Hébert Stoneberger, Andrew Strauss, Michel Strauss, Yoshitomo Takahata, Motoo Takemura, Dominic Tambini, John Tancock, Harry A. Thompson II, Patricia H. Tompkins, Samir Traboulsi, Elena Travelli, Mikako Tsukada, Tomonori Tsurumaki, Rosemarie M. Weber, Guy Wildenstein, Georges Wilhelm, Ully Wille, Ronnie Wohl, Tiffany Wood, Koji Yamada, Susumu Yamamoto, Franco Zangrilli, Kazumi Zenitani, and Victoria and Robert Zoellner.

I have been lucky throughout this project to be able to draw upon the advice and knowledge of many scholars. Richard R. Brettell, Beverly L. Brown, Caryl Emerson, Wlad Godzich, Deborah Haynes, John House, Steven Z. Levine, Alain Renaut, Richard Shiff, Charles F. Stuckey, Tzvetan Todorov, and Paul Hayes Tucker have all been extremely generous with their comments and critiques.

It is also fair to say that the preparation of this project has drawn upon the resources of every member of the staff at the Kimbell Art Museum. Edmund P. Pillsbury, the Kimbell's director, encouraged this complex project from its inception and gave it the sustained direction and unflagging support that were needed. Very special thanks are due to Anne Adams, the museum's registrar, who skillfully and patiently administered the complex transportation planning of the entire exhibition; to Nancy E. Edwards, Associate Curator for European Art, who kindly negotiated a number of loans; to Claire Barry, Chief Conservator of Paintings, who undertook the conservation of particular works and advised on the condition of a number of loans; and Michael Bodycomb, Patty James Decoster, Liz Johnson, Isabelle Tokumaru, Jo Vecchio, and Barbara White, each for helping with critical aspects of this whole project. Additionally, our colleagues at the Brooklyn Museum of Art have played a vital role in orchestrating and coordinating their efforts with ours to allow this exhibition to travel: we are especially grateful to Linda S. Ferber, Roy R. Eddey, Elizabeth W. Easton, Sarah Faunce, Elizabeth Reynolds, Ken Moser, Lisa Rotmil, Elaine Cohen, Cheryl Sobas, and former Director, Robert T. Buck.

Each stage of the preparation of the manuscript for this publication has benefited from the efforts of colleagues, to whom I am immensely grateful. My sincere and foremost gratitude goes to Wendy P. Gottlieb, Assistant Director for Public Affairs and Museum Editor, who has worked tirelessly, and with enormous dedication

9

and meticulous attention, on numerous editorial improvements to this book. My very special thanks to Beth Figgers, Julie Herrick, Mary Lees, and Pam Muirheid for instilling order into every step of the development of the manuscript. I am thankful too to Eileen S. Kahng for her editorial input, and to Marina Feretti for her vital and intelligent help in providing the research material needed throughout this project.

At Rizzoli International Publications, I was fortunate to meet in Charles Miers the initial enthusiasm that launched this book. I am also most thankful to Solveig Williams for monitoring this project with her known wisdom and flair. My deep personal thanks to Barbara Einzig, Senior Editor, whose intelligence and sensitivity turned the usually taxing editorial stage of a book into a rewarding and enjoyable experience.

Finally, it is not possible to put into words the extent of my debt to Annabel Daou: this book is simply dedicated to her.

— JOACHIM PISSARRO

MONET'S
MEDITERRANEAN

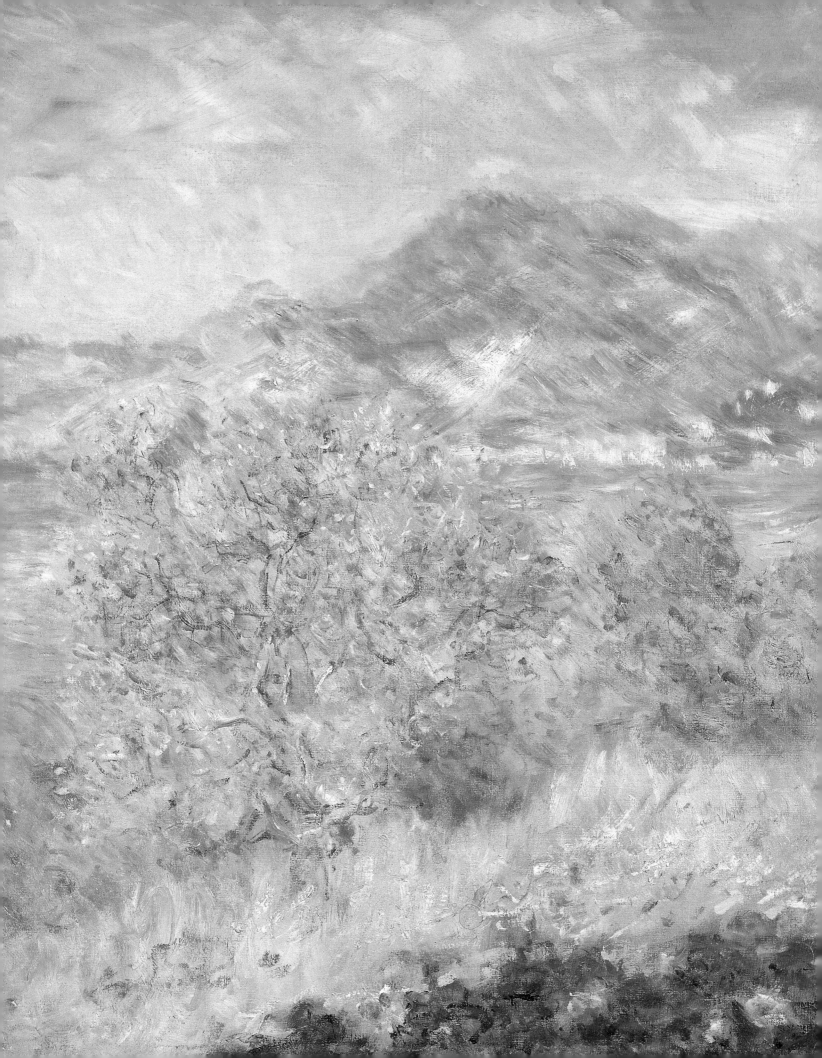

Introduction

Claude Monet was an indefatigable traveler. Among the Impressionists, he was the most peripatetic, the one who explored the greatest variety of places. And as an artist, he was ceaselessly nurtured and dependent upon travel and the exploration of new pictorial destinations. Moreover, Monet tried to incorporate within his art the very flux of appearances he confronted. Particularly after 1879, when his first wife died, Monet traveled extensively, seeking an ever greater gamut of visual stimuli, to which he responded with an almost chameleonlike variety of styles. As in the past, Monet vacationed regularly in Normandy in the 1880s, but he also began to venture further afield. He journeyed to Bordighera and Menton on the Riviera in 1884; to the Hague and to Belle-Ile, in Brittany, in 1886; to London in 1887; and to Antibes, London, and Juan-les-Pins the next year. In 1889 Monet toured the Creuse Valley, in the center of France. In 1892 and 1893 he spent time working in Rouen, and in 1895 he visited Norway. He made additional trips to London in 1899, 1900, and 1904. He also visited Madrid in 1904 and Venice in 1908. The Venice excursion was Monet's last. The trips to Bordighera and Venice thus bracket a quarter century during which Monet was traveling almost constantly. Rather than chart the entire realm of these wanderings, this book will focus on Monet's sudden interest in the South—the Mediterranean world.

When his good friend Pierre-Auguste Renoir invited him on a brief tour of the Italian Riviera in 1883, Monet was already forty-three years old. Set in his ways, Monet was a very different traveler from Renoir: he had remarkably little curiosity about new cities or cultures for the sake of novelty and was no tourist at all. In Italy, Monet did not feel tempted to explore—he never visited Florence or the Bay of Naples or Algeria, where Renoir had gone. Monet's drive to discover new and diverse sources of motifs was for one purpose only: to paint. Once he had found them he turned away from being a traveler and became a pictorial digger. As if in a gold mine, he proceeded to exhaust each location, refusing to leave until it had yielded all.

Ignoring nearly all distractions, he never gave up until he had achieved his goal. In Venice, for instance, Monet apparently only went to one museum (presumably the Accademia),[1] and only with reluctance did he accompany his wife to a Venetian church—on the condition that they not stay too long! These diversions stood in the way of his quintessential task: to create relentlessly.

All in all, Monet took three major trips to the Mediterranean from 1883 to 1908. After the brief visit to Monaco and the Riviera with Renoir during the last half of December 1883, Monet returned alone almost immediately, in January 1884. On this first real expedition south, Monet stayed in Bordighera on the northwest coast of Italy for about ten weeks and produced thirty-five landscape paintings plus one portrait (Plate 31) and two still lifes (Plates 32 and 33).[2] On his way back to Paris, he stopped off for nearly two weeks near Menton, on the French Riviera, where he produced an additional eleven works.[3] Monet decided to return to the south of France for a second campaign four years later, in 1888. He stayed in Antibes during the late winter and early spring and produced thirty-nine paintings.[4] Finally, Monet returned to the Mediterranean for a third time in 1908. On that occasion, he and Alice, his wife, were invited to stay at the Venetian home of a relative of the painter John Singer Sargent. The couple visited for a few weeks in September but soon moved to a hotel so that Monet could complete his series of paintings of Venice. In December, they left Italy, Monet having produced thirty-seven works.[5] Altogether, about 125 works by the artist chart his various stays on or near the shores of the Mediterranean.

Clearly, there is no one Mediterranean, but many Mediterraneans—or, at least, many representations of it. Current definitions of the Mediterranean in the Anglo-Saxon world, for instance, differ from those accepted in continental Europe, for historical as well as ideological reasons. As the French historian Fernand

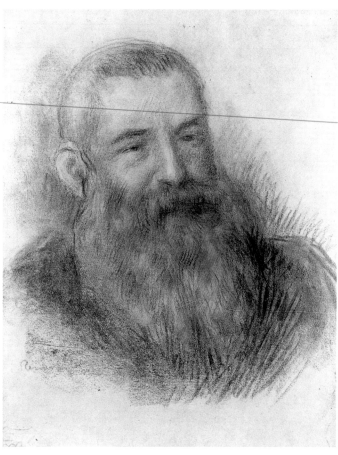

FIG. 1 Pierre-Auguste Renoir
Portrait of Claude Monet, c. 1885–90
Pencil on paper
Private Collection

Braudel stated in his classic study *The Mediterranean and the Mediterranean World in the Age of Philip II*:

There is no lack of authoritative statements as to what it [the Mediterranean] is not. It is not an autonomous world; nor is it the preserve of any one power....The question of boundaries is the first to be encountered; from it all others flow. To draw a boundary around anything is to define, analyze, and reconstruct it, in this case select, indeed adopt, a philosophy of history.[6]

This book is not about *the* Mediterranean, it is about Monet's Mediterranean—or, to put it differently, it is about the construction that Monet created out of the limited and very circumscribed set of

locations in the Mediterranean world that he chose to represent.

Braudel goes on to explain that the Mediterranean consists of two parts:

In the first place, it is composed of a series of compact, mountainous peninsulas, interrupted by vital plains: Italy, the Balkan peninsula, Asia Minor, North Africa, the Iberian peninsula. Second, between these miniature continents lie vast, complicated, and fragmented stretches of sea, for the Mediterranean is not so much a single entity as a "complex of seas."[7]

This view is supported by the nine-teenth-century Larousse dictionary, which defines the Mediterranean as "a vast interior sea, located between Europe to the north, Asia to the east, Africa to the south....It communicates westward with the Atlantic Ocean through the Gibraltar Strait, and eastward with the Black Sea."[8] Among the numerous smaller seas that are listed in the dictionary as belonging to the larger Mediterranean are the Aegean, the Ionian, the Adriatic, and the Tuscan seas. Whether painting in Bordighera on the Ligurian Sea (the technical name for the sea on the northwest coast of Italy) or on the inside canals of the Adriatic, Monet was always working in one of these infiltrating seas, in a part of this "complex of seas." Thus, it is clear that to his French contemporaries Monet's artistic excursions south, whether to Antibes or to Venice, would have been identified with nothing but the Mediterranean.

Ultimately, the meaning of Monet's Mediterranean has less to do with geography than with anticipation and memory, emotions and visual imagination. His "Mediterranean" was defined first through a train journey undertaken with Renoir (and capped, on their way back to Paris, by a visit to Cézanne). It was also shaped by certain expectations that Renoir's paintings from Italy must have aroused in him. Monet could not have gone to

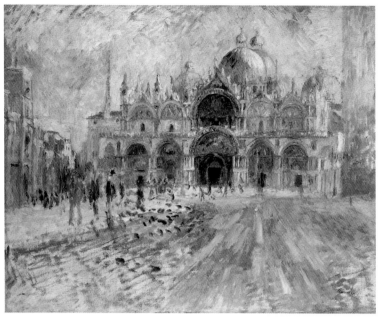

FIG. 2 Pierre-Auguste Renoir
San Marco, 1881
The Minneapolis Institute of Arts

Italy with Renoir without thinking about what he knew Renoir had done in Venice. When Monet finally reached Venice himself, twenty-five years later, it was not with Renoir. Yet it was Monet's memories of Renoir's paintings of Venice and of their first steps in Bordighera together that led him to make a final detour from Venice to Cannes to see Renoir once more.

Monet's decision to paint by the Mediter-ranean in 1884 was bound to an inner strategy: his art was a constant search for shatteringly new pictorial motifs. From Bordighera to Venice, Monet sought visual contact with landscapes and views that possessed a sense of strangeness, unfamiliarity, and unpredictable multifarious-ness. As the artist himself explained, he was searching for a type of nature that would be "even crazier than his art." Before the beauty of the Mediterranean coast, Monet saw only new visual elements that he had to dominate. To him, the Mediterranean was anything but a vacation. It was a major challenge, even an obsession, and one fraught with considerable difficulties. In the end, it intro-duced deep and significant changes into his art. From

15

1883 to 1908, Monet's contacts with the Mediterranean marked a period of intense and systematic exploration in his career.

Monet was, in turn, fascinated and dejected, elated and almost maniacally depressed by his experiences and emotions along the Mediterranean. In this, Monet's ambivalent responses are consistent with two centuries of French attitudes toward Italy and the South.[9] Of the estimated 3,000 to 4,000 travelers who left memoirs of their passages through Italy from 1700 to 1900, most tended to regard the country as either a delightful Arcadia or as purgatory.[10] One could further divide the French literary approaches to Italy into two camps: the lyric and the heroic. The lyric tradition sought in Italy the source of an exuberant haven of escape, filled with lush, sunny, and picturesque scenery; the heroic one saw in Italy the privileged site for a conquest of one's self. It is to the latter tradition that writers like François René de Chateaubriand, Stendhal, and George Sand clearly belong, as each places such a strong emphasis on their own subjectivity. In his own pictorial and unique way, Monet furthered this tradition as well, although there had been comparatively little such interest within the world of pictorial arts. For the most part, the Mediterranean remained the privileged domain of more literal-minded academic painters. How Monet subverted this pictorial tradition, while on its very terrain, is a key question in trying to understand his later work.

In the Mediterranean, Monet strove not only to see what he had never seen but also to stay away from and, possibly deliberately, subvert what others had

seen. This attitude was entirely consistent with his outspoken opposition to all conventions of the French Academy and the École des Beaux-Arts throughout his career. Monet was well aware that the Mediterranean was a veritable bastion of a certain iconographic tradition in which Academic artists routinely drew upon the Mediterranean as a backdrop for their mythological constructions or for sentimental genre scenes documenting

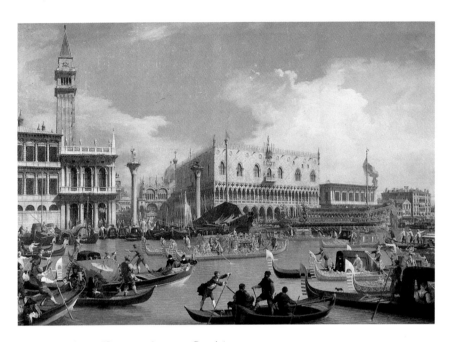

FIG. 3 Canaletto (Giovanni Antonio Canale)
*The Bucintoro Returning to the Pier
at the Doges' Palace on Ascension Day*
1727–29
Pushkin State Museum of Fine Arts, Moscow

the everyday life of the region's native inhabitants (whose paradigm seems to have been the sardine fisherman). In an essay on the French pictorial tradition of the Mediterranean, the Larousse dictionary provides an extensive list of respected artists working there. Needless to say, Monet is not on it, nor would he have felt himself in good company there. Among the artists noted by Larousse are Madame Dubos, with a *Vue des bords de la Méditerranée près de Marseille* (1833); Ambroise-Louis Garneray, with *Pêche de la sardine dans la Méditerranée* (1834); Gustave de Beaumont, with *Bords de la Méditerranée, midi de*

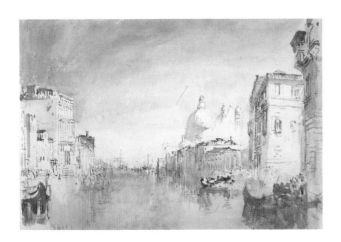

FIG. 4 Joseph Mallord William Turner
*Venice: Looking Down the Grand Canal towards
the Casa Corner and the Salute,* 1840, watercolor
Clore Collection, Tate Gallery, London

l'Italie (1841); Louis Lottier, with *Plage de la Méditerranée à
Toulon* (1841); Alwazowski, with *Calme sur la Méditerranée*
(1844); Emile Lambinet, with *Bords de la Méditerranée à Alger*
(1847); and Philippe Tanneur, with *Côtes de la Méditerranée
entre Antibes et Cannes* (1865). Eugène Delacroix, one of the
few artists listed who has not since fallen into oblivion,
is mentioned for his *Des Pirates africains enlevant une jeune
femme; Côtes de la Méditerranée* (1853).

　　　　Yet in this same discussion of the masters
who tried "to translate the strong impressions" that the
Mediterranean aroused in them, no mention is made
of foreign painters such as Turner, Bonington, or Sargent;
Canaletto is the only non-French artist featured. It is as
though the depiction of the Mediterranean were a
specifically and almost exclusively French phenomenon.[11]
Indeed, at the end of the article, Larousse reminds the
reader that "Méditerranée" was, until recently, the name
of a *département* (an administrative subdivision—the equiv-
alent of a state in the U.S.) given to an Italian province
under French occupation during the rule of Napoleon.
There is little doubt that Monet was aware of his own
participation in this gallocentric pictorial representation
of the Mediterranean, even though he rejected it.[12]
In fact, Monet's stance was paradoxical: while he felt a

certain pride in the strong tradition of French artists in
the representation of the Mediterranean, he also fought
against that very tradition in his own terms.

　　　Monet treated the Mediterranean very
differently than did other French artists. His paintings do
not even remotely resemble those by Salon artists, even
when they depict the same scenes. (See, for example,
the difference between his views of Antibes and Boudin's
depictions of the same motifs [Figs. 6 and 7] executed
five years later and still indebted to a more traditional
approach to landscape.) Monet's choice of similar motifs
was largely coincidental, since he refused to consider
art made by others, even while in Venice (except for his
aforementioned visit to one museum, probably the
Accademia). His opinion of all artists who had
represented Venice before him was typically blunt: no
one had ever been able to see or paint Venice. Monet
then proceeded to cultivate his uniquely personal
experiences of Venice as a breeding ground for his con-
tinuously developing pictorial idiosyncrasies. Venice, and
the Mediterranean in general, supplied the artist with
a fresh set of pictorial problems. In response to this odd-
looking reality, he was able to forge a new pictorial
vocabulary that owed little to the early Impressionist
collective movement.

　　　Impressionism began as one of the first
truly democratic movements in the development of
modern art. Originally the Impressionists had relatively
little to do with one another; the individual artists
were separately forging new and assertive art forms that
addressed a wide and noncohesive range of subject
matters and deployed a variety of pictorial strategies.
During this "heroic phase" of Impressionism in the
1860s, the Impressionists were bound together as strong
artistic individuals who agreed upon one thing: their
rejection of (and rejection by) the traditional system of
taste and evaluation of "success" dictated by the Academy.
As a result, the viewing public suddenly became the
arbiter of artistic taste, superseding the authoritarian
central role of the Academy. A letter from Paul Cézanne

to the superintendent of the Académie des Beaux-Arts in 1866 typifies these shifts:

Recently I had the honor to write to you regarding the two pictures the jury has just turned down. As you have not yet answered me...I am therefore writing to you to insist on my petition. I wish to appeal to the public and to be exhibited at all costs. My wish appears to me not at all exorbitant and, if you were to interrogate all the painters who find themselves in my position, they would all reply that they disown the jury and that they wish to participate in one way or another in an exhibition which would perforce be open to all serious workers.

Therefore let the *Salon des Refusés* be re-established. Even were I to be there alone, I should still ardently wish that people should at least know that I no more want to be mixed up with those gentlemen of the jury than they seem to want to be mixed up with me.[13]

In this letter, which embodies one of the most radical moments in the history of modern art, Cézanne makes several fundamental claims that typify the future Impressionist position. He asserts that his individuality is essentially inalienable and, on the basis of his uniqueness, he claims certain rights. This was a major step by the Impressionists, since previously, if an artist was considered too individualistic, he was, as a rule, excluded from the system. Not content to be left outside the system of the juries, Cézanne claims the fundamental right *to be seen by the public.* This was a logical consequence of the pre-Impressionist stance: if the Academy would not bestow its recognition (awards, medals, distinctions, etc.) on an artist who rejected its value system and tradition, the artist could turn for support nowhere but to "the public," as Cézanne put it.

Following this early heroic phase came the public and mature phase of Impressionism in the 1870s. The Impressionists began to show their art as a group for the first time and, as a consequence, fully exposed themselves to public criticism. Not only were these artists

bound by the fact that their art, during the early 1870s, was still largely viewed as scandalous. They also together began to develop a recognizable "group style": while retaining their own identities, these artists at that point were sharing so much in their common striving for artistic innovation that it became difficult to distinguish one artist's work from another. The epitome of this short-lived period is, of course, the Ernest May triptych, at the Musée d'Orsay, Paris. All three works are of a similar format: one by Monet—*Pleasure Boat, Argenteuil,* c. 1872; one by Pissarro—*Entrance to the Village of Voisins,* 1872; one by Sisley—*The Ile Saint-Denis,* c. 1872. All three works are framed as a medieval triptych and made inseparable. As Robert Rosenblum states:

They have, in fact, a unity....They are all about the same size, were all painted at approximately the same time, around 1872, and are all by artists who repeatedly showed together at the Impressionist exhibitions. Seen as a trinity, they reflect the remarkable convergence of individual viewpoints into a communal style just before the first group show in 1874.[14]

During the 1880s, Impressionism gained further momentum, even though it was by no means fully accepted by the more conservative critics or the official juries of the powerful Salons. Disparaging critics, while no fewer in number than at the origin of the movement, now felt compelled to defend their objections. Jeers, scorning laughter, and cynical remarks were no longer sufficient to convey one's opposition to the movement.[15] Monet even remarked on this fact in March 1883, after a press preview for his one-man show, noting that for the first time not a single journalist had dared to laugh. Impressionism had become an artistic force to be reckoned with.[16]

Critics were beginning to perceive subtle changes in the development of the works of Impressionist artists. They began to write about Monet's Impressionist paintings seriously, regarding them as

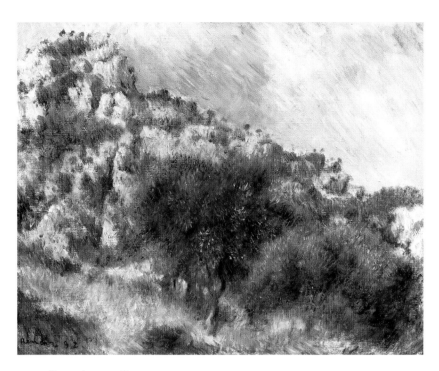

FIG. 5 Pierre-Auguste Renoir
Rocks at L'Estaque, 1882
Private Collection

part of an evolution. Monet was perhaps not quite part of history, but his art was certainly seen as having its own history. The critic Philippe Burty offered a good instance of this new historicizing approach in an article that appeared only a few months before Monet's first journey to the South:

He is entering into a new phase. We ascertain this with a pleasure increased by the fact that we have had complete confidence in him from the beginning. We knew what obstacles he had to fight, and our only worry was that, as in the year before when he tried to show at the Salon, he would make too many concessions, thus sacrificing the honor of his cause.[17]

Having, therefore, gained some form of public and critical recognition, the Impressionists felt more at ease with distancing themselves individually from the movement. Yet, while they became more isolationist in the 1880s, they still depended to a vital extent on some form of public recognition. This was particularly true for Monet in the Mediterranean. Despite (or perhaps because of) his prolonged and self-imposed isolation, Monet grew increasingly dependent on the opinions of others—his family, close friends, dealers, critics, and the public at large. In general, though, the Impressionists had achieved sufficient public recognition to allow them to look for new challenges and new plastic problems, beyond the boundaries of the Impressionist system. In other words, the group was now strong enough to enable each individual artist to go his or her own way, while capitalizing on the gains of the 1870s. Paradoxically, as even the harshest critics were warming to Impressionist "eccentricities," the artists themselves were beginning to show signs of disinterest toward the artistic tenets that had originally brought them together. Monet and Renoir had already made clear their ambivalences and their less than whole-hearted commitment to the Impressionist group exhibitions: Renoir showed at the Academy's Salon of 1879, and Monet participated the following year, when one of his works was accepted and another rejected. Monet eventually refused to show at the sixth Impressionist group exhibition in 1881.[18]

Meanwhile, Monet was looking for ways to hone a more clearly individual idiom. At the end of 1883, when he and Renoir explored the Mediterranean shores of France and Italy, Monet found what he was looking for. In the exotic, wild, exuberant aspects of the South, he discovered a source of profoundly challenging new pictorial problems. This challenge drew from him some of the most powerful, resonant, and innovative painting he had ever produced—work that went well beyond Impressionism. It is significant, in this regard, that on their way back from Italy, the two artists stopped off in Aix to visit the greatest iconoclast of them all,

19

Cézanne.[19] Having given up hope of exhibiting at the Salons, Cézanne had withdrawn to the South and was forging a form of art that was so highly and unmistakably individual that Monet could not but be impressed by it.

Cézanne's work had an immediate effect on Monet. This is most obvious in a group of three views of Bordighera (Plates 2–4) that employ a typically Cézannesque device: the branches of the trees form an inner frame within the compositions. In general, however, the two artists pursued parallel paths, each seeking in rather different ways to explore the limits of their individual visions. Cézanne's example was significant in that he offered visual proof that a resolutely forceful and original pictorial idiom could be attained through intense experimentation in isolation. The Mediterranean world, to which Renoir had introduced him and in which Cézanne was living and pursuing his art, would present Monet with an ideal laboratory.

The twenty-five years spanned by Monet's visits to the Mediterranean coincide with the period in which he used what has been called a "serial procedure."[20] In this approach, Monet would often paint more than one picture of a subject from similar vantage points but under different circumstances. John House points out that the genesis of this procedure goes back to the 1860s when Monet, following the example of the Dutch landscape painter Johan Barthold Jongkind, would make "more than one painting of equal status of the same subject."[21]

The series paintings that Monet made in Bordighera and Antibes paved the way to his full-fledged serial practice several years later. His *Wheatstacks* series of 1890 came to be considered by Monet and others to be a turning point in his work.[22] Thereafter, from the 1890s onward, Monet systematically exploited the series concept until his last series undertaken away from his Giverny garden: a group of views of Venice painted in 1908, exhibited in 1912 at the Bernheim-Jeune exhibition in Paris.

In the Bordighera series of 1884, we see the formation of several "clusters" or small series of two to five paintings that depict the same site. These works are painted from slightly different vantage points and differ also in aspects that are formal (size, finish, chromatic scale), objective (weather, lighting, status of the sea, growth of vegetation), and subjective (moods of the artist alternating from high optimism to self-deprecating bouts of depression). At the other end of the spectrum, the Venice series of 1908 is a group of smooth, fully integrated, masterfully conducted works. But Monet's experiments with series over the course of this twenty-five years were not, as House points out, just "a matter of the number of versions of any subject."[23] Rather, the concept involved the way the artist saw his own works and the way he hoped others would see them.

Monet's systematic use of seriality also testifies to his approach to painting: a work of art inherently had to be nonreiterative. Seriality emphasizes the natural uniqueness of painting, not only in its subject matter (representing a fragment of the real that is constantly under flux) but also in its temporality (reflecting a moment of the creative individuality that cannot be repeated). This nonreiterativity of the picture was perhaps the most radical innovation introduced by Monet. Furthermore, instead of being regarded as a formal limitation to creation, within Monet's serial procedure this nonreiterativity became the paradigmatic representation of the ceaselessly changing world as seen by a ceaselessly changing subjectivity.

Monet was constantly aware of the problems involved in this new way of painting. During his Antibes campaign, he expressed reservations about the town of Agay because it was "not greatly varied, and I must beware of giving way to repetitions."[24] But Monet's self-addressed warning was partly rhetorical: he knew full well that repetition was impossible in the case of his art. He knew that the given circumstances of the outdoor motifs he chose to paint (the time of day, weather, wind, light, season, color of the sea, and so on) never repeat themselves. He knew also that even if these conditions were to repeat themselves exactly (an impossible

hypothesis), he would experience them differently every time. He would not focus on the same sequence of details, prioritize the same elements, or paint them on the canvas in the same exact order—he would inevitably introduce elements of variation. Indeed, Monet's whole procedure in the South was constructed around the infinite degrees of variability of a given motif.

The first critic to focus on this issue of uniqueness (or nonreiterativity) was the Russian literary critic Mikhail Bakhtin. In a text that could almost be applied word for word to Monet's work, Bakhtin writes:

Natural uniqueness (the fingerprint, for example) and the signifying (semiotic) nonreiterativity of the text. Only a mechanical reproduction for the fingerprint (in unlimited quantity); such a mechanical reproduction is, of course, also possible for the text (a reprinting, for example); but the reproduction of a text by a *subject* (return to the text, new reading, new performance, citation) is a new and nonreiterative event in the life of the text, a new link in the historical chain of verbal communication.[25]

In other words, not only is every text and every picture impossible to repeat (nonreiterative) in terms of the way it is created by an individual; every experience of looking at a picture is always different and is also unrepeatable. The interaction between creator and receiver constitutes another unique circumstance. Not only was Monet a maker of series but, as viewers, we are the makers of our own series: a series of examinations, of observations—one of which never quite equals the previous nor the next. To Bakhtin, an "utterance" (any expression produced in a living, concrete, and unrepeatable set of circumstances) is always directed toward somebody. An utterance is inconceivable without a speaker *and* a listener. As he puts it:

Discourse (as all signs generally) is interindividual. All that is said, expressed, is outside of the "soul" of the speaker and does not belong to him only. But discourse cannot be attributed to the speaker alone. The author (the speaker) may have inalienable rights upon the discourse, but so does the listener, as do those whose voices resonate in the words found by the author (since there are no words that do not belong to someone). Discourse is a three-role drama (it is not a duet but a trio).[26]

Of course, Bakhtin is speaking here of texts, not paintings. Texts are written to be read and to tell us something. The pictures of Claude Monet do not tell us anything; they merely represent forms that we visualize and identify with palm trees, the Alps, the Mediterranean Sea, and Venetian palaces. It is impossible to "read" any of these pictures directly, though obviously we can "recognize" the Alps, say, or the sea with as little difficulty as we can read the simplest text.

In other ways, however, Monet's work is to be linked with texts, clearly meant to be read. First, throughout his two early sojourns to the Mediterranean, he never ceased to write *about* his paintings, and about the whole context of his painting. A prolific letter writer, Monet sent stacks of letters to his dealer, his artist friends, and, above all, to his mistress (and later his wife), Alice Hoschedé. Secondly, Monet expected reviews to be written by critics *about* his work. He knew that the critics would not fail to write these texts and he occasionally experienced fear, even nightmares, about what they might be writing. These two sets of intersubjective texts are an inherent aspect of Monet's approach to his art and will be the subject of considerable investigation here. These dialogues are, it seems to me, inseparable from the very notion of Monet painting on canvas. He lived for the next day to paint and to collect his mail; he anxiously anticipated what Alice had to say about him or what critics might say about his work. Monet's paintings were always addressed to someone; they solicit, even demand, a response.

Although in his first two stays by the Mediterranean Monet totally isolated himself from his family, colleagues, and dealers, he was dependent

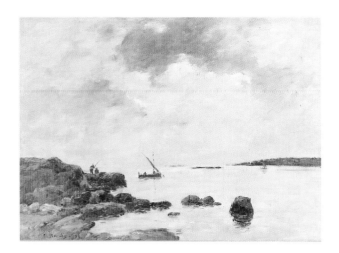

FIG. 6 Eugène Boudin
The Rocks at Antibes, 1893
Musée des Beaux-Arts et de la Dentelle, Alençon

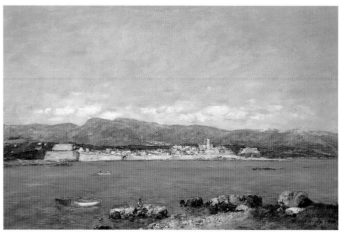

FIG. 7 Eugène Boudin
Antibes Seen from La Salis, 1893
Private Collection

upon communication with others. Bakhtin thus expressed this paradox:

I achieve self-consciousness, I become myself only by revealing myself to another, through another and with another's help. The most important acts, constitutive of self-consciousness, are determined by their relation to another consciousness (a "thou"). Cutting oneself off, isolating oneself, closing oneself off, those are the basic reasons for loss of self….It turns out that every internal experience occurs on the border, it comes across another, and this essence resides in this intense encounter…. The very being of man (both internal and external) is a *profound communication. To be* means *to communicate.*[27]

Monet cut himself off from the rest of the world but, at the same time, was as dependent as a child on the responses he received, or anticipated from others.

Monet's most privileged respondent during this period was Alice Hoschedé, his confidante, his lover, and, eventually, his wife. Alice occupied a paramount position in Monet's mind and life throughout the three decades defined by his trips to the Mediterranean. During the first two trips, he wrote to her constantly; on the third journey, to Venice in 1908, she accompanied

him.[28] I will argue throughout this book that not only was it impossible for Monet to undertake any trip without Alice's support but also that Alice's voice acted as a form of foil response that sustained and affirmed Monet's own pictorial self. That self, in my opinion, was the ultimate pictorial destination of each of these trips, and that destination could only be reached via the echo of Alice's voice.

When Monet first met Alice, she was married to Ernest Hoschedé, a wealthy textile manufacturer and one of the pioneering collectors of Impressionist paintings. Hoschedé collected the works of the Impressionists even before they showed together as such. In 1875, the year after the first Impressionist group exhibition, Hoschedé was forced to sell his already significant collection of contemporary art, and in 1878, the rest of his art collection and all his possessions were disposed of by adjudication. In October 1878, Hoschedé and his large family (Ernest and Alice had six children) moved into a rented property in Vétheuil with the Monets (Claude, his wife Camille, and their two sons). The Hoschedés and the Monets were up against the same precarious financial situation: Monet found it difficult to pay his share of the rent, while Hoschedé had to fire the children's nanny and tutor. The financial bankruptcy

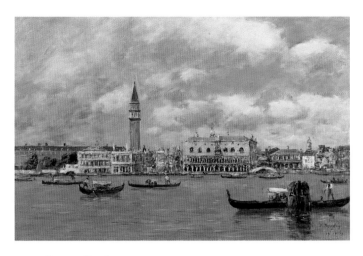

FIG. 8 Eugène Boudin
*Venice: The Campanile, the Doges' Palace,
and the Piazetta, Seen from San Giorgio Maggiore*, 1895
Private Collection

that forced him to sell his collection left Hoschedé a broken man.

Rumors that Monet was having an affair with the wife of his erstwhile patron and collector developed soon after the death of Camille in 1879. Two years later, Alice and her six children moved with Monet and his two children to a rented house in Poissy. In February 1883, Ernest Hoschedé visited Poissy to discuss his family's future, causing Monet to worry that Alice might be persuaded to return to her marriage. It was in this context that Monet undertook his longest and furthest trip away from their new home in Giverny. Alice was left to look after the eight children, and to fend off Ernest's entreaties to try to revive their marriage. It is not surprising, therefore, that the dialogue between Monet and Alice was especially intense throughout his sojourn.

Monet took several journeys far away from home and from Alice, seeking to renew and strengthen his pictorial identity, or, to put it differently, to affirm his artistic individuality in increasingly radical ways. Yet, away from home, Monet could only find himself through others. In Bordighera, Monet could not sleep without speaking to a photograph of Alice that he carried with him. This nightly ritual, as well as the daily anxious anticipations of the mailman's deliveries, suggests the

fundamental need for recognition and dialogue that most characterizes Monet's sojourns in the Mediterranean. By isolating himself—from home, from Paris, from the worldly art scene—and by confronting unfamiliar aspects of nature, Monet sought to push further the limits of his artistic self and to establish his art by consistently challenging himself. Yet, while cultivating his artistic self in isolation, he was highly dependent on the comforting, confirming, and supportive voices of others. Hence, the vital importance, for Monet, of his dialogues with others.

For anybody who spends some time with Monet's correspondence, it soon becomes painfully obvious that his "I" is definitely not autonomous and that his addressees bear a daunting responsibility. It is one of the main aims of this book to highlight this process. If in the Mediterranean Monet was in search of a certain pictorial and human unity, this process was, as Mikhail Bakhtin would put it, "not as an innate one-and-only, but as a dialogic *concordance* of unmerged twos and multiples."[29] Monet's task was to amplify this very principle. "This consciousness of the other is not framed by authorial consciousness," Bakhtin writes, "it reveals itself from inside as standing *outside* and *beside*, and the author enters into dialogical relations with it. Like Prometheus, the author creates (more precisely, re-creates) living beings independent of himself, with whom he appears to be on an equal footing."[30]

The story of Monet and the Mediterranean thus lends itself to the form of a set of dialogues. First, there is an internal dialogue between Monet and himself, addressed to his "pictorial characters," to use a phrase coined by one of Monet's late critics, Louis Gillet. These characters, whom Monet in turn praises and curses, may be any of the elements of the environment: the light, the wind (the dry, strong mistral), the vegetation, the mountains, the blue sea, the palatial facades.

A second, unverbalized dialogue is between Monet and the past, particularly artists before him who dealt with the Mediterranean: Cézanne, Renoir, and

23

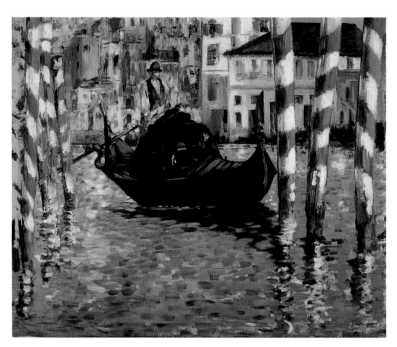

FIG. 9 Édouard Manet
The Grand Canal, Venice (Blue Venice), 1875
Shelburne Museum, Vermont

Frédéric Bazille, an early Impressionist and one of Monet's closest friends. Eugène Boudin, Monet's teacher, journeyed to Antibes after seeing the creations of his ex-student and visited and painted in Venice in 1895, producing works that Monet could not have ignored (Figs. 6, 7, 8). A most important figure looming in Monet's biography is Manet. The year Monet discovered the Mediterranean, 1883, was the year Manet died. This had a tremendous impact on Monet, who bought a pastel work by Manet from the Manet estate auction in 1884, sending his bidding instructions from Bordighera. Manet painted a few seminal works in Venice in 1875 (Fig 9), but was even more important to Monet, in my opinion, because he had established analogous antitraditionalist pictorial strategies with which Monet felt a very close empathy.

Another Impressionist who probably catalyzed Monet's interest in the Mediterranean was Berthe Morisot. Monet was most likely aware of the works produced by Morisot in Nice in 1882 (e.g. Bataille and Wildenstein 1961, nos. 111–118). But what is more, Monet even

promised to produce a decorative panel for her out of one of his Mediterranean works. (This work was *The Villas in Bordighera* [Plate 8], an enlargement of Plate 7; see W, vol. 2, letters 462, 467, 515, 529, and 530.) It is also fascinating to note the relationship between Monet's *Olive Trees* series and van Gogh's work in the south of France. This resemblance has seldom been emphasized, obvious though it appears when one sees Monet's (here reproduced for the first time: Fig. 11 and Plates 14–17) next to any of Van Gogh's pictures depicting a similar theme (Fig. 10). Another young protagonist was Paul Signac, who was in Venice in 1904 and 1908; Monet, we know, acquired several of his watercolors of Venice. As far as Venice was concerned, Whistler and Sargent also played important roles. The key common denominator that these memories had for Monet was that they all addressed the same question: as Michael Fried has posed it, in relation to Manet, "not how to overcome the power of the past to determine the present, but what to make of a past that had lost the power to do just that constructively."[31]

A third dialogue, between Monet and Alice, principally took the form of an exchange of letters throughout the first two campaigns (Bordighera and Antibes).

Finally, there was a dialogue between Monet and the critics who responded to his pictorial accomplishments. Monet was always anxious to hear and read reviews of his work. The critical voices rose in full celebration in 1912, when Monet's *Venise* (a retrospective of works executed in Venice, organized by his dealers, the Bernheim-Jeune brothers) was exhibited for the first time. These dialogues—cultivating independence while being highly dependent on others—are an essential aspect of Impressionism and, indeed, modernism.

Cézanne's 1866 letter makes clear that for the early Impressionists, dialogue was not just a pleasant or socially enriching mark of validation but was an intrinsic and irreplaceable condition of possibility for a modern work of art. This demand by artists for a response from others was sometimes vehement, sometimes pleading,

and sometimes fearful (what if nobody responded?), but the key was the active engagement of a listener or viewer. When Bakhtin remarked that every discourse refers to at least two subjects, he might well have been speaking of what was happening with Impressionism, as embodied, through its various stages, by Monet:

"Style is the man"; but we can say: style is, at least, two men, or more precisely, man and his social grouping, incarnated by its accredited representative, the listener, who participates actively in the internal and external speech of the first.[32]

One of the essential aspects of Impressionism was *interchange*, a profound sharing of ideas, techniques, and compositional recipes. For the Impressionists, this process should not be read in terms of influence but as a fascinating, mutually enriching give-and-take.

The more overt version of this collaboration in Impressionism occurred during the 1870s when Monet worked side-by-side with Bazille, Pissarro, Manet, and Renoir successively. This collegial approach soon gave way to a more individualistic turn in the 1880s, however. Like many of his colleagues, Monet tried to assert a pictorial idiom that was unique. While distancing himself quite deliberately from his colleagues, he became more dependent, in different ways, on the opinions of others, the critics and the public. Thus, the Bakhtinian principle ("style is at least two men") remained true, but the "second" (or the other) shifted. Instead of an artist collaborator, the "listener" became a critic, a friend, a lover, a collector. Monet did not stop having contact with his artist friends and colleagues—far from it—but his relationships with those artists changed substantially, from collaboration to mutually respectful, though distant, recognition of each other's differences. *Monet and the Mediterranean* is, in a sense, the story of this shift.

FIG. 10 Vincent van Gogh
Undergrowth, 1889
Van Gogh Museum, Amsterdam
(Vincent van Gogh Foundation)

FIG. 11 Claude Monet
Study of Olive Trees, 1884 [Plate 14]
Courtesy Marc Blondeau, S.A., Paris

The Italian and the French Rivieras
January–April 1884

On the first day of December 1883, Monet announced with relief that he had nearly completed the interior decoration panels commissioned for the luxurious Paris apartment of his dealer, Paul Durand-Ruel. This project had been quite an ordeal for Monet; he painted thirty trial panels of floral decorations and destroyed or erased one after the other before achieving a satisfactory result.[33] Monet's frustration was due not only to the technical difficulties involved in realizing the six large panels and the time they required but also to the indoor environment, which he felt stifled his mind and his pictorial imagination. "I cannot wait until I am out of all of this," he wrote. "It has been a century since I last worked outdoors, and it's all because of this. I sometimes reach the point where I wonder if I'm not going insane."[34] This self-declared "insanity" (if but hyperbolic) of Monet's has lately become a subject of acute interest to certain scholars who emphasize this as a trait inherent to Monet's practice. Charles Stuckey, for example, has pointed to

Monet's sense of pronounced desperation, which at times took on pathological dimensions.[35]

Monet made recurring references to his supposed madness: "For me it is increasingly difficult to be satisfied, and I've gone so far as to ask myself if I've gone mad, or if it's just that what I've been doing isn't better or worse than what I did before, only I've more difficulty doing today what I used to do easily. And yet I find that I'm right to be difficult."[36] This sentence deserves attention both because it provides context for the issue of Monet's mental health and because it is emblematic of a situation that developed over Monet's three trips to the South. Here, Monet dwells specifically on the notion of difficulty and on a complementary loss of facility. The complexity of this sentence derives from the recurrent use of the same terms ("mal" or "difficulté") in three different phrases with three different meanings. The first phrase ("I find it increasingly difficult to be satisfied") points to the subjective aspect of Monet's worries: his self-imposed standards are too high and he cannot meet his own expectations. The second phrase ("I've more difficulty doing today what I used to do

easily") uses the most obvious and familiar sense of the word "difficulté"; it points to the usual obstacles confronted by Monet in order to accomplish what he wants to do in paint: to translate his visual perception of an external reality onto canvas. The third phrase returns to the original problem, although set here in a reflexive form, saying in effect, "When I demand so much of myself, I find that I am right to do so." This nexus of contradictions will later become a recurrent theme throughout Monet's first two trips to Bordighera and Antibes. Monet will ceaselessly complain of the difficulties he faces in realizing his sensations of nature. And yet, at the same time, Monet will always insist that he is tougher on himself than anyone else could possibly be and that he is right in imposing these exacting standards on himself.

At any rate, in December 1883, Monet needed to escape from this sensation of madness. A trip to the Mediterranean seemed the ideal cure and it was undertaken with Renoir, it seems, on impulse. There is scarcely any doubt that this short excursion of about ten days felt like a deliverance to Monet.[37] Not only did this trip put an end to the "century-long" imprisonment at Durand-Ruel's but it also plunged him into an entirely alien world, rich with marvelously strange vegetation, exotic fragrances, and, of course, brilliant colors. Seized by a desire to respond to these new stimuli, Monet produced two paintings of equal size in less than a week. One represents a road leading to the small village of Roquebrune near Monte Carlo (Plate 1) and the other, *Near Monte Carlo*, 1883 (W. 851, not illustrated, location unknown), depicts a seascape with rocks and vegetation. In a way, these two motifs announce Monet's entire production during his first campaigns in the South— *The Monte Carlo Road* is about the Mediterranean light, while *Near Monte Carlo* dwells on the sea. These are the themes he explored in depth when he returned to the South a month later and again, to Antibes, four years later. In Bordighera, Monet immersed himself in the lush nature surrounding him, developing further the motifs

depicted in *The Monte Carlo Road*. At Menton, on the French Riviera, where Monet stayed during the last week of his three-month sojourn in Italy, he concentrated on the sea, returning to the theme begun in *Near Monte Carlo*.

From letters written by Monet to Durand-Ruel, we know that this extended three-month stay in Bordighera and Menton was originally meant to be taken in the company of Renoir. However, Monet seems to have decided he no longer needed to rely on Renoir's intimate knowledge of Italy, though he may have led Renoir to believe otherwise earlier on. This is how he announced his plan for a sustained stay in Italy to Durand-Ruel:

I beg you to mention this trip to *nobody*. It isn't so much that I want to keep it a mystery. It's just that I want *to do it on my own*. As fun as it was to play the tourist with Renoir, it would be a real hindrance to my work to take this trip with somebody else. I have always worked far better in solitude and after my own impressions only. So please keep this a secret until I tell you otherwise. If Renoir knows that I am about to set off there again, he will most likely wish to come with me, and this would be just as bad for him as it would be for me. You will most likely agree with me.[38]

Why would Renoir want to come with Monet, if the latter had not led him to understand that they would undertake this second trip together? In a letter written to his dealer about ten days after having settled in Bordighera, Monet apologetically tried to justify his decision: "I did write to Renoir. I am not making a mystery out of my stay here. I was only intent on coming here on my own in order to be freer with my impressions. It is always a bad thing to be working alongside somebody else."[39] To Monet, work, particularly while away from home, meant intense, passionate, exclusive engagement. As Steven Levine has recently noted, there was something almost solipsistic about Monet's attitude to nature—his sense of immersion within nature and,

through nature, his sense of reunion with the self.[40] For Monet, painting was anything but a holiday, even though he chose a site of burgeoning tourism as the base for his newest series.

Arriving in Italy, Monet felt no sympathy whatsoever with the tradition of the "gentleman of leisure," who sought in the Mediterranean a source of recreation or of lyrical transport. Neither did he have any sympathy for the whole pictorial tradition that was producing an imagery of Italy as either the backdrop for various types of mythologies or as the continuation of picturesque landscape painting. More in tune with Monet's state of mind was a certain trend in literature that had virtually no equivalent in the visual arts, particularly as applied to the Mediterranean. In this trend, which first developed in the early part of the nineteenth century, one's immersion in new landscapes was intrinsically connected to a process of self-discovery.

This theme is clearly evoked in the early-nineteenth-century travel writings of, among others, Chateaubriand. During his first of eleven trips to Italy, in 1803, when he was sent by the Emperor Napoleon as the ambassador's secretary in Rome, the author tried to describe Tivoli but could not help returning to himself:

This place is propitious for reflection and for reverie: I go back through my past life; I feel the weight of the present and I seek to penetrate the future. Where shall I be, what shall I do, and what shall I be twenty years from now? Every time one descends inside oneself, one finds that all those vague projects that one forms for oneself are met with an invincible obstacle, or with a feeling of uncertainty dictated by something certain: this obstacle, this certainty, is called death—that terrible death that stops everything, and strikes you as well as others.[41]

So much for a description of Tivoli!

A different and less direct search for oneself was proposed by Stendhal, who sought in Italy experiences that could bring him to a state of ecstasy. Thus, Stendhal juxtaposes such pleasures as listening to music at La Scala, making love, and viewing a Correggio fresco in Parma. All these quintessentially Italian "sensations" lead the author on his quest toward his self, which, unlike Chateaubriand's, can only be discovered through heightened emotions.[42]

Chateaubriand, Stendhal, and George Sand all grant a privileged status to their sensations of Italy by night. Sand offers a vivid description of Venice as a restful place to forget the world and focus on the self: "No one ever told us of the beauty of the sky and the delights of the Venice nights....Water and sky are unified in a veil of azure, where reverie gets lost and falls asleep.... When everything is white—water, sky, and marble.... I start to live through the pores of my skin alone, and a curse on anyone who would come and call upon my soul! I vegetate, I rest, I forget. Who would not do just the same in my place?"[43] It is one thing to state that such confrontations with nature involved an examination of the self and another to comprehend what that means. Our difficulty today is in ignoring stereotypes of the Riviera—and, for that matter, of Impressionism— as "pretty" and "easy." Our difficulty, then, is precisely in comprehending that Monet was not working within our preconceived image of sunny Italian ease but within a continual flow of difficulties that constantly put him at risk. His goal was clear: to search for himself. The risk involved was no less clear: to lose himself.

Before leaving on his own for Bordighera, Monet wrote to Durand-Ruel announcing his plans to return to that site on the Italian Riviera that he referred to as "one of the most beautiful places" he and Renoir had seen.[44] Only about twelve miles east of the French town of Menton, the small village of Bordighera was Monet's residence for about ten weeks, from January 17 or 18 until April 6, 1884. From there, Monet visited Menton and Monaco for just over a week, leaving for home on April 15. The relative length of these stays is reflected in the number of paintings he produced:

thirty-eight in Bordighera and its environs, eleven on the French Riviera. The latter figure translates to over one canvas per day, which is astounding when one knows how exhausted the artist must have been by this point. According to the artist's own account, however, this productivity may have been due to his relative familiarity with the motifs, many of which he had encountered on his initial reconnaissance expedition with Renoir and, again, on several occasions during his stay in Italy, when he would cross the French border on brief excursions.

Before beginning to work in Bordighera Monet had to find a place to stay. Finding lodging was not so easy. Tourism in the area was mushrooming, and Bordighera was fast becoming a favorite gathering place for budding European tourism. It also served as a sort of southern court for Charles Garnier, the famous Parisian architect of the Second Empire.[45] Ernest Meissonier, Jules-Eugène Lenepveu, Alexandre Bida, and Georges Clairin, all among the celebrated Salon artists of the time, adorned Garnier's villa with frescoes on biblical themes. None of this interested Monet in the least; he apparently never even attempted to contact Garnier. His immediate concern was with finding a decent hotel room in order to set off to work. He was shocked to discover, while dining at his hotel, that he was the only Frenchman among the guests, all German tourists. Declaring "I would not have stayed there at any price," he found alternative lodgings where "the English dominate, since the French hardly ever cross the border these days."[46] Thereafter, Monet behaved as though he were entirely isolated, boasting that he was ignoring nearly everyone, obsessively engaged in his own work.[47]

Once settled, Monet wasted little time in starting to work, as he promptly reported to Durand-Ruel: "In short, I am now settled and I started to work yesterday. Beginnings are always mediocre, but I am certain

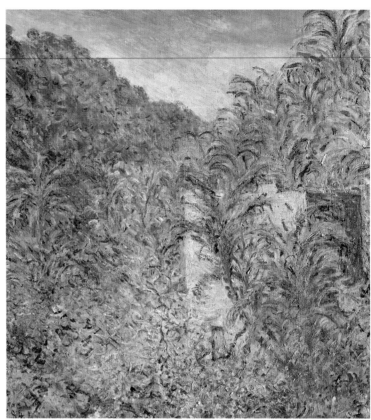

FIG. 12 Claude Monet
The Valley of Sasso, Bordighera (detail), 1884 [Plate 11]
San Francisco Museum of Modern Art
Bequest of Mr. James D. Zellerbach

that I will bring back interesting things, for everywhere all is beauty and the weather is superb."[48] The promptness of Monet's report to Durand-Ruel shows that he felt compelled to provide reassurances. According to the letter (dated January 23, 1884), Monet had begun to paint "yesterday." This indicates how long it took between the artist's departure and the actual beginning of his labor. Leaving Paris on January 17, Monet arrived in Bordighera the following day. The initial reconnaissance took about four days. Such spans of exploratory survey were vital for Monet's late work. He would walk around his new environment, getting a feel for the landscape and the all-important climate, noting obstacles and devising a strategic plan for its pictorial conquest. He would envision how much time and space he would need to realize a group of paintings, even though his plans rarely turned

30

out as anticipated. In this case, by the time he wrote this letter, he obviously knew the area quite well. Most likely his entire program was in place, as his self-satisfied and confident tone reflects.

Early on, Monet had already selected two kinds of motifs: the "somewhat exotic aspects" of the region, such as palm trees, and "water, beautiful blue water."[49] Later, a third motif featuring the Moreno garden also emerged, as well as a fourth, consisting of views of the mountains surrounding Bordighera. Of the planned motifs, the "exotic" series is exemplified by *Small Country Farm at Bordighera* (Plate 21), *Palm Tree in Bordighera* (Plate 22 and Fig. 13), and *Bordighera* (Plate 23). The palm was at that time an emblem of Bordighera: "As Nice claims the orange as its emblem, or Menton the lemon, Bordighera's pride stems from its palms."[50] The village was the capital of the palm-leaf industry, most in demand during the religious celebration of Palm Sunday. In the same group of works as the "exotic" series is the extraordinary Sasso Valley series (Plates 10–13 and Fig. 12), as well as a group of three works in which Monet orchestrated a kind of dialogue between the agave and palm trees of Bordighera (Plates 6–8).

Relatively few works depicted "water, beautiful blue water." In one series, presented here for the first time as an ensemble illustrated in color (Plates 2–4), the sea is overshadowed by the rooftops of Bordighera and the surrounding vegetation. Another pair of paintings represents the French coast from a hill near Bordighera (Plates 24 and 25). The sea dominates only one work, which Monet clearly decided not to develop into a series, *The Marina in Bordighera* (Plate 5).

Monet's intentions and their conflicts with his actual patterns of work can be followed in his correspondence with Alice. While the first few letters are lost, a letter of January 24 proudly announces that he is hard at work and has already begun four canvases.[51] In this intriguing letter, Monet indicates his intention of proceeding from one group of paintings to another: "It is therefore now a matter of finishing them, and then

to begin another four, and so on." Indeed, the extant works from the Bordighera campaign readily lend themselves to such small groupings around various themes or motifs. However, none of these subseries contains four works, so the first among these series cannot be determined.[52] It seems likely, however, that Monet worked on an array of different motifs from the very beginning. In another letter to Alice he describes the scope of his concerns, "I am living the life of a dog and never spare my legs. I climb up and down, and up again. When I want to rest between each study, I explore every little path, as I am always eager to see something new."[53]

All the Bordighera paintings are imbued with this sense of physical and mental exhaustion. At the end of each day of work, Monet was spent, falling effortlessly into a deep slumber. He was intent on exhausting every single pictorial possibility of this new and strange world. He would only leave Bordighera when he felt it could yield nothing more. While in or near Bordighera, Monet needed to cover as much ground as possible; in his own words, he was insatiably "curious," forever hungering to see "something new." This was very different from the situation of his previous work, which stemmed from a long familiarity with the surrounding landscape. In Bordighera, it was the unknown that fired his pictorial imagination.

At work, Monet became nearly pathological in his obsessiveness. Everything else had to give way, including his relationship with Alice Hoschedé. At first, Monet planned to stay in Bordighera for a month, but three months later he was still there. Most of Monet's daily correspondence over the course of these three months was devoted to convincing Alice that he was *kept* in Bordighera, almost against his will, by some kind of ineluctable need to paint ("to do" or "to catch") this incredible country.

Only ten days after his arrival in Bordighera, Monet described to Alice his silent and solitary life, only interrupted by meals and occasional visits from a group of English artists staying, like Monet, at *La Pension anglaise*.[54]

To Alice, the fact that he made an exception to his quasi-monastic existence to socialize, especially with ladies, was vexing. She became fixated on an allusion Monet had made to one of the guests at the *pension*, a pretty, young American with a particular hat that Monet described at some length. To her worries, Monet replied angrily:

Yes, it is true: I have all the pleasure I could want—work, the country, the sun—but that's all. There are no ladies, no hats *à la Rembrandt* to distract me. Please drop this matter and remember once and for all that you are my life, you and the children, and that while I work I never stop thinking of you….Tell yourself that I am working, that this is good for me and be patient.[55]

This injunction to Alice to remain patient recurs throughout Monet's letters. His work had taken over his life and imposed on him a feverish and persistent schedule. Weather permitting, Monet would work twelve hours per day, taking only a short lunch. Time was of the essence for the artist when he was working away from home. Time was not simply measured by the clock, however. For Monet, there were three distinct dimensions in his experience of time: emotional or psychological time (the experience of the prolonged separation from Alice); natural time (the duration of natural phenomena that he studied, such as the light or the weather); and pictorial time (the time it took him to block out a motif or work out a series). These three kinds of time were always in conflict with one another. The separation from Alice was always too long to bear for her—hence, the constant flow of complaints on her part, reassurances on his, and mutual frustrations. The natural time, in contrast, was always too short—hence, the ongoing race against fleeting time. The time it took Monet to look, to manipulate paint, brush, and canvas was always having to catch up with the relentless pace set by nature. Monet's greatest frustration stemmed from the impossibility of reconciling pictorial and natural time; hoping but ultimately ever failing to match his working time at the easel with the pace set by the shifting conditions of light and weather. The solution was always to steal from emotional time, but the problem was always the same: emotional time could not feed pictorial time without dire consequence.

As Monet wrote to Alice on February 12: "Today there has been splendid weather and I have worked *all day* with more devotion than ever. But, my God, this damn country is so difficult. I can't manage to complete even my studies. I think they will just about do, only to find when I get back to the hotel, that they still aren't it."[56] This frustration became all the more acute as Monet developed his serial procedure. Each time the problem worsened, he would once again postpone his departure back home. Ultimately, he needed so much more time that he had no choice but to return home, with the thought of coming back to the South, as he did four years later, to pursue further what he had begun. Of course, by then, his pictorial interests had shifted and he worked in an entirely different manner—and therefore had to start all over again.

While Monet was away in Bordighera, struggling with his art, Alice was feeling increasingly frustrated at home. Monet knew that his departure had created a fragile emotional situation; she had eight children to care for. He pleaded with Alice to be patient and to write positive letters to give him the strength to confront time patiently: "You must not think there was any premeditation when I spoke of prolonging my stay a while. Never! And believe that I will not be so late as you think and that I will be overjoyed to come home and take up my life in the country. I have a feeling that it will give me enormous pleasure to paint over there [in Giverny]; know that even the most beautiful country in the world can't replace the joys, or even the small trials of our intimate life together."[57] In his letters, Monet returns over and over to the importance of time, the time to work and his frustration with the impossibility of reconciling working time with natural time. "You can't know how happy I would be to see you, to hear you, to

be in your life. In the end, when I don't work all day long, I become completely melancholic. Only work makes me forget a little, and time then passes quite differently."[58]

For Monet, psychological time became fully dependent on his correspondence with Alice. Mail deliveries became the metronome of Monet's and Alice's emotional lives. Monet was still newly in love with Alice and was anxious over the uncertainty of their future together. This preoccupation was a vital feature of Monet's daily existence while in Italy during the winter and spring of 1884. But the letters to Alice reveal more than Monet's passion for his new companion. They also offer a sustained and continuous account of Monet's progress with his thoughts and plans as he painted along the

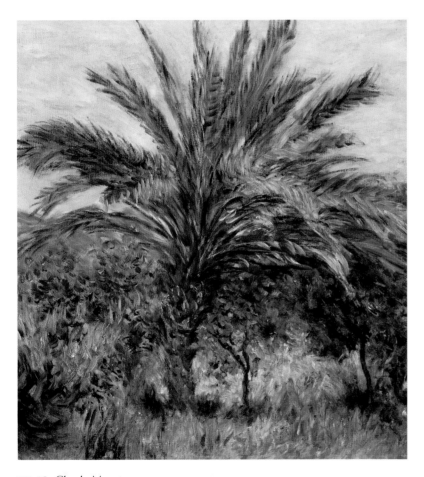

FIG. 13 Claude Monet
Palm Tree in Bordighera (detail), 1884 [Plate 22]
Private Collection

shores of the Mediterranean. The intensity of his recent passion for Alice made him write to her every day. There is no previous phase in Monet's life where we are able to follow so closely the artist's thoughts and feelings —his enthusiasms, depressions, uncertainties, fears, and joys—as we gaze at his paintings dating to a known time period. These letters also simply betray the need to be heard, to be read, to be recognized through the artist's relentless artistic pursuit.

The emotional dialogue between Monet and Alice was intense. From the beginning he enjoined her to avoid forming "dark thoughts."[59] Monet's epistolary tactics swung between emotional blackmail and promises of future happiness and luxury. Amidst a sea of responses to Alice's reproaches—avowals ("I never cease to think of you, and I would give anything just to spend one evening with you"); apologies ("forgive me for leaving you all alone with your worries"); and hopes ("I hope tomorrow to hear good news from you, a good letter without reproaches")—Monet also told of his daily progress. On January 26, he noted that he had started a fifth canvas and expected to begin another the following day. His verdict was ambivalent, as usual. "It's going well enough," he writes, "though not without difficulty. These damn palm trees are driving me crazy." In addition to confirming that palm trees were indeed among his earliest motifs, this letter clarifies the nature of the "difficulty": the palm trees did not lend themselves to the format of his canvases. They were either too tall, or too wide, or too dense ("touffu").[60]

Monet's third week in Bordighera began auspiciously with a thunderstorm on Monday, January 27. In his daily letter, Monet describes the "spectacle" he saw after the rain. "Then, there was an unforgettable spectacle, possibly even more beautiful than the adorable calm weather of previous days. All of the mountains were capped with snow, for

33

when it rains down below, at these enormous heights, it falls as snow. Then, the sea, always and even bluer than ever; no, this just cannot be described. As for painting it, one must not even think about it. These effects are far too short-lived and can never be found again."[61]

Monet then tells of a brief exception to his otherwise "silent and lonely" existence: a promenade he undertook in the company of two English male painters. During this short tour, he discovered a few villages a good distance from Bordighera, as well as new motifs. In fact, the trip led to some of Monet's most masterful landscapes, such as *Valle Buona near Bordighera* (Plate 9). But the biggest obstacle was the sheer distance from his hotel: "We visited three little Italian villages lost in the mountains: Borgetto, Sasso, and Valbona [known today as Vallebona]; so many landscapes, so many marvels, but far too remote to go and paint them." But if Vallebona was too far away for Monet to paint it, a sketch was at least possible. A pencil sketch of this

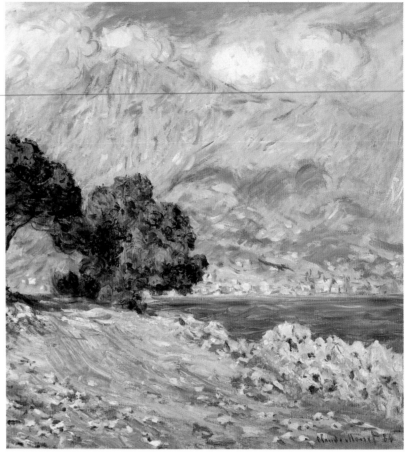

FIG. 14 Claude Monet
Cap Martin, near Menton (detail), 1884 [Plate 38]
Museum of Fine Arts, Boston
Juliana Cheney Edwards Collection

motif (now in the Musée Marmottan in Paris) was probably executed on this occasion. Monet was like a prospector, ever searching for the hidden spot with the richest pictorial yield.

Ten days after arriving in Bordighera, Monet offered a quite encouraging assessment of the work he had accomplished: "I spent the morning looking at my recently started canvases. Well, I can tell you that I am not dissatisfied. With good weather on my side, I may yet hope to bring back some good things." With fine weather over the next few days, Monet began to paint in a "frenzy," working on six canvases per day. In a letter written to Alice on January 29, Monet hints at his growing obsessiveness and agitation; he describes himself

as frantic ("forcené") and as masochistic ("je me donne terriblement de mal"). He remarks that he even scares himself with his relentless pace: "I am feverish with what I am doing" ("je suis enfiévré par ce que je fais").[62] Yet, if Monet was terrified by the novelty of the Mediterranean landscape, he was also buoyed by its effects: "What makes you happy here is to rediscover your effect each day and be able to take up the battle once again."[63] From six canvases, and at least six sessions of work devoted to each, Monet increased the number to eight.[64]

By the beginning of February, Monet was on to new subjects despite gray weather. His exhausting work schedule demanded that he paint from dawn to twilight, with only a short break at lunch time. Monet's

prodigious output can be gauged by the fact that he had started only six canvases by January 29 but by February 2 he was "on top of fourteen canvases."[65] The same day, in a letter to the art critic and collector Théodore Duret, Monet details not only what he is seeing but also what he has been painting: "Well, I'm working hard and will bring back palm trees and olive trees (how admirable are the olive trees!)—hence, my blue tones."[66]

While it has been believed that Monet's paintings of olive trees only began once he had obtained access to the private Moreno garden, presumably on February 7,[67] this letter suggests that he had already encountered this motif elsewhere—despite the fact that the work is titled *Grove of Olive Trees in the Moreno Garden* (Plate 15). How, then, are we to explain the title given to the painting?

There is one plausible explanation. Monet had heard about Francesco Moreno and his famous garden as soon as he arrived in Italy. Moreno was Bordighera's most important landowner, and he collected rare plants and unusual species of palm trees, to add to his already enormous plantations of olive and palm trees. Access to Moreno's garden had once been routine but had been restricted after a few acts of vandalism. As soon as he arrived, Monet asked his dealer to help him gain entrance to them.[68] But the privacy of the section given over to rare species would not have affected Monet's access to the olive trees in the garden, which were open to the public. Most likely, Monet began his series of olive trees in this unrestricted portion of the Moreno garden, continuing to work on other specimens of the olive-tree motif once he was granted access to the "off-limits" area of the Moreno plantation from February 7 onward. Monet's first description of Moreno's garden confirms that the *Olive Trees* series (Plates 14–17) had been started earlier. He explains that he had to interrupt a group of five studies (the exact number of works in the *Olive Trees* series) in order to go and meet Francesco Moreno:

I was wonderfully welcomed by this gentleman....In

short, a delightful promenade through the nooks and crannies of his estate, which is unlike anywhere else. A garden such as this cannot be found; it is pure paradise. It seems all the plants in the world grow effortlessly from the soil there; you find a jumble of every variety of palm tree, orange and mandarine trees.[69]

In a letter dating from early February to Durand-Ruel, Monet uses three adjectives to describe his performance as a painter: frantic ("forcené"), well-trained ("bien entraîné"), and self-contented ("content de moi"). A short time later he had a nightmare in which his pictures were covered with extreme tones, colors that were not true to life.[70] When he brought them back to Paris, everyone swore they could not understand them. Monet felt "hopeless" ("désespéré"): Durand-Ruel had no interest in the stuff, and Monet ended up cursing the whole trip.[71] The nightmare—and perhaps, a touch of hypochondria—convinced Monet that he had taken ill, and he suffered a dreadful headache the next day. This self-diagnosis found confirmation in the opinions Monet solicited from his fellow hotel guests, who agreed that he looked sick. So, with his illness as an excuse, Monet decided to take a break.

Hiring a horse and carriage, Monet headed west toward Menton and Monte Carlo on the French coast. These two sites were not entirely new to Monet, as he had visited them with Renoir a few months before. In fact, some of his earliest pictures of the Mediterranean were executed during that earlier visit (Plate 1). As usual, Monet found many motifs to which he wanted to return, particularly one in Cap Martin. Later, Monet visited Cap Martin on his way back to Giverny and produced several paintings (Plates 34–39 and Fig. 14). Despite his inevitable "overexcitement"—the result of too much work, he felt—Monet continued to work well, "seeing things better and better."

Given Monet's complex state of mind, it is no wonder that time seemed to pass rather fast. On February 9, he accepted an invitation from Moreno to

take a trip to Ospedaletti, a new resort that Monet regarded as "insanely luxurious." Monet sampled ice creams, listened to chants, and strolled on the terrace before returning to Moreno's gardens, where he was invited to taste all sorts of exotic fruit. In a letter to Durand-Ruel, Monet says, "You ask me whether I am content. Yes, I am more and more enraptured ['dans le ravissement'] and I work a lot."[72]

In fact, in his letter of February 11, Monet reports to Alice that painting in Italy "is extremely difficult to do and it is very time-consuming, mostly because the large self-contained motifs are rare. It is too thick with dense foliage ['touffu'], and all you can find are motifs with lots of detail, jumbles terribly difficult to paint, and I, in contrast, am the man of isolated trees and large spaces."[73]

In the same letter, Monet first suggests the principal dynamic of his Mediterranean trip: Bordighera, with its palms and bushy jumbles, is offset by Monaco, with its "broad mountain lines" and its sea.[74] Again, Monet proclaims Monaco the most beautiful spot on the entire Riviera. He then articulates the pictorial qualities to be found on the French Riviera in contrast with the motifs of Bordighera: the quality of "completion" of the French motifs versus the abundance of detail and excessive diversity in Bordighera; the quality of "readymade pictures" and consequent quality of ease of execution ("ils sont plus tableaux") in Monaco.[75] Bordighera and Monte Carlo are so different, so visually antithetical to each other that Monet, who was totally seduced by both towns, occasionally expressed some doubts about his choice of Bordighera. If Monte Carlo was so superb, did he make a mistake by coming to Italy?

A dreadful rain on February 11 prevented Monet, back in Italy, from painting, and prompted him to renew his predictable litany of complaints:

My God, this infernal country [the South] is so difficult; I cannot even complete my studies; I always think that this is going to be it; then I come back only to realize that this is not it at all. I have no idea whether my pictures will please, but it is certain that they are giving me a lot of trouble to do.[76]

By February 15, a gloomy day, Monet was scared ("épouvanté"), feeling that he had too much to do and finding everything he had done "ghastly" ("affreux"). He was obsessed with the idea that no one would like what he had done. He had never had as much trouble with anything else; some of his paintings had required ten or twelve successive sessions of work, and still were not finished. Monet turned morose and "melancholic." Bad weather and despair continued to dog him until mid-February. But as soon as the sun returned on February 17, Monet's paralysis was automatically remedied. He accepted an invitation to join English comrades on a Sunday excursion to the Valley of the Nervia, where he discovered Dolceacqua, a "little town extraordinarily picturesque," where he would later execute three works (Plates 28–30).

Ironically, Monet's ongoing despair offered Alice her main hope for his early return—and he seems to have perpetuated this emotional game. "I can't tell you how bored I get," he writes, "and how desperate I become at the thought that this situation [bad weather] might last. If this were to be the case, I would erase everything I did, and would catch the first train back."[77] Yet, he knew that this would not be the case, and so did Alice. On Alice's birthday, February 19, Monet returned to Dolceacqua, amidst a "frightening" wind.[78] There, he began two studies that represent the motif he described to Alice of the village and its bridge (these can be identified as being from the Plates 28–30 series).[79] The same day, he received a rare visit to his room from the two English painters with whom he traveled to Dolceacqua the previous Sunday. They were astonished to see that he had already painted two studies of the site in a single afternoon.

Each passing day thereafter was characterized by a rhythmic repetition, with slight variations, of the

events of the first three weeks in Bordighera. When the weather was good, Monet worked well and abundantly, explaining to Alice: "My trip absolutely must be productive. If I am to bring back lots of good things, I must take full advantage of it [the good weather] at any cost. If I were listening only to my own desires, I would hop on the next train."[80] Gradually, he became obsessed with finishing some of his works, perhaps in the face of pressure from Alice to stop prolonging his stay. His original two-week trip had by then stretched into six weeks. Even Monet conceded, "It's been too long." But he immediately adds, "and yet, I must bring this whole trip to a good end."[81] The message is simple: he will leave when a "good end" is in sight.

 Not surprisingly, tension began to escalate between Alice and Monet by the end of February, about six weeks after his arrival in Bordighera. As usual, Monet responded to Alice's complaints in several ways. He tried to exhort her to be "courageous" and "reasonable," for he "has to work." Indeed, he claimed, "the result of this trip might be very profitable to me." He also countered Alice's expressions of pain with his own bouts of hypochondria, saying he felt feverish and worried, and at night had "a terrible headache."[82] Finally, Monet insinuated that the longer he was troubled by her expressions of suffering, the longer he would have to stay in order to fulfill his intentions. In the end, Monet admitted that maybe the trip was "badly inspired." For, despite his extraordinary efforts, he still had not completed a single painting.

 Finally, on February 29, Monet announced to Alice that he had just completed his first two paintings in Bordighera—perhaps, he implied, the end was in sight. (This, in fact, was only the beginning of the end: Monet was to stay there another eight weeks.) These first two finished works depicted olive trees (quite possibly Plates 14 and 15 and Fig. 15). He was also working on

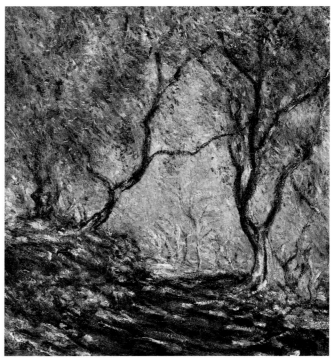

FIG. 15 Claude Monet
Grove of Olive Trees in the Moreno Garden (detail), 1884 [Plate 15]
Private Collection

Under the Lemon Trees (Plate 18), which he completed a few days later. Monet then confessed to Alice that things were much more arduous than he had thought—he had expected to be able to execute his paintings very quickly. He also lamented that with the exception of "two or three paintings" (Plates 3–5), the sea was nowhere to be seen. Yet, as he claimed, the sea "is very much my element." He would therefore have to stop off at Menton to do two or three motifs by the sea—seemingly implying that he could not do the sea in Italy.[83]

 In reply to fellow Impressionist Gustave Caillebotte, who had sarcastically inquired if he expected to settle in Bordighera for good, Monet explained that every corner of the Italian coast was conspicuously different from "our country." Monet writes, "Overall you find here an extraordinary pink tone; it is untranslatable. The mornings are ideal."[84] And, in a well-known and exemplary passage from another letter, Monet continues:

Of course, quite a few people will yell that there is no likeness to nature, that this is crazy. Too bad! They say this sort of thing when I paint our country, too. I had to come here to catch the striking aspect of this place. Everything I do is flaming-punch (*flamme-de-punch*) or pigeon-throat (*gorge-de-pigeon*), yet, my work remains at a timid distance from reality. I am starting to get there; every day it is more beautiful.[85]

If people scream that his painting is too far from nature, Monet says defensively, they must understand that his painting is less excessive (or less crazy) than the nature it depicts.

Clearly anxious about critical response to his new work, Monet wrote to Alice on March 12 that he had long feared that he might bring back nothing but dreadful things ("horribles croûtes").[86] But, after much effort (erasing, giving up canvases, starting all over again), he felt he had finally obtained "useful" results. Monet wanted to return with good things, for he felt that people expected it of him. By March 13, he had eight completed canvases. On that day alone he worked on seven studies, a record.[87] But he still complained that "nothing of what I have done in Italy satisfies me entirely."[88]

A week later he confirmed to his dealer in another letter that he would like to stop off in Menton for "two or three superb motifs there that I would like to bring back."[89] Monet seemed intent on demonstrating to his dealer his degree of self-sacrifice and his efforts to carry out this "courageous" campaign of work in the South. Here is Monet's self-evaluation after over two months of work:

I do not know whether what I did is any good. I no longer know anything; I have worked so much, and tried so hard that I am losing my head. If I could afford the time, I would erase all this, and would want to start all over again, for you have to live in a country for a certain while in order to paint it; and you have to have worked there painstakingly before you can render it with any

degree of certainty. But anyway, shall we ever be able to feel contented before nature, above all in this place? When surrounded with such dazzling light, one finds one's palette rather poor. Here art would need tones of gold and diamonds. In the end, I did all I could. Maybe, once all this hangs at home, it will recall for me what I saw.[90]

This letter is important in that it reveals Monet's forthright and candid sentiments about his pictorial problems in the South, the goals of his art as well as its limitations. One of the central themes of Monet's self-description is again the notion of time: he needs time, not only to paint but also, even before painting, to absorb his motifs, to penetrate them fully, and, afterwards, to rework them. If, as some claim, one cannot paint a place unless one lives there, Italy, Monet claims, requires this acclimatization even more so, for one's artistic means simply cannot rival the reality of "this dazzling light" and of this copious, rich, surrounding nature.

Toward the end of March, in a letter to Alice, Monet offers an important notation regarding the status of "finish" in his work. Although the paintings from this journey are essentially finished, he says, they still do not satisfy his criteria for completeness; they will require extra work once back in Giverny. Moreover, this problem introduces the notion of the end of painting: when does painting end? When does a painting reach the point of finish that it can be packed up and shipped away? The concept of "completion" is now the key to Monet's strategy for concluding his stay in the South. Monet later established a crucial distinction: rather than using the term "finished," he preferred to refer to his "complete" works as "works that I decide not to touch again." He also established for himself the following rule: once a work seemed sufficiently finished, it had to be put in its crate, where it would stay until the artist's return to Giverny. Facing his departure, Monet had an extraordinary realization: even if he were to stay another three months in Italy, his problems regarding the completeness of each work would persist.[91] The same day, Monet

38

wrote to Duret these lines, which could be an epigraph to his entire stay in Italy: "I hope I will have made a serious mark in that land of the sun. Can you imagine, during all the time I have been here I have not ceased painting: the amount of color I have wasted is enormous. I cannot see clearly anymore and I have gone berserk with work."[92]

As the end of March approached, Monet tried to cover all his motifs, one after the other, hoping to finish them as much as possible: "I do not know how I can accomplish my task: I go from one motif to another, racking my brains to figure how I can pack as much light as possible into these canvases. It is the work of a madman."[93] When he decided to get three studies over and done, it was "just because I absolutely want to come to an end with all this." At last, on Thursday, April 3, Monet announced that he would leave Bordighera on Sunday, no matter what happened. For once, his stated intentions to Alice were to coincide with facts.

In an extraordinary letter to Durand-Ruel, Monet summarized his work of the past three months:

I can see that you are expecting marvels; do not delude yourself: indeed, even though I work plenty, I am not happy. You might say that this is always what I am like, and that I never stop complaining, but there is no doubt that the result is in no direct relation to all the effort I have put in....What is certain, however, is that I am worn out and fed up with painting. It is therefore great courage on my part to stop in Menton; it is just that I feel I ought to bring back the souvenir of two or three pretty things I found there.[94]

After leaving Bordighera, Monet had his infamous run-in with Italian customs on April 5. When he presented his paintings in Ventimilia to be shipped to Vernon, he was told that no painting could leave Italy without authorization in writing from the Academy in Rome. Monet became enraged, but the authorities insisted that he had no choice but to comply with the

law.[95] Finally, he submitted all his canvases to the customs officials so that they could see for themselves that they were not Raphaels. Writing to Alice later, Monet said that he had gotten through customs "miraculously."[96] He left Bordighera; it had been almost three months since he left Giverny.

Once he arrived at Menton on April 7, Monet sent Alice a detailed program of what he intended to do: execute a few rough sketches (pochades) as "souvenirs of the place." If the weather was consistently good, he felt he might be able to complete one or two of them. At the end of his first day, however, he had already started four paintings. Monet optimistically predicted, "If the weather does not change, I will be able to finish them."[97]

Later, Monet grudgingly admitted to Durand-Ruel that it would be absurd for him to hope to "complete" the studies he undertook on the French Riviera, as the weather was too unpredictable.[98] But the next day, with "exceptional, wonderful weather," Monet worked very well and predicted that, with one or two more sessions of work, he might be able to bring back several finished works. Finally, on Easter Sunday, Monet announced to Alice that he had completed three acceptable canvases and hoped that, if the weather is still fine, another two works will have "taken off."[99] The next day, at last, he headed home to Giverny.

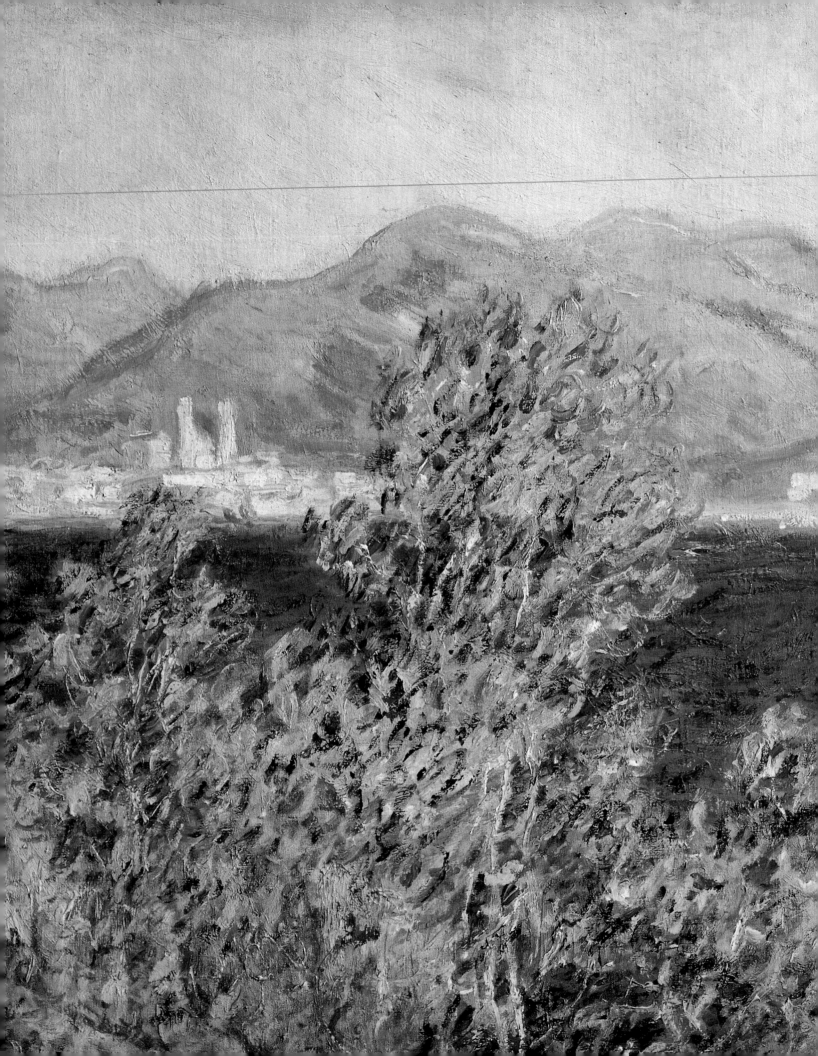

Antibes, January–May 1888

What I will bring back from here will be pure, gentle sweetness.

— Claude Monet to Alice Hoschedé, February 3, 1888

Unlike Monet's extensive plans for his trip to Bordighera, the genesis of his Antibes expedition remains relatively undocumented. No letters to dealers or friends announce his imminent departure. Perhaps given the complicated emotional issues raised by the first Southern campaign, Monet was loathe to allow too much time for reflection. In all likelihood, he decided on the trip spontaneously. Whatever the situation, there were direct parallels with the trip to Italy four years earlier, including the season in which he was traveling. With all the scars and bad memories the first trip had left at home, this second leavetaking must have been difficult to negotiate. However, on January 14, almost four years to the day after beginning his Bordighera adventure, Monet left Paris on a fast luxury train, heading south to Antibes.

Abundant emphasis has been placed on the importance of the railway system as a subject whose very selection is in itself expressive of the concerns of Impressionism. It is true, of course, that Impressionism would not have been the same without trains;[100] one thinks of the many renditions by Renoir and Monet of *La Grenouillère* and also of Seurat's *Sunday Afternoon on the Island of La Grande Jatte*. This was an art movement very much about the newness of nineteenth-century urban life, from which leisure time was now exiled, to be passed in suburban recreational spaces. Monet was one of the artists among the Impressionists whose work continued to feed off of the rapid expansion of the railway system. Of course Pissarro and Cézanne often traveled by train to the Normandy coast or to the Mediterranean. But no one depended so much on the long-distance train as Monet: from Paris to Norway, to Holland, to Brittany, to Italy, to the Creuse Valley, to the French Riviera. Indeed, the whole of Monet's wide-reaching pictorial searches are enmeshed with the conditions of modern life. A Jean-François Millet, for instance, could simply not have even conceived of how fast Monet would be

moving through space. Monet at Antibes clearly offers another pointed example of a later nineteenth-century artist's ability to exploit the new era of quick, relatively affordable travel.

As the train approached the Riviera, Monet was able to do much of his reconnaissance work along the way. He first stopped in Cassis, which he found "very pretty" and where he scoped out "a few superb motifs,"[101] though he hoped to find better motifs farther on, and reserved Cassis as a possible stop-off for his return trip. Then he took a slow omnibus from Toulon to Cap d'Antibes, where he had decided to stay. Unfortunately, his hotel was frequented by painters, including Henri Harpignies and a whole group of his students.[102] Over the course of the next week, Monet chafed at the proximity of these students, whom he called "idiots." He cherished his solitude and had very little tolerance for the company of other artists. Even Renoir, who was staying with Cézanne in nearby Aix, was not welcome to visit.[103]

Saying he had "no time to waste," Monet immediately set to work. Two days after his arrival he went to the small town of Agay, where he found beautiful things but ones that seemed a bit too repetitive. The next day he traveled to Monaco. From there he walked to Nice, a distance of more than fifteen miles. On his way back by train, he glimpsed a couple of motifs near Antibes, which he was intent on exploring.[104] By January 19, Monet had found "five or six superb motifs" and begun to work. He wrote to Alice, "The weather is so admirable that it would be a crime not to set to work right away."[105]

Soon Monet was at work on several paintings of the town of Antibes, "a small fortified town, baked to a golden crust by the sun."[106] He even asked the Minister of the Army for special authorization to circumvent a new law that prohibited any images, drawings, or sketches to be made of a military site, such as the fort of Antibes.[107] Although Monet reported that the weather was superb, there was too much variety in its beauty. He was frustrated because he was unwilling to

undertake too many canvases, which is what the extraordinary flux of the scenery seemed to demand. "I am enchanted with what I am doing," he wrote, "yet alas, it is only working half-way."[108]

The status of Monet's painting in Antibes changed as fast as the weather. One day he would work "admirably," thanks to the "eternal and resplendent sun," and the next a terrible wind would make work impossible. Nevertheless, Monet worked relentlessly. On February 1, Monet reported that he had "worked all day without a break: it is definitely so beautiful, but so difficult as well!"[109] He had already started working on fourteen canvases; this represented an average of one painting per day for the first two weeks. In fact, Monet was very proud of this number of works, which he felt was the result of intense training and years of experience.

In both Bordighera and Antibes, then, Monet was engaged in painting the same number of canvases at once only two weeks into his stay. But the number of works undertaken is a deceptive indicator of Monet's work rhythm during each campaign. In Bordighera, he was seized by some sort of frenzy after a long preparatory period of simply looking. In Antibes, Monet knew almost exactly what he wanted to do and set to work much earlier than in his Italian campaign. The pace of work in Antibes thus appears more constant and regular. Bordighera had presented many more problems and surprises than Monet encountered in Cap d'Antibes. Bordighera had been a pictorial shock; Antibes, in contrast, seemed to flow almost naturally onto Monet's canvases. Even his correspondence from Antibes reflects this greater ease. In Italy, Monet's imagination was captivated by the exuberant chaos, the "unpaintable," and the "indescribable" exotic vegetation; in Antibes, Monet's imagination seems to have been fired more by the natural contrasts of the environment (sea/town, mountains/sky, etc.). Also, in Bordighera and Menton four years earlier, the problem of finishing each canvas was left for the end of his trip. But in Antibes, by February 1, Monet was already talking of finishing some of his works—or, more

accurately, of "not being able to finish all of them at the same time."[110]

The very choice of themes, the artistic problem of the relationships between what is paintable and unpaintable—this aspect of Monet's state of mind owes a great deal to Guy de Maupassant, Monet's friend. The same could in fact be said for much of Monet's Antibes experience; we know that his choice of hotel was suggested by

FIG. 16 Claude Monet
Antibes Seen from La Salis (detail), 1888 [Plate 56]
The Wohl Family

Maupassant, who was visiting his brother nearby. Maupassant was also keeping his yacht, the *Bel-Ami*, named after his famous novel, moored in Nice. In 1888, he was about to publish his intimate sea diary, *Sur l'eau*, in the artistic periodical *Les Lettres et les Arts* (see the recent English translation of this important text, Maupassant

1995). In *Sur l'eau*, water—in this case, the Mediterranean Sea—is the vehicle for revealing Maupassant's intimate reflections and his inner suffering. The whole book merits an interdisciplinary comparison with Monet's treatment of the same motifs. Indeed, the two friends no doubt followed the same path. The opening of *Sur l'eau* is here worth quoting: "This journal contains no interesting story or adventure. Having been, last spring, on a short cruise on the Mediterranean coast, I amused myself by writing down each day what I saw and what I thought. In short, I saw water, sun, clouds and rocks—there is nothing else to tell —and I thought simply, as you think when the waves rock you, make you languid, and carry you on." (Maupassant 1995, 19).

Monet's expectations of his audience were also totally different in Antibes than they were in Bordighera. In Italy, Monet was so dumbstruck by the "novelty" of everything he saw that he was constantly struggling with the fear that his art would be weaker than the model, or that people would simply not be able to understand. In Antibes, on the other hand, Monet was already gearing up for a great show, "an artistic event," as he called it in a letter to the sculptor Auguste Rodin.[111] Unable to paint one rainy day, Monet passed the time in his room, just gazing at his own work: "I spent the whole day in my bedroom, looking at my canvases. It is good in the end to see quietly what one has achieved, for on other days I usually come back when it is dark and can hardly see what I have done."[112]

This rare expression of serenity and self-confidence reflects Monet's general response to Antibes and the work he had been able to accomplish. To Alice,

43

he wrote, "What I will bring back from here will be pure, gentle sweetness: some white, some pink, and some blue, and all this surrounded by the fairylike air."[113] But then, pushed by fatigue and overexposure to the sun, Monet fell into a depression and allowed his old ambivalent sentiments about his work to resurface. With some lucidity, he analyzed his own state:

I get bored to death as soon as I am away from my painting, by which I am obsessed and tormented quite a bit. I do not know where I am going; one day, I think I am producing masterpieces, and the next day, nothing is left. I am struggling. I am struggling without getting any further. I think I am seeking the impossible.[114]

Monet compared his ordeal to the experience of the Sunday painters at his hotel, whom he despised. Unlike them, he was unable to have a session of work that starts and ends neatly. Unlike them, he could not stop thinking about his art after he stopped working. Unlike them, he was not having any fun while in the midst of work: "What a curse, this damned painting. I get into such a state and I do not progress, never being able to manage what I want—and this all happens with the greatest weather one could imagine."[115]

On February 10, Monet had an excellent day, working on seven canvases.[116] Yet he was still unsure whether he was making progress with the various versions or just repeating himself. For the first time, he noted problems inherent in his serial procedure: "I feel that I am doing the same task over and over again without progressing. One day, I am deluded; the next day, I realize everything looks wrong. I tell you that I fear I am finished, dried up."[117] The next day, Monet wrote a note to art critic Gustave Geffroy that carried all the ambivalence of his experience in Antibes: "I am digging and I am plagued by every devil. I am very worried about what I am doing. It is so beautiful here, so bright, so luminous. One swims in blue air, and it is frightening."[118] For Monet, the more delightful nature appeared, the more complex, frightening, and troublesome was the task of representing what he saw.

For ten days, from February tenth to twentieth, Monet was forced to endure a frustrating period of "enforced rest" due to bad weather. Rain, wind, and cloudy weather disrupted his intensive painting regime. By the time the skies cleared, the seasonal position of the sun had changed substantially, affecting all other related phenomena. Monet had to adjust his entire production to this new situation, which made the lighting in some motifs very different. In addition, there was now so much snow in the mountains that it substantially affected his work as well. He had no choice but to start some of his canvases over again. "Everything is against me," he concluded, "it is hopeless; and I am in a feverish state and in a bad mood that makes me sick. I used to sleep so well when I arrived; I was not able to sleep at all last night."[119]

FIG. 17 Claude Monet
The Mediteranean (Cap d'Antibes) (detail), 1888 [Plate 45]
Columbus Museum of Art, Bequest of Frederick W. Schumacher

In addition to the weather, money worries consumed Monet. One of his principal dealers at the time, Theo van Gogh, informed him that the market was flooded with his works and that as a consequence he could not accept the prices Monet had suggested. Monet was also deeply upset to hear about an upcoming auction in which eight of his works, among his best, were to be sold. He feared that they would be sold for nothing, which would be "a disaster for me and would mean the impossibility of getting any money."[120] Sick of all of this, Monet was "on the verge of collapse" and "frightened of the future."[121]

By March 2, however, the weather had cleared and Monet was once again in good spirits: "At last a great day; I would need almost a dozen days such as these."[122] He worked hard and obtained good results, although he continued to complain that the sun had "walked" too far off. Despite this fact, Monet finally managed to bring a painting to near-completion: the first finished canvas of his Antibes campaign. After two weeks of miserable and destructive weather, he was now working abundantly, giving himself a lot of trouble. He was not quite satisfied with his work, though, and feared that another period of bad weather might jeopardize everything that was under way.[123]

In a letter to Alice in mid-March, Monet explained that he could only work on four canvases that day, implying that normally he worked on many more at once. Although he was able to work on his favorite canvases, he could not work on a complete series. He was in the middle of "finishing" or completing his works, and he felt pressed, even "forced" by the weather, to finish some works. But finish could not be obtained under duress. In Monet's eyes, works finished "by force" remained incomplete. Therefore, if his new work were again to be interrupted for some days, all would be lost.[124]

As in Bordighera, in Antibes Monet found it increasingly difficult to accommodate the fast succession of changes brought about in nature by the spring: "Everything grows, everything changes before your eyes."[125]

Moreover, three days of miserable weather were enough to ruin a good number of works. And soon it was not only rain and wind that hindered Monet's work but also the fog. With work again made impossible, on March 26 Monet contemplated the results of his enterprise. For the first time, he estimated a total number of works initiated in Antibes: "It is heartbreaking to see these things that could have looked very good, with over thirty canvases; and yet, hardly more than six or seven of them will be exhibitable."[126]

One of the biggest differences between the Antibes and Bordighera series is that the works conceived in Italy were not intended for a specific exhibition, whereas, almost from the beginning of his Antibes campaign, Monet had in view the possibility of the exhibition at Georges Petit's. But on April 7, he abruptly announced to Alice that this would not take place: Monet was furious with Petit for organizing an auction without having first informed him.[127] At the same time, Monet refused to consider resuming contact with Durand-Ruel, for that would mean "falling back into the middle of all the gang and their followers" (by which he meant, of course, the Impressionists).[128]

As Monet began to plan his departure, he continued to be frustrated by fickle weather: "A curse follows me to the end: there is a splendid sun, but the mistral wind is so strong that it is impossible to stand up in it."[129] He could scarcely stand to observe such a deep, intense blue, and then was obliged to keep his arms close to his chest due to the weather. As a result, though, Monet announced to Alice, he was forced to delay his return, planned for the following week. Monet later tried to reassure Alice, saying that she should interpret his silence not as neglect but as a sign that he was working unceasingly and was on his way to reaching his goal. This time, he claimed, he was seized by a true working fever.[130] He writes to the unhappy Alice: "Don't lose courage; you should think on the contrary that I am the one who needs quite a lot of courage in order to persevere....Let me do some beautiful canvases,

if possible: this is just the most important thing."[131]

On April 18, less than two weeks before his final departure from Antibes, Monet concentrated in a single letter to Alice all the arguments he could devise to persuade her of the necessity of prolonging his stay. The weather and his self-proclaimed "happiness" were the first reason. The second set of reasons enlisted by Monet were financial: the household badly needed money and he was, in essence, painting money. The third and final set of reasons had to do with Monet's identity as a painter—painting was his life. "Do remember that I desire you as much as you do me," Monet wrote, "but painting, that damn painting, is my life, and, consequently, it is your life too: and this is what keeps me away from you for another few days."[132] Monet later claimed that he needed to finish more paintings as well. He explained that it would be terrible for him to have worked so hard and to leave so many things incomplete.[133]

During his last several days in Antibes, Monet experienced some more misty weather, clouds, and wind. At one point he was forced to chain his easel and canvas to the ground during the mistral, but his palette and paints were soon covered with sand. He also began to feel hopeless because several of his canvases—the best in his series—were, he felt, "insufficient" or incomplete. Desperate, Monet wrote to Alice, "Forgive me, I implore you, for delaying my departure by yet another two or three days; it is a necessity. I cannot leave these canvases in the state in which they are: I must absolutely give them what they lack. I think they will be very good, or else I am screwed up and have become mad."[134] On April 30, his last working day in Antibes, Monet was still confronted by these demons and by overcast weather. He worked on a gray canvas, but his heart was not really in it. The next day, he left by train for Giverny, having virtually completed thirty-nine paintings in Antibes.

Venice, October–December 1908

I hides itself in the *other* and in *others*; it wants to be but another for others, to fully penetrate the world of others as another, and heave aside the weight of an *I* unique in the world (the *I-for-itself*).

— *Mikhail Bakhtin, 1970–71*

By 1908, Monet had settled into life at Giverny almost as a recluse. He was totally absorbed by the maintenance of his famous Water Lily Garden and, no less, by the constant invitations to exhibit his work. Very far from his circumstances in 1883, when he had just moved to Giverny, Monet was now heading a considerable business. The American art market had been sizably won over by Monet's paintings, with both collectors and museums consistently acquiring major examples of his work. Monet was a very rich, influential artist, whose political and economic weight was widely acclaimed in France and abroad. There was no reason for him to want to leave home. In fact, he had not traveled for years—at least since he went to Madrid and London

in the fall of 1904. He was also caught up in the massive paintings he was doing in the garden at Giverny. As he confessed to Geffroy in 1908, "The landscapes of water and reflections have become an obsession."[135]

The fruitful summer of 1908 was interrupted by a bout of nasty weather, which was enough to plunge Monet into some depression. Then came an invitation from Alice's friend, Mary Young Hunter, to join her at the Palazzo Barbaro in Venice.[136] Alice sought to persuade Monet to accept the invitation, but he was not enthusiastic about leaving Giverny for Venice.[137] He told critic Octave Mirbeau that he would refuse to go. Mirbeau later wrote, "I remember a few words by Claude Monet: 'Venice…No…I will not go to Venice.'"[138]

One could say that Monet's decision to go to Venice was the result of fear: essentially, the fear of being disappointed, of not being up to the challenge emanating from Venice. This initial fear can be explained in part by the fact that Venice for Monet, as Pierre Schneider has put it, was the site of an almost irreconcilable dichotomy between the pictorial and the picturesque.[139] Throughout his career, Monet had always

FIG. 18 Pierre-Auguste Renoir
Venice: Fog, 1881
The Kreeger Museum, Washington, D.C.

given priority to the former over the latter. In Venice, however, it would be very difficult for Monet to resist the seductions of the picturesque.

Venice had been indelibly printed on Monet's mind ever since his first trip to the South with Renoir in 1883. More than any other French Impressionist, Renoir had a fervent and exhaustive attachment to Italy. He had first traveled there in October 1881, writing, "I have suddenly become a traveler and I am in a fever to see the Raphaels....I have started at the northern end, and I am going to proceed towards the toe of the boot."[140] Renoir traveled to cities throughout Italy — Padua, Florence, Rome, Naples, Calabria, Palermo. The principal purpose of his trip was to see art rather than new motifs, and especially to discover the art of Raphael. Renoir wrote to Durand-Ruel,

I am like a school boy...and I am forty years old. I went to see the Raphaels in Rome. They are very beautiful and I should have seen them sooner. They are full of knowledge and wisdom. He did not seek, as I do, things that are impossible to do, but there is much beauty.[141]

Renoir wanted to ground his art in tradition so as to gradually distance himself from the old radical core of the Impressionists (mainly Pissarro and Degas). His refusal to share their intransigent views against the Salons coincided with his renewed interest in tradition, which, of course, he was able to nurture in Italy. "There are those who like what is new; I am one of those who like what is old," Renoir confided to dealer Ambroise Vollard. "New art wears me out."[142]

If Renoir's lengthy trip to Italy was the natural extension of his frequent art-historical studies at the Louvre, Venice offered something more. There, he not only saw a lot of art but also painted a small group of important works: *San Marco* (1881, Minneapolis Institute of Arts [Fig. 2]), *Grand Canal, Venice* (1881, Museum of Fine Arts, Boston), *Venice: The Doges' Palace* (1881, Sterling and Francine Clark Art Institute, Williamstown, Mass. [Fig. 20]), *Venice: Fog* (1881, The Kreeger Museum, Washington [Fig. 18]), and *Gondola in Venice* (1881, Private Collection [Fig. 19]). Two of these works were exhibited at the 1882 Impressionist exhibition, where they received a less than enthusiastic response.[143] Since the friendship between Monet and Renoir was at its strongest at that point, Monet certainly saw the exhibition just a few months before leaving for Italy with Renoir. Undoubtedly, he would have associated the prospect of discovering Italy with Renoir with the only views of Italy that Renoir ever exhibited—his views of Venice.[144]

The chilly reception given to Renoir's views of Venice by critics of the 1882 Impressionist exhibition is not insignificant. Alexandre Hepp said Renoir's *View of Venice* "looks like an intensified Ziem," and Armand Silvestre wrote that the Venetian landscapes were "an utterly successful compromise between Ziem and Monticelli."[145] These were not compliments. Renoir complained that nobody understood his Venetian views, comparing them to a good wine that must be left in the bottle to be fully appreciated later: "The general idea shared by the bourgeoisie is that I should not show my

painting before at least a year after I bottle it. I expect that in three or four years, Wolff will find my views of Venice very beautiful."[146] In Monet, Renoir found someone who was not only prepared to appreciate and comprehend what he had done but also to undertake the same trip.[147]

Monet's departure for Venice in 1908 was very sudden. He had at first been reluctant to leave Giverny, but on September 25 abruptly made the decision to go.[148] This time Alice, who had been Monet's faithful correspondent on his two previous trips South, traveled with him as his wife. They had been married in 1892, a year after Ernest Hoschedé had died. One practical result of Alice's presence by Monet's side during his ten-week sojourn in Venice is obvious: there was no

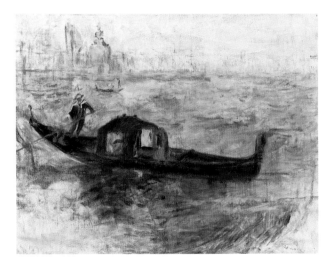

FIG. 19 Pierre-Auguste Renoir
Gondola in Venice, 1881
Private Collection

longer a need to communicate daily through letters. Consequently, Monet's experience in Venice is documented by remarkably few letters.[149]

Monet and Alice arrived in Venice on October 1, having left Giverny on September 29.[150] Mrs. Hunter, their hostess, immediately offered to take them on a tour of the canals and the city. The next morning Alice and Monet went on their own gondola tour of the city. Alice wrote to her daughter, "I live in

a dream—arriving in Venice; it is just so wonderful, the calm that wins you over, the careful attention of Mrs. Hunter, this admirable palace—it feels like a fairy-tale come true…. If Monet works, [my wishes] will be fulfilled."[151] But Monet, she says, has concluded that

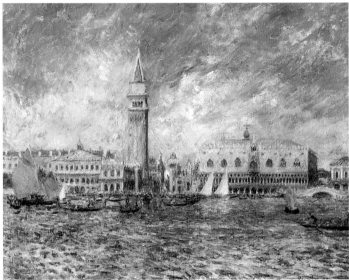

49

FIG. 20 Pierre-Auguste Renoir
Venice: The Doges' Palace, 1881
Sterling and Francine Clark Art Institute
Williamstown, Mass.

Venice is "too beautiful to be painted" ("trop beau pour être peint").[152]

At first, Monet actually refused to take his brushes out, arguing that Venice was "unrenderable" and that nobody had ever been able to capture Venice in paint.[153] Again, it was the inexpressible or unrepresentable quality of Venice that compelled Monet's silence. Also, his crates of canvases had not yet arrived from Giverny. So, as usual, Monet used this first period of acquaintance to conduct a sort of reconnaissance of the area.

Finally, on October 7, Monet set out to work. The wind, however, forced him back. The next day, Monet, who had been ready to work, totally gave up, claiming that he was "too old to paint such beautiful things."[154] Alice felt "real anguish" at Monet's despair, and was relieved when the following day he "at last

decided to set off to work. I only whisper this very discreetly because I am still afraid that he might not be serious. Yet I am now hopeful."[155]

 After so much procrastination, Monet soon adopted a rigorous schedule in Venice. Alice's description of his work day establishes that from the very inception of his Venetian campaign, Monet organized his time and conceived of the seriality of his work very differently from his previous projects.[156] In Venice, Monet divided his daily schedule into periods of approximately two hours, undertaken at the same time every day and on the same given motif. Unlike his usual methods of charting the changes of time and light as the course of the day would progress, here Monet was interested in painting his different motifs under exactly the same conditions. One could say that he had a fixed appointment with his motifs at the same time each day. The implication of this decision is very simple: for Monet in Venice, time was not to be one of the factors of variations for his motifs. Rather, it was the "air," or what he called "the envelope"—the surrounding atmospheric conditions, the famous Venetian haze—that became the principal factor of variation with these motifs.

 Monet started work at 8:00 A.M., sitting on the protruding platform of the island of San Giorgio Maggiore—visible in one group of works (Plates 79–83). From this position, Monet faced San Marco and began work on his first series of canvases focusing on the facade of the Doges' Palace, framed on the left by the tower of the Campanile and on the right by the platform of the Schiavoni. According to Alice, Monet would then move from San Giorgio to San Marco, from whence he

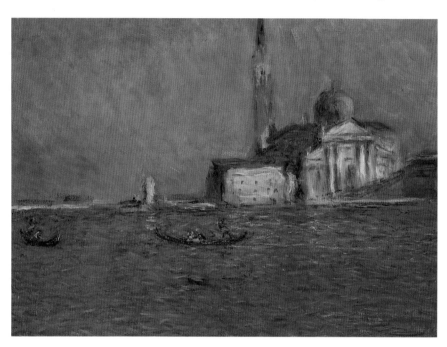

FIG. 21 Claude Monet
San Giorgio Maggiore (detail), 1908 [Plate 88]
Private Collection

could observe his second motif, the island of San Giorgio itself. In other words, Monet moved from the point of observation to the point observed. There, he made another set of works (Plates 87–90), which were in all likelihood executed from the tip of the Punta della Salute, facing the Church of San Giorgio on the island of San Giorgio. After lunch, Monet would work from the steps of the Palazzo Barbaro itself, not wanting to exert himself too much after a rich meal. There he could level his gaze on the Palazzo Contarini (otherwise known as the Palazzo Manzoni-Angarani), which he represented in two important canvases (Plates 95 and 96). Also executed at this site was one of the key groups in the entire Venice series, six works focusing on the Church of Santa Maria della Salute, seen in the background of the Grand Canal (Plates 73–78). From 3:00 to 7:00 P.M. he and Alice would go on a gondola tour of the canals until twilight.

 What is remarkable about Monet's working approach in Venice is what I would call the search for

a purity of conditions. The time was the same for each motif; each motif was treated in a subseries of six works only. Moreover, Monet proceeded as though he were setting up a system of mirror reflections: from San Giorgio he painted San Marco, and from San Marco he painted San Giorgio. In a way, Monet followed a procedural methodology not unlike that of an experimental scientist who endeavors to safeguard the accuracy of his results through a thoroughly controlled environment with known variables. Monet very carefully established his experimental ground to enable his "pictorial truths" to develop. The conditions set for his pictorial investigation were very strict and rigorous. One could say, in fact, that Monet attempted to eliminate time as a variable, to better concentrate on the interrelationships between atmosphere, light, color—and, of course, how the water refracted these elements.

By the second week of October, the Monets had developed a plan to visit Bordighera and to see Alice's daughter, who was living nearby. Although Alice very much wanted to see Bordighera with her own eyes, the idea of going there must surely have brought back bad memories of Monet's long-delayed return twenty-five years earlier. The need to know the date of departure from Venice was made all the more pressing, as Germaine kept asking her mother when she could count on seeing her. But Alice understood that Monet, who "starts a new painting every day," could easily keep them in Venice for quite a while longer. Monet would only leave if it started raining. Furthermore, he was becoming more and more passionately absorbed in what he was doing.[157] (Ironically, Alice's description of her husband's work contrasts sharply with Monet's own explanation to Durand-Ruel: "I am in awe of Venice; unfortunately, I will not be able to stay here very long. Therefore, I will not be able to work *seriously*. I am just doing a few canvases haphazardly, just to have some record, but I really intend to give it serious time next year."[158]

Because of a chilling wind and rain, Monet was only able to work on two canvases—presumably the two views from the hotel (Plates 102 and 103), twilight scenes of San Giorgio—during the last week in October. Monet wrote to art dealer Gaston Bernheim on October 25 to tell him that the entire Venetian enterprise had come to an end with the rain and cold, and that there would be nothing to show for it except "beginnings" and "souvenirs."[159] Soon, Monet was showing signs of desperation, related to the unyielding persistence of bad weather: "If [the rain] does not stop soon, we will be very close to departure time."[160] Monet had at that point started more than fifteen canvases.

Despite fine weather at the end of October, Monet did not regain his enthusiasm. The quality of the light had changed and, in turn, the reflections on the water—a vital factor in his compositions—were transformed. But soon Monet was back at work. Following the sun, he and Alice, who accompanied him to most motifs, began work by 7:45 every morning. Their life did not allow them to do anything but work.

Monet worked ceaselessly in early November, doing "beautiful things," buoyed by wonderful weather and those mother-of-pearl reflections in the water. Alice was alarmed at the number of artists in Venice—on San Giorgio alone, she counted "five of them, plus a woman, plus Monet." Her explanation of Venice's popularity among painters was simple: "It is so beautiful and so made to tempt you; but really, who is capable of *rendering* these marvelous effects?" Her answer: "I really see only one capable of that: my Monet."[161] Alice expressed surprise at finding out that even in rainy weather, Monet had at least one version of a palazzo on which he had worked, sheltered inside a gondola.

Adding to the complications of his elaborate painting process was the difficulty of painting certain works from a gondola moored in the middle of a canal and steered by a couple of *gondolieri* Monet hired expressly for this purpose. After a break because of bad weather, the *gondolieri* were unable to find the exact spot from which Monet had started to execute a group of works focusing on the facade of the Doges' Palace (Plates

51

85 and 86). He was furious because he could not find his effects again, due to the change of light. Peculiarly, though Monet faced this sort of problem constantly throughout his late career, he always behaved as though he were discovering it for the first time.

After numerous changes of weather in mid-November, resulting in very slow progress for "the canvases," as Alice called them, Monet resumed work "again and again, so that the return home is postponed to the eternal tomorrow."[162] The next day there was a lot of mist, "but Monet has a few motifs under this effect, and so, he is still working!"[163]

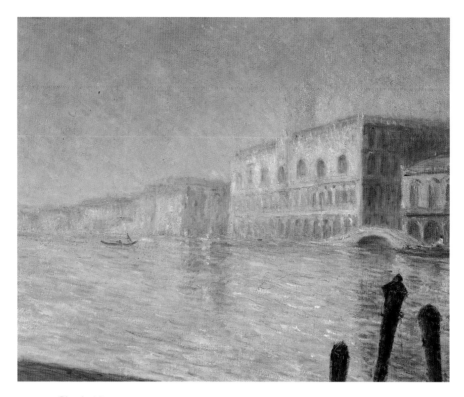

FIG. 22 Claude Monet
The Doges' Palace (detail), 1908 [Plate 84]
·Private Collection

In another letter, Alice adds, "I am happy now to see Monet so full of zeal, and doing such great things, and between you and me, something else besides the inevitable water lilies."[164] Even as they were planning their departure, Monet began three new paintings set in the small canals.[165] Clearly, this must be the series Monet executed in the narrow canal of the Rio della Salute (Plates 99–101)—the last paintings he executed in Venice, with the exception of the gondola (Plate 104) that he painted only a few days before his departure.

On the evening of November 26, Alice managed to convince Monet to accompany her to a marionette show. Monet found it "marvelous and so amusing." Earlier that same day, he had worked on nine different canvases. He was so utterly absorbed in his work in Venice that he rarely even took time to visit the museums or churches. Later, Alice wrote to her daughter Germaine that she was concerned about Monet, who was working

too much. He was at it from 8:00 to 5:00, with only a short break for lunch: "At his age, he ought to take greater care of himself, but he is so happy."[166]

Eventually, their departure from Venice became imminent. Alice tried to convince her daughter to come and meet them in Bordighera on their way back, emphasizing the symbolic importance of Bordighera for Monet: "Monet will be happy to see Bordighera again, and I, to discover it."[167] Yet even with the departure set for December 7, Monet decided to undertake a new painting—the study of the gondola (Plate 104). It was as if he could not tear himself away from the canals. Before leaving Venice, Monet conveyed his feelings to his good friend Georges Clemenceau: "Always further into the enchantment of Venice, which, alas, I will be forced to abandon."[168]

Considering the intense and highly emotional attachments formed between Monet and the

places he elected to paint, it was almost a surprise when
he finally managed to leave. On the Monets' last day in
Venice, they formed plans to come back. Unfortunately,
Alice's deteriorating health and eventual death in 1911
precluded that second visit, and Monet never returned
on his own. On his last day, Monet wrote a letter to
Geffroy summarizing his experience in Italy:

Well! [My enthusiasm for Venice] has done nothing but
grow, and the moment has now come to leave this
unique light. I grow very sad. It is so beautiful, but one
has to see reason: many factors force us to return home.
The only consolation I have is the thought of coming
back here next year, for I have been able to do nothing
but sketches, beginnings. But what a dreadful shame that
I did not come here when I was young and would dare
anything! Anyway...I have spent some delightful
moments here and nearly forgot that I am the old man
that I am.[169]

Monet was sixty-eight years old and leaving
the Mediterranean for the last time.

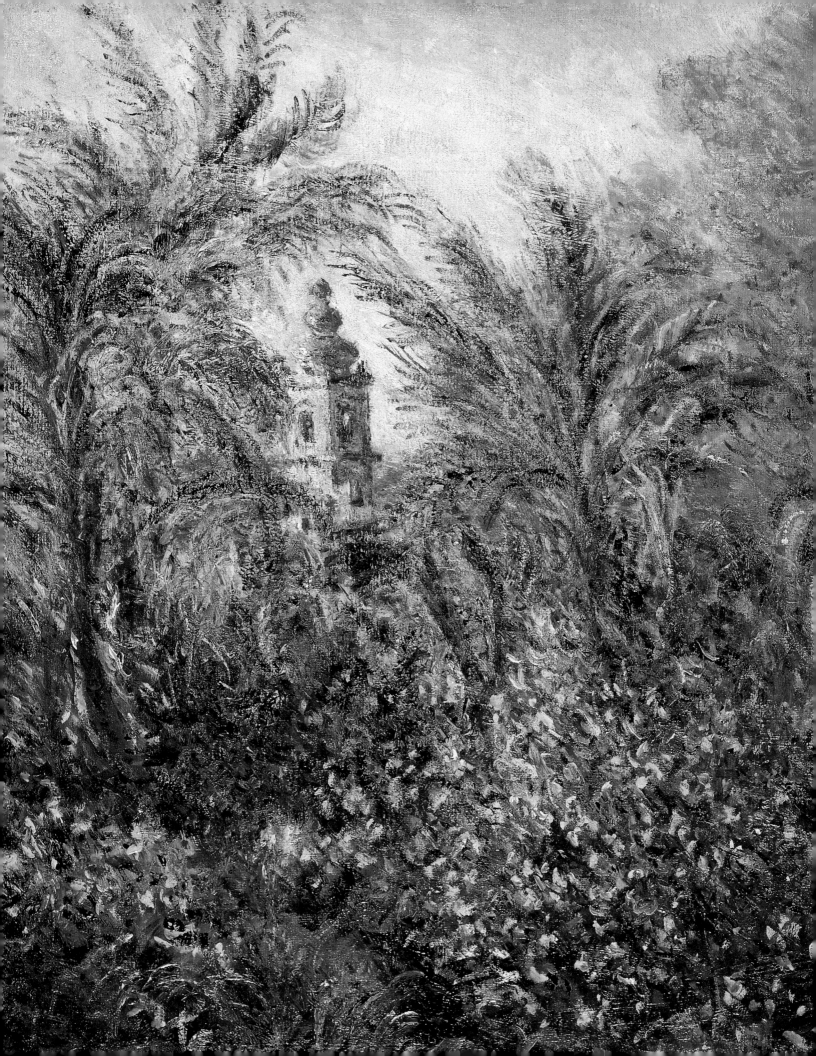

Monet's Mediterranean and His Critics

For discourse (and, therefore, for man) nothing is more frightening than the *absence of answer*.

— *Mikhail Bakhtin, 1959–61*

When the public responds with silence and indifference, that is a non-success.

— *Claude Monet to Paul Durand-Ruel, March 6, 1883*

I do not want to be compared to the great masters of the past; my painting belongs to the critics, and that is enough.

— *Claude Monet to the Bernheim brothers, November 24, 1918*

SELECTED EXHIBITION HISTORY

The exposure of Monet's works created in 1884 on the Italian and French Rivieras was very sparse. They were never seen as a series, let alone as a thematic group of works; their identity, as a separate entity within Monet's larger oeuvre, never became clear. In 1885, Georges Petit exhibited two paintings executed in the South among ten paintings by Monet, primarily depictions of motifs of the Normandy coast or of Vernon and Giverny.[170] The following year in New York, under the aegis of Durand-Ruel, a group show of the Impressionists was held at the American Art Galleries. Monet was by far the most represented artist in New York.[171] With approximately fifty works, Monet dominated the exhibition, well beyond Renoir, Pissarro, Signac, Guillaumin, Caillebotte, or Sisley. Among the works by Monet in the exhibition, one could recognize from his recent trip to the South, no. 171, *Valle Buona, Bordighera* (Plate 9) and an unidentifiable picture titled *Cap d'Antifer* (*Antifer* was evidently a typo for Antibes; this misspelling was compounded by a confusion of date, since in 1884 Monet painted in Cap Martin and not in Cap d'Antibes—where he sojourned only in 1888). In 1886, Monet complained to Durand-Ruel:

Do you really need so many paintings for America? People are forgetting about us because as soon as you have a new painting you make it disappear. My paintings from Italy, for example, are unique among what I have been doing, and no one has seen them here.[172]

This frustration was on the whole unheeded by Durand-Ruel, as well as by other dealers. The situation would only change halfway through the next century.

In 1886, the important annual Brussels exhibition *Les XX* included two paintings from Bordighera, even though in this case the selection of the works was made by Monet himself.[173] In 1888, Theo van Gogh organized an exhibition at Boussod & Valadon that included ten of Monet's paintings of the South.[174] Vincent van Gogh did not see these works at his brother's gallery but was referred to them by a letter from his friend, the Australian painter J. P. Russell.[175] The following year, in 1889, three paintings from Antibes were exhibited in *Les XX*.[176] It was not until Georges Petit organized the historic exhibition that same year, titled *Claude Monet—A. Rodin*— which Monet had been thinking about while painting in Antibes—that a group of five of the Bordighera paintings was first shown to the public (among the 145 entries devoted to Monet).[177] Even more significantly, one of the most critical ensembles of views painted in or near Antibes—seventeen paintings—was brought together for the first and last time until now.[178] Even today, the idea of gathering more than a dozen paintings from that group has proven extremely difficult. The selection of works for that show, largely made by Monet, included a wide array of works from his earliest to his latest periods; the Antibes work, however, was more amply represented than any other group of works up to that date.

With the exception of the Rodin/Monet dialogue organized by Georges Petit in 1889, the works by Monet from his first two trips to the South were rarely shown, if not entirely omitted from public displays of Monet's work. Two works from Antibes were shown at the *Exposition universelle* of 1900.[179] One of these views, lent by Durand-Ruel, was presented again in Brussels at the *Libre Esthétique*, in 1904.[180] At a group exhibition of works by four Impressionists at Durand-Ruel's in 1910, two of Monet's works from the South were shown: one from Antibes and one from Bordighera.[181]

The grand *Claude Monet: Venise* exhibition, which included almost all of the works Monet painted in Venice in 1908, was shown at the Galerie Bernheim-Jeune in 1912. Two years later, there was a large group exhibition entitled *Le Paysage du Midi*, including only one painting by Monet, a view of the Valley of Sasso.[182] The vogue of the Riviera and the Mediterranean landscape, as it soared with the rise of tourism shortly before World War I, led to several such thematic exhibitions featuring the Midi. For example, *Interprétations du Midi* was organized by the *Libre Esthétique* in Brussels in 1913. It included six works by Monet, one depicting an olive grove in Bordighera, and five of Antibes.[183] This was the largest single group of works from Monet's first two trips to the South since the Georges Petit show in 1889.

It was not until 1921 that works from Monet's three trips to the Mediterranean were included in the same exhibition. Bernheim-Jeune presented one work from Bordighera (depicting palm trees and incorrectly dated to 1887), one titled *Les Pins parasols*, two of *Antibes*, one of *Cap Martin*, and one of the *Baie des Anges*.[184] Lastly, a work, simply titled *Venise*, was isolated among half a dozen *Nymphéas*. It was one of the views of the Palazzo Dario and is illustrated in the catalogue (although difficult to identify with certainty due to the poor reproduction, it is most likely Plate 94). Even though accuracy and chronological rigor were not the main virtues of this exhibition or its catalogue, it did bring together for the first time examples of these three sets of works.

In 1925, a year before Monet died, Durand-Ruel organized another exhibition, with works by Monet, Pissarro, Renoir, and Sisley. Monet was the only artist of the four who was still alive. His meridional venture was illustrated with two works: again the *Pins parasols* (thus most likely the same work as in the Bernheim-Jeune 1921 show) and a view of *Antibes*.[185] After Monet's death in 1926, many posthumous exhibitions featured one or several works of the South by Monet. But it was infrequent to find more than one painting from each of the three groups, and fairly rare to find a set of works

representing all three groups within the same exhibition. In the 1928 memorial exhibition organized in homage to Monet, the Thannhauser Galleries in Berlin showed five works representing the three trips to the South: *Bordighera; Antibes; Palazzo Ca d'Oro in Venedig; Dogenpalast in*

in Venice in 1908 (Plates 99–101). Certainly the dramatic motifs packed into each of the works illustrated here—the sharp mountainous village soaring above the

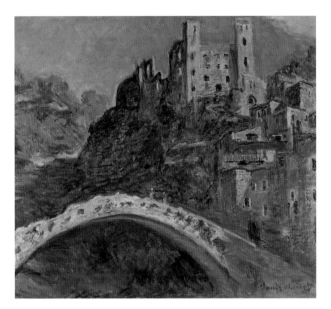

FIG. 23 Claude Monet
Dolceacqua (detail), 1884 [Plate 29]
Courtesy Marc Blondeau, S.A., Paris

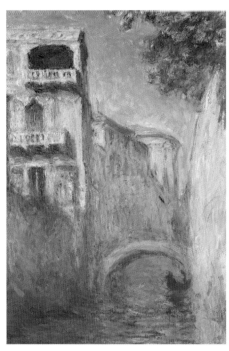

FIG. 24 Claude Monet
Rio della Salute (detail), 1908 [Plate 100]
Private Collection

Venedig; and *Venedig, Canale Grande.*[186] This catalogue was unusually systematic for the time and conceived according to a rigorous—and unprecedented—chronological order. At that time, the French approach in most exhibition catalogues (particularly well illustrated by the Durand-Ruel volumes) tended to be much looser in its delineation of the exact dates in the artist's career.

In the same year as the Thannhauser exhibition, Durand-Ruel organized one of its numerous monographic selections of works: included in the catalogue was *Dolceacqua, près de Vintimille* (misdated 1886) listed just above a work representing *Venise, Rio della Salute.*[187] The merit of this catalogue, however, was that for the first time it drew the reader's attention to the fact that there were links between Monet's work in Dolceacqua in the 1880s (see Plates 28–30) and

fishbone-thin, fragile bridge illustrated in Figure 23; the tight, narrow canal of the Rio della Salute contrasting with the vertical structure of the abutting palaces in Figure 24—bring to mind analogous spatial conceptions and similar compositional problems.

The catalogue of the important 1931 Monet retrospective at the Orangerie in Paris is uncharacteristically clear and methodical in its presentation. Divided into chapters, it reflects the various developmental phases of the artist's career and thus allows the reader to engage in the multifarious shifts in the artist's relentless pictorial search. This catalogue reflected a growing change in the perception of Impressionism itself in the 1930s; there was a growing tendency to see the development of Impressionism from a historical or "scientific" vantage point.[188] This was the beginning of a

new historicist trend that would impose itself upon generations of art historians and that still dictates the chronological hanging of works in most art museums.

If in its regimental form this historicist discipline led to excesses, it also provoked some interesting effects in the understanding of various facets of the corpus of most artists. In the case of Monet, in particular, the effect was very readable. The fourth chapter of the 1931 catalogue was titled "Giverny—Bordighera—Etretat," and gave a brief narrative description of Monet's moves during the 1880s. Bordighera was illustrated with four works, including two of the Dolceacqua bridge (thus underlining the notion of repetition of a given motif with differences of treatment and effects) and the very large *Villas in Bordighera* painted for Berthe Morisot. There were also two works from the Antibes sojourn. In chapter eight of this catalogue, titled "Londres et Venise," the author established an interesting relationship between the London and Venice series. In London, he explained, the forms "melt in the fog"; in Venice they are "dissolved" in the canals, even more than in the surrounding light.[189] This exhibition established for the first time that the three sojourns in the South—Bordighera, Antibes, and Venice—were three momentous forays during which the painter "extracted himself out" of his garden in Giverny.

In 1935 a relatively small show, with less than fifty works, was presented at Durand-Ruel's: the two final works were a view of *Antibes* and one of *La Méditerranée.*[190] Five years later, a concise exhibition of thirty-three works was organized by André Weil to celebrate the centenary of the artist's birth. The exhibition opened just as the French government, ill-prepared for war, was in the process of totally misreading Hitler's intentions, or simply refusing to face the consequences of his aggressive invasions of Poland, Norway, Holland, and Belgium. In May 1940, Hitler caught the Franco-British armies by surprise and won a rapid victory against the allied forces. What, then, was the *symbolic* value of this exhibition for French visitors? With three works from Bordighera and one from Norway, two of the

farthest spots Monet traveled to in order to paint, the show might have been perceived as an indication of how far-reaching the cultural and pictorial influence of French art had been in Europe. No one in Paris at that time could ignore the symbolic resonance of this exhibition of the great hero of French art. Furthermore, the exhibition was a benefit for an association in support of French soldiers.[191] Monet's centenary exhibition was therefore celebrated in a very loaded context, offering a bright relief to the gloomy, ongoing war and standing as a hymn to the artistic grandeur of France.

Postwar exhibition efforts exploited the resurgent glorification of Impressionism. In more ways than one, Impressionism was seen not only as the art of the victors but also as an art in which brightness, light, and freedom prevailed. This was the primary historical reason for the sudden explosion of "Impressionist" exhibitions in the late 1940s. This growing popularization of the Impressionist movement also generated a greater need to understand the history of individual artists. Nowhere can this phenomenon be better observed than in comparing two exhibition catalogues of French art at the Royal Academy of Arts in London, one before the war and one after it. The first, organized in 1932, was comprised of 1,021 entries and was modestly titled *Exhibition of French Art, 1200–1900.* It included an extraordinary array of objects, from a carved Provençal capital of the twelfth century to Monet's *Nymphéas.* The latter work was presented in the catalogue following works by Gauguin and prior to paintings by Hubert Robert and Champlevé enamel reliquaries of the Limoges school. . The show was mostly ahistorical, with divisions according to medium.[192] In 1949, a show of similar scope was organized under the aegis of the Arts Council of Great Britain.[193] In that exhibition, the Impressionists were presented with proper analytical effort, with Impressionism divided into "early" and "late" periods. An effort to apply serious art-historical methodologies to the study of Impressionism was underway.[194] In the 1949 show, Monet was represented by two views of London, one painting

of water lilies, and three paintings of Venice.[195]

After the wave of research that shed new light on the development of Monet's art and on Impressionism in general, one of the most significant developments in the 1950s was the introduction of new techniques of reproduction. The Kunsthaus Zürich retrospective of 1952,[196] for instance, featured two full-page color reproductions of *The Valley of Sasso, Bordighera* (Plate 11) and *San Giorgio Maggiore* (Plate 88). The seminal *Monte Carlo Road* (Plate 1) was also given a full-page treatment in the catalogue from a monographic exhibition at the Marlborough Gallery in London in 1954.[197] The ability to study such works in reproduction was an immensely important step in the fuller perception of Monet's pictorial achievements on the whole and in the South in particular.

In 1960, the Bibliothèques et Musées de Nice organized an exhibition on painters who had worked on the Riviera. Monet was represented with two works. But the novelty was that the Nice librarians had meticulously researched their facts. In two-and-a-half very concise lines, Monet's three pictorial tours on the French Riviera were described, for once, without a single factual inaccuracy.[198] Exhibition catalogues continued to provide invaluable color reproductions. In the catalogue for the monographic exhibition organized by Richard L. Feigen & Co. in New York, for instance, one finds the only color reproduction of *Grove of Olive Trees in the Moreno Garden* (Plate 15).[199]

The following year, one of the last exhibitions organized by Charles Durand-Ruel, prior to the closing of his gallery, announced in its catalogue the publication of the Monet catalogue raisonné. The preface, written by Daniel Wildenstein, was more thoroughly documented than any other text written on Monet in the South and still constitutes a cornerstone for the documentary knowledge of Monet's oeuvre today.[200] Although a new generation of art catalogues opened new avenues of interpretation and understanding of these pictures, many Mediterranean works by Monet have yet very

seldom been seen by the public and seldom, if ever, have been reproduced in color. The present publication aims to help rectify this shortcoming.

SELECTED CRITICAL HISTORY

Although Monet's views of the South have been seen in exhibitions less frequently than others of his famous series, they have been the focus of considerable critical attention. One reason for this imbalance is the vast output of the few early critics—Gustave Geffroy and Octave Mirbeau chief among them; they became acquainted with Monet in the 1880s shortly after his Mediterranean experience. The goal of the present work is to highlight the multifaceted nature of the dialogue that has taken place between Monet's paintings of the South and several generations of critics. These dialogues between Monet and his critics should be understood here in the sense given to the term by Bakhtin: "It could be said that all verbal communication, all verbal interaction takes place in the form of an *exchange of utterances*, that is in the form of a *dialogue*."[201]

A few months before first leaving for the South with Renoir, Monet was given his second one-man show at the Durand-Ruel Gallery. This show was Monet's first real *succès d'estime*, even drawing attention from the more conservative and traditional members of the press, such as Alfred de Lostalot of the *Gazette des Beaux-Arts*. A long, sympathetic article by Philippe Burty in *La République française* offered the first biographical survey of the artist's life and his career.[202] What is especially striking is that the article ends on a somewhat patriotic tone, extolling the virtues of the French landscape from the North to the South, and opposing the fresh qualities of the French landscape to the dreary landscapes brought back from Italy by French Beaux-Arts students: "In reality, France in its southern reaches is sweet, poetic, graceful—strong in its depths and captivating at the surface." Following these comments, which could almost be drawn from a contemporary tourist brochure, Burty

59

says that viewers should be grateful to artists like Monet who track down France's rich nature to its most subtle details. In a bout of nationalistic fervor, Burty exclaims,

We are not Greeks! We are not Romans! We do not drink wine that smells of resin, we eat running Brie. While we are building stone by stone the Republican edifice, let us not forget that it will be up to the artists themselves to prepare its finest jewels.[203]

Monet must have been aware of Burty's article, yet his Mediterranean venture was no naive response to such ethnocentric calls to extol the French vision. First of all, the trips to Italy and Holland in the 1880s interrupted this flux of Gallic devotion. Secondly, although numerous critical writings of the time attempted to inflame patriotic feelings and to view Monet's art as a loyal vision of France by a true Frenchman, there is no evidence that Monet personally endorsed or chose to express those ideological views through his painting. Even if by the mid-1880s Monet was being perceived as the ultimate custodian of French values, the only one capable of resisting the pernicious influences of the Acropolis on French art, it seems extremely important not to confuse the reception of his work with his intentions, which in no way encouraged nor endorsed this nationalism.

Another text written shortly before Monet's departure to the South was very pertinent to the issues he dealt with in the Mediterranean. Since Monet felt that reality was excessive (extreme light, excessively abundant vegetation), he was keen to find in nature's extremity a justification for his own art. But the question was this: was Monet seeing things in an objective way or was he hypersubjective? Alfred de Lostalot addressed this question in his review of Monet's 1883 show:

M. Monet paints, so to speak, in a foreign language, to which only he and some few initiates hold the key. It is not a language that can be learned; it is instinctive, and those who understand it are not aware of the abundance of their riches, if indeed that is what it is.[204]

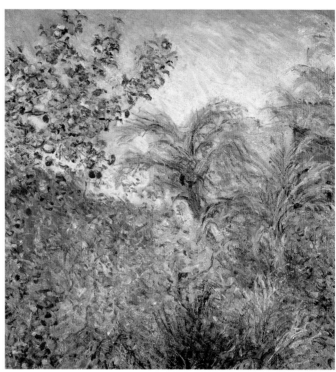

FIG. 25 Claude Monet
The Valley of Sasso, Bordighera (detail), 1884 [Plate 13]
Private Collection

Here the notion of language is used as a metaphor for what Monet is endeavoring to do. Yet this metaphor defeats its own purpose: Monet's language is virtually incommunicable. According to this article, Monet evolved a solipsistic pictorial language that only *he* could understand.

Why is Monet's pictorial language misunderstood by most? Lostalot's argument shifts to the hypersubjective: Monet "sees in a way that most human beings do not, and, because he is sincere, he attempts to reproduce what he sees."[205] Lostalot likens Monet's insights to recent discoveries about ultraviolet rays:

Recent experiments by M. Chardonnet have proven

positively that some people respond strongly to this invisible part of the spectrum. Without a doubt, M. Monet belongs to this number; he and his friends see ultraviolet: the masses see something different. Hence the misunderstanding.[206]

Is Monet some sort of pictorial mystic, whose "language" is only accessible to a few? Or is he capable of reaching a layer of reality that is not "visible" to most of us? Lostalot, on the whole, prefers to provide a physiologically based answer:

The public's eye rebels when M. Monet pitches battle with the sun. The brilliance of the yellow rays stimulates the painter's *nervous sensibility*, then blinds him; at that point he undergoes a well-known *physiological* phenomenon: the complementary color is evoked; he sees violet.[207]

Whatever the discourse used to explicate or justify Monet's works, they were seen as going beyond or outside the known range.

Monet's first group of works executed in the South received relatively little attention, which created friction between Monet and his dealer Durand-Ruel. Interestingly, however, since Durand-Ruel was at that particular time concentrating his efforts on developing a new market for Monet's works and for Impressionism in general, the first articles written on these works emanated from the United States. Coincidentally, the first exposure of his work to the American market was virtually contemporaneous with his return from Italy.

One of the most important early reviews of Monet's work in the American press resorted to the scientifically oriented explication that was then common in Europe. In her article on Monet, the American biochemist and doctor Celen Sabbrin (pseudonym for Helen Abbott, 1857–1904) does not mention the Bordighera paintings. However, she goes further than Lostalot in her assumptions about Monet's intentions:

"The color scale of Monet's pictures is original, and essentially calculated to produce upon the observer an intense psychological impression."[208] She sees in *Landscape at Giverny*, for instance, "an expression of hopelessness, of the unattainableness of absolute truth, and a confirmation of science's teachings, in the ultimate uselessness of human effort."[209] Here, science is used to suggest a totally different reading than that offered by Lostalot. Sabbrin argues that Monet reveals through his art that "geometry is soulless" and that "natural forces are relentless and pitiless." His art, she claims, manifests "the end of the struggle of the human race; all work and thought have been to no avail; the fight is over and inorganic forces proclaim their victory."[210] The fundamentally pessimistic conclusion of this text is strikingly in line with Monet's own desperate attitudes toward "natural forces." Sabbrin claims that "[Monet] does not offer any solution to the result to which his pictures lead. He is occupied in giving expression to the most serious truths of our life. He is recording the chronicles of modern thought."[211]

Octave Mirbeau is undoubtedly one of the most important Monet scholars of the second generation. For his first article on Monet, Mirbeau visited with Monet just a few months after his return from his Italian campaign, probably while Monet was actively completing some of these works.[212] In the text, Mirbeau essentially agrees with Lostalot's argument that our visual capacity is far more limited than that of the great artists. He, however, turns it into a strong moral argument. Omitting all physiological considerations, Mirbeau concludes that the public is deaf and blind before beautiful things—and this is intolerable. Monet, on the other hand, treats nature with a universalist mind: there is not a single aspect of nature that escapes him, or that he fails to render. Mirbeau then compiles a sort of catalogue of all the facets of nature with which Monet grappled. Having evoked the artist's "infuriated seas whose waves ride on top of each other, capped with foam, which come all tensed up, and ready to leap on the pebbles of

the beach" (an unmistakable allusion to Belle-Ile), Mirbeau continues his rather rich evocation of Monet's multifarious art with what he calls "his own Italy, so *personal*, which bursts with crude bright patches and suns that are ablaze."[213] The critic then refers to flowers, the emblem of Monet's Italy, whose bright and fresh delicacy the artist succeeded in capturing. What Mirbeau emphasizes, however, is what he calls "that living and inexpressible quality in them: their scent."[214]

The other great Monet critic of this period was Gustave Geffroy. The mid-1880s was unquestionably a critical time for the perception of Monet's art by the public. It was essentially a time of acceptance; what was unacceptable ten years previously was now tolerated, if not lauded: "Those who could not understand in the old days now can understand; a few are now paying compliments and forget that they used to denigrate."[215] The breadth of the public's acceptance corresponds to the stretch of the artist's pictorial geographic search: he is able to paint the North and the South with the same dexterity. To make this point, Geffroy compares a picture of Holland to a picture of San Remo, and then evokes three pictures of the Bordighera series:

A group of fig trees, with their glistening leaves, draws an intricate pattern with its trunks and its branches, as soft as some tropical creepers; through these intertwined branches, one can gaze at the bottom of a vacuum, where the blue sea appears in the far, remote distance and where the white houses of a town asleep in the heat can be seen.[216]

Geffroy resorts to hyperbole to describe the impact *Bordighera* (Plate 4) had on him: "Extraordinary canvas, filled with an outgrowth of unseen vegetation, ablaze with light, which bleaches out everything around, and bursts out like a sudden apparition of the sun."[217]

Geffroy then outlines a certain unity among the Italian works: he sees in *The Valley of Sasso, Blue Effect* (Plate 10), for instance, the same impression studied

under a different aspect. There, writes Geffroy, "a warm mist hovers by the hillside of the mountains, introduces its delicate steams among the palm trees and the pine trees in terraced rows, the lemon trees punctuated with golden fruit."[218] He also mentions a *Strada Romana in Bordighera* (Plate 6), in which the Bordighera street is cluttered with palm trees and where the mountains appear almost transparent in the blazing sun. Geffroy ends this rather lyrical evocation of three views of the South by Monet on a scientific note, allegiant to the ideology of the time: "One has to accept the truth and the subtlety of this painter's vision" who sees what we do not see: the green and blue vapors in suspension in the atmosphere, scattered sun rays, the reflections of things.[219]

In his contribution to the 1887 *Exposition internationale*, Mirbeau uses Plato's metaphor of the cave to describe the feeling of walking out of the dreary dark works of the Salons to Monet's work, which provided him "inexpressible relief."[220] Mirbeau blends lyricism and scientism to evoke Monet's "formidable and novel works" that depict "the prodigious lives of the meteors, which grasp the ungraspable, and express what remains inexpressible in things."[221] One is not sure whether Mirbeau sees in Monet a visionary or a mystic, on the one hand, or an exceptionally lucid observer, on the other. Among all the works in the *Exposition internationale*, Mirbeau singles out the same three Bordighera works described by Geffroy. Mirbeau notes in all three works "vibrations, heat, and colors of incomparable gaiety," and discusses the "overheated and pulverized air" of *The Valley of Sasso, Blue Effect* (Plate 10).

If, on the whole, the first group of works from the Mediterranean received relatively little critical attention, the Antibes works were widely discussed, though not always positively. Eaque (pseudonym of Paul Robert), for instance, remained "perplexed" by the ten pictures of Antibes shown at Boussod & Valadon in June and July 1888.[222] Eaque sees in these works a "poetic vagueness" that he finds incomprehensible, and he

refuses to believe the objectivists' claim that Monet paints what he sees, as he sees it. He regards Monet less as a translator of nature than as the creator of a "garish originality" devised solely in order to catch the eye of the viewer. Eaque finds the proof of his allegations in a work that he describes as two parallel layers of different blues (sky and water), offset with some leftovers of the artist's palette laid there in order to depict "a reef of the Provençal coast, burnt by the sun, as red as a bleeding wound, looking like the heavy body of an amphibious boat."[223] Eaque concedes, however, that four of the works offer qualities that compensate for the otherwise painful attempts.[224]

In his review of the same exhibition, Geffroy situates "these ten canvases that the great land-scapist Claude Monet has just brought back from Antibes" within the broader context of the turmoil of the international political arena.[225] Anti-German feelings in France had been exacerbated by the recent war-monger-ing proclamations of Wilhelm II, the newly enthroned Kaiser. According to Geffroy, the Monet exhibition came as a comforting relief in the face of this ominous politi-cal scene, offering "satisfaction to the eye and rest to the mind." It also offered aesthetic relief from the dreadful bore of the ongoing Salons. Expanding on this theory of contrasts, Geffroy points out that Monet's works were created at a time when "the beautiful and bright light" of the Mediterranean brings illuminated flowers and fresh green trees, while the snow is still melting on the crest of the mountains. The whole subject of this series of works, according to Geffroy, is precisely what he calls the "charm and luster of this blooming transformation." The "strength of the vegetation," he says, is offset by the "sweetness of the air," the "neat delineations of the mountains" by the "static movement of the Mediterranean sea." Finally, as far as Monet's technical devices are concerned, Geffroy opposes "the accuracy of his drawing" with "the formulas of his secret color-making alchemy."[226]

In the same article, Geffroy also describes

Monet's serial methods, resorting to the classic rhetorical device of repeating "Antibes" at the beginning of each sentence: "Antibes d'abord..."; "Antibes, vue autrement..."; and "Antibes toujours...." Each paragraph addresses a particular characteristic that differentiates each version shown: the town is seen ablaze under the sun with an infinite multiplication of reflections on the sea; or it is less sharply defined and offset with a tree, whose cool foliage seems to have grown out of the pink soil; or it is seen under "the golden awakening light of dawn," as a tree shakes off the remnants of the cold dark blue hues of the night that is ending.[227] Geffroy summa-rizes the elements of Monet's paintings: the changing colors of the sea; the enormous iridescent mountains; the pale green olive trees and dark pine trees; the dazzling red of the earth; the pink and golden silhouette of the town. Out of these elements Monet produces the story of a countryside, told through "its atmosphere, its shim-merings, the vibrations of its light...its aroma."[228] Thus, Geffroy confers upon Monet a new title: "the poet and the historian of the south of France."[229]

Geffroy and Mirbeau continued to be the major critical supporters of Monet's Mediterranean works. Nobody spent as much time, effort, or energy as they both did defending and attempting to explain to the public the positive elements they saw in Monet's work there. Their mostly unqualified enthusiasm did not win over all the critics, however. Although reviewers were becoming much more tolerant of Impressionism,[230] Monet's work, especially his Mediterranean paintings, were readily associated with excess and lack of truth. J. Le Fustec's review of the *Monet–Rodin* exhibition typi-fies this stance. He states that Monet's works do not translate "the truth" but the artist's "thought." He takes as a perfect example of his argument *View of Cap d'Antibes* (Plate 63) "a scorching landscape" in which "a flare of violent sunlight" sets ablaze "trees, water, town and mountains."[231] Le Fustec sees, however, a redeeming fea-ture of this excess in one of the versions of *Juan-les-Pins* (Plate 68), which the critic hails as one of Monet's few

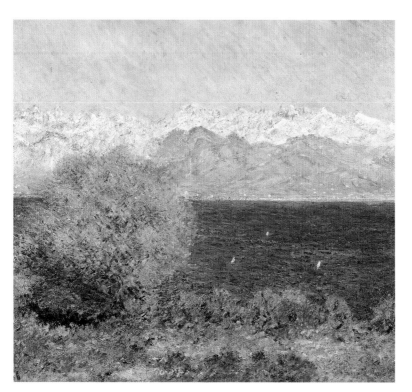

FIG. 25 Claude Monet
View of the Bay and Maritime Alps at Antibes (detail),
1888 [Plate 63]
Hill-Stead Museum, Farmington, Conn.

the artist respond to a logic, that each brush stroke is the result of a sincere vision. The more one looks at it, the more one becomes used to this dizzy-making way of disseminating light [on the canvas]. Everything becomes harmonious, complete, recognizable.[233]

The emphasis on the physical properties of Monet's art was to become an important theme in the second part of the twentieth century. But it was very unusual for any critic in the 1880s to point to these aspects of the work.[234] Monet's output from his first two Mediterranean campaigns can be seen as apodictic of the dialectical opposition at the heart of his art. Here, the discovery of a new space was interwoven with the discovery of a new plastic vocabulary. Monet's pictorial imagination (his artistic individuality) was honed through contact with this new reality. This duality was at the core of almost all of the critical accounts of Monet's early Mediterranean works. Of these two forces at work in the critique of Monet's works in the South, the first leans toward interpreting his work as a hyperobjective representation of the world, even though the elements to be represented are not visible to most of us; the second emphasizes Monet's unique vision. Representative of the first trend were the proponents of scientism;[235] representative of the second trend were the proponents of symbolism.[236]

This selective review of some of the critical articles focusing on Monet's Mediterranean work illustrates this duality and shows that most reviewers tended to illustrate one side or the other. On the whole, the two paradoxical facets of the interpretation of Monet's art in the South were often juxtaposed, seldom reconciled. Philippe Burty, for instance, tended to place his emphasis on the highly "personal" and idiosyncratic

works that do not resort to a "false contrivance."

One of the first critics to allude to the materiality of Monet's *making* was Fernand Bourgeat. In a key text on the *Monet–Rodin* exhibition, he singles out the Antibes paintings, which, he says, show that Monet is "truly in love with the sun."[232] The most important aspect of this article, however, is Bourgeat's emphasis on the highly personal physical properties of Monet's handling of paint. Bourgeat then maps a kind of genesis of the viewer's response based on the extreme examples provided by the Mediterranean works:

The material making of the artist is so personal, so different from that of the "usual artists," that his rough flickering, these little taut brush strokes, that kind of brutal mosaic looks atrocious. Gradually, however, one realizes that nothing in that deliberately weird surface is left at random, that the hardy tones used by

virtues of Monet's work,[237] while Roger Marx saw in the same works an expression of truth ("vérité").[238] While the critic Fourcaud interpreted the work as the products of a "realist,"[239] the infamous Albert Wolff, still not quite reconciled with Impressionism, saw little more there than eccentricism and marks of "fantaisie."[240] Not much more flattering, if more sympathetic, was J.-K. Huysmans's famous article (on an exhibition which included several works from Italy) in which he identified Monet's eye with that of a cannibal.[241]

More interesting, however, are those critics who oscillated between the two facets discerned in Monet's art and indeed attempted, in vain, to reconcile them. Right from the beginning, Alfred de Lostalot and Théodore Duret sought in Monet's works an art that was "personal" and "accurate" ("juste"), or "true" and "personal."[242] In the same vein, Gustave Geffroy summarizes Monet's art as the product of a "true and subtle vision."[243] Of all the critics of that time, André Fontainas was the one who most bluntly addressed the two contradictory aspects of these works, referring to them as the expression of both "truth" and "exaggeration," and, in a subsequent article, as both "an exercise of sensibility" and "loyal observation."[244]

These early critics responded strongly to Monet's efforts to renew his work in the Mediterranean. They embodied the two forces inherent in the development of modern art: the subjective and the objective or, as Luc Ferry suggestively put it, the "ultraindividualist" and the "hyperclassical" sides of the avant-gardes—sides that are inseparable. Ferry succinctly explains:

At the heart of the early avant-gardes, we have to distinguish between two divergent, not to say contradictory, moments: the will, on the one hand—elitist, historicist, "ultraindividualistic"—to break with tradition to create the radically new; but, on the other, the no less remarkable project of leading classical aesthetics to their logical end, of taking them to their limits in the name of a new realism that, however much it may be oriented to the expression of what reality—whether internal or external does not matter much—may contain that is chaotic and "different," remains all the same bound to the intelligence more than to the imaginary and, to that extent, accepts new constraints and new rules.[245]

By the 1900s, the situation had become notably different. It was now impossible to deny that the Impressionists had performed an important step in the history of art. If the critics of Impressionism remained as passionate as ever, they now had to situate themselves in a historical context to claim validity. In Emile Bernard's paradigmatic anti-Impressionist article "Réfutation de l'impressionnisme," for instance, he vituperates against the decadent taste for novelty imposed by the Impressionists.[246] Yet he cleverly articulates his opposition by arguing that this taste for novelty has a history: Bernard traces the origins of the perversion of the ideal to the Mannerists, who, he says, blemished the "beautiful findings" of Michelangelo.

Impressionism was therefore seen as having initiated a march that was unfolding toward "new artistic preoccupations," in the light of which it no longer appeared radical.[247] In the context of the Impressionist retrospective organized in Belgium in 1904, André Mellerio focused on a small group of works by Monet— including *Antibes Seen from La Salis* (Plate 55), which he felt led the way to the "famous series," the *Wheatstacks*, the *Rouen Cathedral*, the *Water Lilies*—and analyzed them in the context of the works of Monet's peers. He found in the group's work "a general harmony in its perpetual and original variety."[248] With the 1904 exhibition, Mellerio claimed, "Impressionism gradually takes up its logical and legitimate place: following romanticism, 1830s landscapism and realism, it appears as the most important art movement of the end of the 19th century."[249]

There is little wonder, then, that in 1912 Venice (or rather *Venise*, as created by Monet) appeared as a testament, the closing link in Monet's oeuvre and perhaps even in his life. One of Geffroy's articles on

Monet's Venice was published in the periodical *La Vie*, and, rather than describing the contents of the exhibition at Bernheim-Jeune's, it recounts Monet's life—or at least Monet's life since he met Geffroy. The meeting between the artist and the critic took place serendipitously on Belle-Ile in 1886, while Geffroy was researching the life of Louis-Auguste Blanqui (1805–1881), a French revolutionary who was largely responsible for the upheavals of the Commune. Arrested by Thiers shortly after the Commune, Blanqui had tried and failed to escape from the prison on Belle-Ile (the French equivalent of Alcatraz). Geffroy thus narrates the event: "The evening I arrived, it was not just the shadow of Blanqui that stood in front of me, it was Claude Monet himself, as big as life, still in his youth, at the peak of his age, whom I saw coming out of a little inn."[250]

The whole article is then articulated around notions of life and death. The "birth" of the friendship between the painter and the art critic offers the pivotal axis for the article. Geffroy notes that the Impressionists have been "reduced to a mere few." And other deaths have struck Monet recently: principally that of Alice, who died in 1911. "Among the last to go, Monet needs the energy of life, by reliving the past through the present day....It is the law of our existence," Geffroy warns us, "to prolong the works of others, before going ourselves, and to bring to the end the work that we started."[251]

Indeed, Geffroy presents the Venice exhibition as Monet's swan song, echoing a prevalent discourse of the time which popularized the death and burial of Impressionism.[252] Geffroy assigns a quasi-messianic role to Monet, whose life finds its whole meaning, its completion, in his "Venice oeuvre." For Geffroy, the 1912 exhibition constituted the culmination of Monet's life, almost his testament: Venice offers a few more pages of "this marvelous poem that [Monet] will leave behind, testifying to his passage among things, seasons and hours."[253]

Venice, to Geffroy, offers proof of the fact that Monet is the painter of "the grandiose syntheses of the spectacles of the universe." By this rather grand statement, Geffroy means that Monet is not the painter of any specific locus, be it Vétheuil, Louveciennes, or Giverny; he is the painter of light, of *essences*. And Geffroy dreams that Monet's voyage might not have ended with Venice alone but that he might have let his "singular capacity of precision and dream" apply itself to "the whole world: from the polar icebergs to the sands of the desert, from the Gothic cathedrals to the Roman Forum and the Greek temples."[254] This quasi-mystical vision of the destiny of Monet's life is called back to reality, however, since "the span of a lifetime would never suffice to such innumerable creations."[255] With some disappointment, Geffroy surveys the extent of Monet's creations, necessarily limited to the scope of his human experience: "the olive trees and the pine trees of the Mediterranean...and the Venetian canals."[256] In Geffroy's eyes, Monet "extracted Venice out of itself...only revealing its essential form, as though it were deserted."[257] In so doing, Monet surpassed himself: as Geffroy writes, "he has never achieved what he sees and understands with as much strength, and relief."[258]

Defending Monet's work against accusations of realism (or literalness, triviality, banality), Geffroy sees in Monet's visions of Venice not a "disfiguration" but a "transfiguration" of reality. Monet does not simply copy the real, Geffroy explains, he "interprets" it. That is, he blends his vision of the real with his dream. Geffroy borrows some of his definitions from the contemporary philosophical writings of Ernst Renan, such as: "Everything is ephemeral, although the ephemeral is sometimes divine." Through Monet's vision, the old architectural settings of Venice adopt a "melancholic and mysterious aspect under the luminous veils that wrap up the city"; likewise, the water, with its waves lapping against the steps of the *palazzi*, seems to be there "to dissolve these wrecks of history."[259] It is death that Geffroy detects in that silent city. He sees in Monet's *Venise* "the magnificence of a city dead under the sun, where nothing

is alive except the swift furrows of the gondolas, stroking the water as black swallows would."[260]

The theme of the precariousness of Venice is common in criticism devoted to Monet's 1912 exhibi

FIG. 27 Claude Monet
The Doges' Palace in Venice (detail), 1908 [Plate 86]
Brooklyn Museum of Art
Gift of A. Augustus Healy 20.634

tion. In an anonymous article, for instance, the architecture of Venice is seen as playing only a secondary role in Monet's work.[261] All that changes, all that gets transformed in an instant (the luminosity of the sun, the thickness of the clouds, the passing of the water, etc.)— these are the real subjects of the artist, his "true motifs." The critic notes accurately that in many paintings of Venice Monet dedicates at least half of his canvas to the treatment of water, while the architectural facades seem to be receding or floating on these mirroring planes.

The obvious connections between Monet's *Venise* and his *Water Lilies*, of course, did not escape the critics. Lecomte, for instance, was one of the first to emphasize the link between these two groups of works.[262] Like Geffroy, Lecomte sees in Monet's Venetian views the work of a poet; he emphasizes the paradoxical balance between a solid attachment to "reality" and the force of the artist's "interpretation." Lecomte's particular insight, however, was to recognize that Monet's Venice paintings were the ultimate link in a sequence of series, which includes "the reflections of sails on the Seine" in Argenteuil; the Saint-Lazare train station; the tulips in Holland; the scenes in Belle-Ile, the Creuse, Pourville, Varengeville, and Vétheuil; the *Wheatstacks*, the *Poplars*, the *Rouen Cathedrals*; and, of course, London. Lecomte concludes that it is impossible to communicate in words the "fairylike novelty of the combinations of colors" displayed in Monet's Venetian works.

Mirbeau was asked by Monet to write the essay for the 1912 Venice exhibition catalogue. From the start, this text echoes familiar themes:

Venice is not a town. Dead or alive, a town can only move us through its houses, its people and atmosphere. Now, in Venice, all the poets know that one finds there no houses, but palaces. There is no atmosphere, since a pink veil has been laid on Venice, just like a scarf around a dancer's neck....Venice has sunk under the weight of the imbeciles.[263]

In Venice, Mirbeau writes, reality has been drowned by myth: "Venice is nothing more than a color postcard." As for its population, the real men and women have been

67

drowned in the lagoon, so that the only people left are the *gondolieri*, who are not real men but poets. Mirbeau argues that Monet is to Venice as Flaubert was to Rouen: an iconoclast, a demythifier. Venice is, to Mirbeau, the ultimate circus where the human ridicule displays itself—in this, he is fundamentally faithful to Monet, of course, but also to Flaubert: "To paint Venice was to grapple with the vastness of human stupidity, which is largely the author of the image of Venice that we have."[264] This is why Monet delayed incessantly his decision to tackle Venice, "that town which is no longer a town, but a mere decoration, a pattern. Claude Monet couldn't dare."[265]

What Monet found in Venice, according to Mirbeau, was a chance to renew himself by tackling the preconceived images of Venice. He no longer hoped to conquer the light, only to "glide" on the surface of the canvas, in the same way that light glides over things or in the same way that "the most intelligent dancer translates a feeling."[266]

As Geffroy had done, Mirbeau also evokes the themes of birth and death. He quotes Hokusai, who, at the age of one hundred years, said: "It is quite a bore to have to die. I was just starting to understand shapes." Mirbeau compares this state of mind to that of Monet, who seems to have discovered new forms in Venice: "Monet discovers a form, as though it were born again in these exact variations of atmosphere."[267]

Monet's *Venise* was celebrated, almost unanimously, as one of the great feats in the history of painting. Up to that point, Monet had never been so unreservedly lauded. The irony is that soon after World War I these much-praised Venetian paintings fell into oblivion, no longer eliciting the sort of praise they had obtained when first exhibited. One of the points of the Kimbell exhibition and of the present volume is precisely to reopen the question of the merits of these works, seen, as much as possible, in the context in which they were created.

COLOR PLATES AND
COMMENTARIES

The Italian and the French Rivieras
January–April 1884

Monte Carlo, 1883

The Monte Carlo Road was one of the first works executed by Monet on the shores of the Mediterranean in December 1883. Interestingly, the sea itself is not represented. Within the Impressionist idiom, this composition is still somewhat conventional; a *V* is formed by the descending line of the hillside on the left intersecting with the curve of the tree's foliage on the right.

This descending triangular form is opposed and anchored by the path that ascends from the bottom right to the center of the canvas, leading the gaze to the sunlit village. These oppositional lines, as well as the contrasts of light and shadow, create a strongly varied composition. The cohesiveness of the picture is precisely assured through these sets of formal oppositions and chromatic complementaries: the pale yellow sun-drenched path, for instance, contrasts with the mauve-purple shadows cast on its sandy surface, setting the tone for the dynamics of the whole work.

72 **The Monte Carlo Road,** 1883.
25 ⅝ x 32 in. (65 x 81 cm)
Collection of Samir Traboulsi [W. 850, Plate 1]

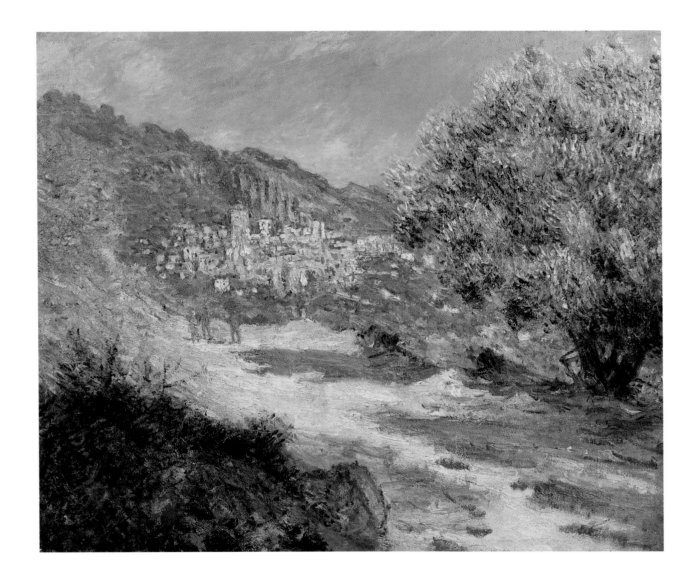

1. The Monte Carlo Road, 1883

Bordighera, January–May 1884

Bordighera, Italy, 1884.

23 ⅜ x 28 ¾ in. (60 x 73 cm)

Private Collection [W. 852, Plate 2]

View of Bordighera, 1884.

26 x 32 ¼ in. (66 x 81.9 cm)

The Armand Hammer Collection, UCLA at the Armand Hammer Museum of Art and Cultural Center, Los Angeles [W. 853, Plate 3]

Bordighera, 1884.

25 ½ x 32 in. (64.8 x 81.3 cm)

The Art Institute of Chicago, Potter Palmer Collection 1922.426 [W. 854, Plate 4]

The Marina in Bordighera, 1884.

25 ¾ x 32 in. (65.5 x 81 cm)

Private Collection [W. 864, Plate 5]

These paintings present a strong contrast to *The Monte Carlo Road* (Plate 1). There is no longer a stable road on which the easel of the painter is set. In fact, one wonders in each painting where the artist stood—where he placed his easel, given the overwhelming vegetation on the hillside. In each of the three paintings, there is an interplay between four elements (or "characters"): the sky, the sea, the town (Bordighera, with its small church tower), and the vegetation. Each view is dominated by two or three pine trees that spring out of the foreground and create a sophisticated, quasi-choreographic pattern that binds all four parts of the painting. This tree pattern is especially apparent in *Bordighera, Italy* (Plate 2) and *Bordighera* (Plate 4).

This procedure is not entirely novel within Monet's oeuvre. In *Varengeville Church* (1882, Barber Institute of Fine Arts, University of Birmingham, W. 727), for instance, the exact same formal procedure is used. Yet in this group of three Bordighera views, the process is brought to an extreme point: in these views, there is no apparent access to the village or the sea, and the vegetation seems to have taken over almost everything. These grotesque arrangements dominate the whole composition in a manner reminiscent of certain works by Cézanne (see, for instance, *La Montagne Sainte-Victoire*, c. 1887, at the Courtauld Institute Galleries, London).

It is interesting to relate *The Marina in Bordighera* to the previous group of three views. The compositional principle is the same in all of these works: the little fishing town of Bordighera appears overcome by the wild surrounding vegetation, pressed against the sea. Yet in *The Marina in Bordighera,* Monet does not resort to the dramatic use of the pine tree as frame; the difference is considerable. Here, the "Borgo Marina," with its cluster of roofs, is sandwiched between three rigorously parallel bands of foliage, sea, and sky.

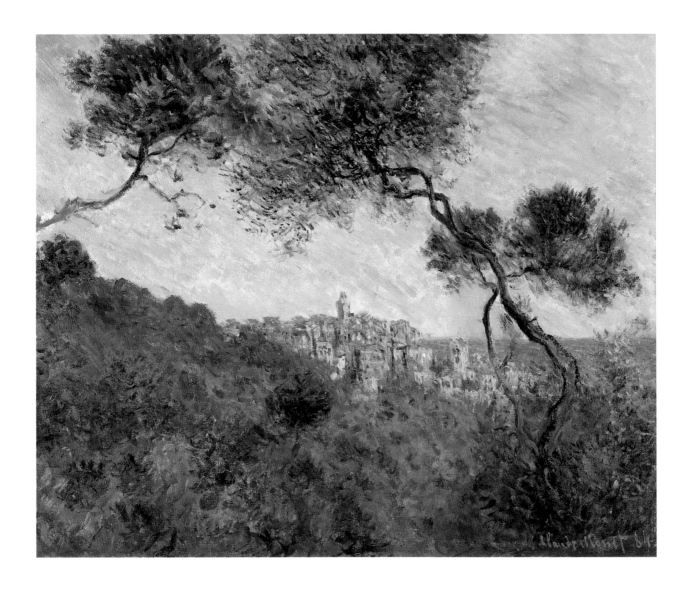

2. Bordighera, Italy, 1884

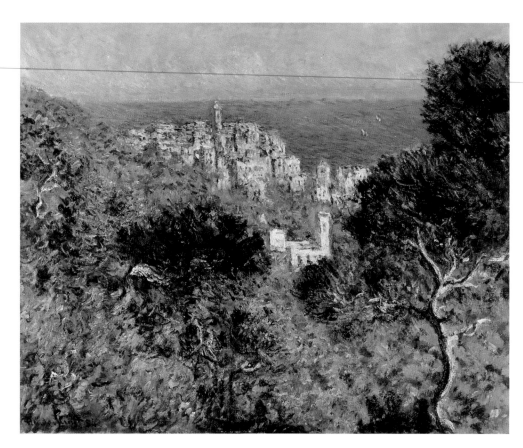

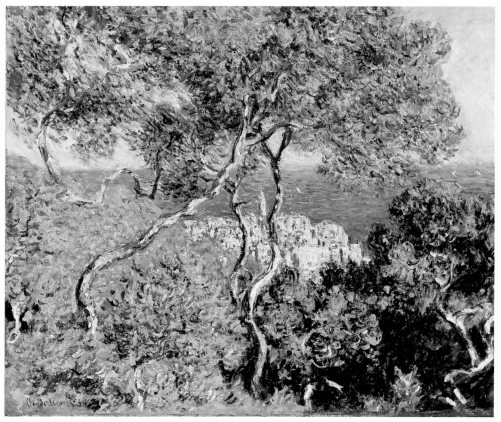

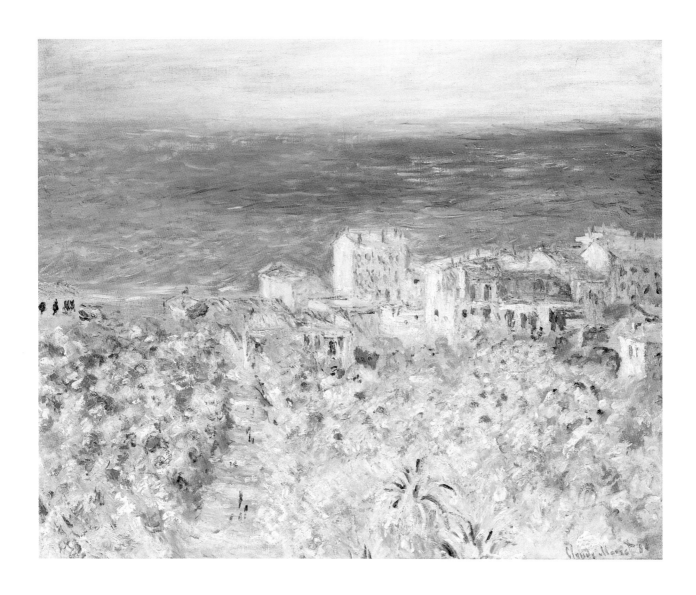

3. View of Bordighera, 1884
4. Bordighera, 1884
5. The Marina in Bordighera, 1884

The Villa Garnier

78 **Strada Romana in Bordighera,** 1884.

25 ⅝ x 32 in. (65 x 81 cm)

Mr. and Mrs. William Wood Prince [W. 855, Plate 6]

Bordighera, 1884.

29 x 36 ⅜ in. (73.7 x 92.4 cm)

Santa Barbara Museum of Art, Bequest of Katherine Dexter McCormick in memory of her husband, Stanley McCormick [W. 856, Plate 7]

The Villas in Bordighera, 1884.

45 ¼ x 51 ⅛ in. (115 x 130 cm)

Musée d'Orsay, Paris [W. 857, Plate 8]

Each of these works obliquely represents, partly cut by the right edge of the canvas, the Villa Garnier, built by the most celebrated French architect of the Second Empire, Charles Garnier; and otherwise known as the famous Villa Etelinda; this dwelling, built for the Baron Bischoffsheim, became a popular tourist attraction and a central gathering place for the elegant international intelligentsia, whom Monet was very careful to avoid.[1] The two smaller works were executed in Bordighera. In *Strada Romana in Bordighera*, the landscape is more unified and harmonious than in the other two works. In the other works the position of the viewer is different as well: while the vantage point is still from the Strada Romana, a main street in Bordighera, it is now further back, allowing a slightly larger portion of the Villa Etelinda to become visible on the right.

The third work (a copy after *Bordighera*, Plate 7) was executed in Giverny for Berthe Morisot. Even though it clearly drew upon the former *Bordighera*, there are obvious differences between these two works. For one thing, the painting made in Italy is a rectangle, while the larger and later work is nearly square. This change in format makes the whole composition more compact. In the nearly square format, the impact of the vertical architecture and the agave stalk that splits the composition is much more dramatic. The color contrasts are also greater in the large-format version: the blazing colors of the agave, in particular, glow on the picture surface. Monet was evidently unafraid of shocking or surprising Morisot, and he boldly intensified the chromatic effects of the picture.

This is also one of the few pictures from Bordighera in which the architecture predominates. But Monet's strange cropping of the buildings, provocatively, leaves only a corner of the celebrated Villa Etelinda visible. This is a compositional technique that he later used in Venice as well. This cropping serves to deemphasize the architectural and historical importance of the buildings, whether it be the Villa Etelinda or the Palazzo Dario, and to heighten their visual effect in his representations.

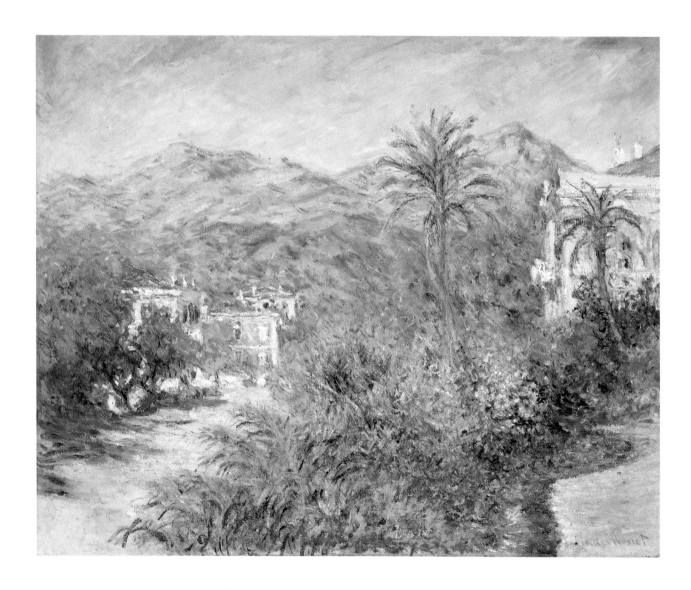

6. Strada Romana in Bordighera, 1884

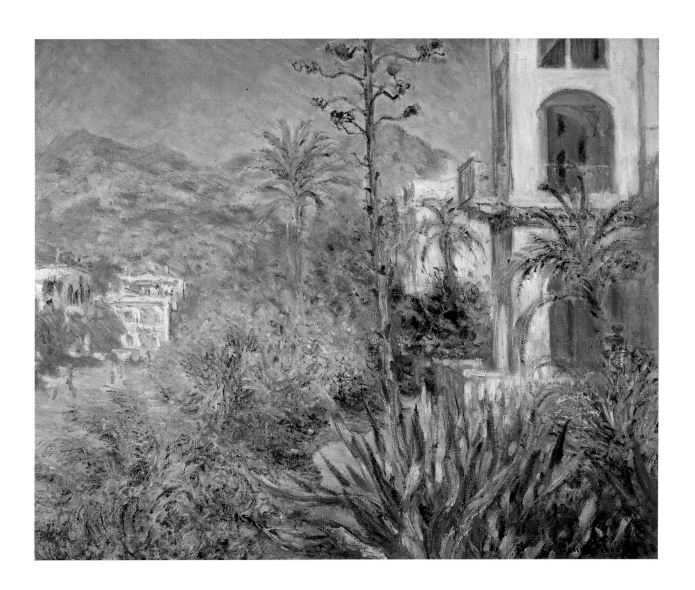

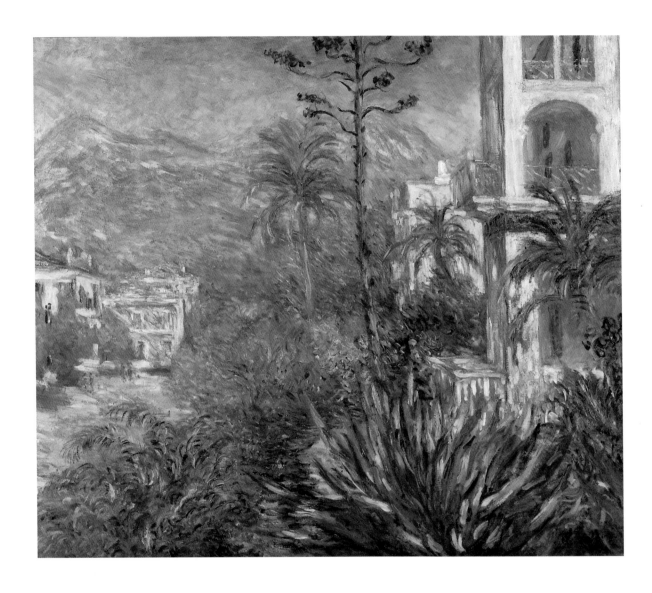

7. Bordighera, 1884
8. The Villas in Bordighera, 1884

Valle Buona

Valle Buona near Bordighera, 1884.

25 x 35 ½ in. (63.5 x 90.2 cm)

Dallas Museum of Art, Gift of the Meadows Foundation, Inc.
1981.127 [W. 858, Plate 9]

This particular motif cannot be found anywhere else in Monet's Mediterranean oeuvre, except for a preparatory drawing executed during one of the artist's reconnaissance promenades as an *aide-mémoire*. This picture is about scale. Here, no human-scale devices such as roads, houses, or tree branches provide perspective. Rather, the space is structured through a succession of layers: a flat ground surface, covered with grass and rocks, is represented in the foreground; trees and bushes appear in the midground; and finally, hills and mountains in the background. The whole composition is crowned with sky and clouds. While at first this appears to be a fairly ordinary landscape composition, when one begins to scrutinize the surface, one quickly sees a tiny village set on top of a hill, another on top of a further hill to the left, and even a small house hidden under the trees in the midground. The immediate optical effect of these villages, seen in minuscule scale, is to demonstrate that the distance and the scale featured in this canvas are vast. A sense of awe takes hold as the viewer realizes that these mountains and hills, which at first seemed so close, are miles away.

The compositional device that Monet used here was not unusual in the picturesque tradition. In fact, it brings to mind the definition of the sublime given by the eighteenth-century encyclopedists: "The *sublime* in general, I would say in a few words, is all that raises us above what we were, and which makes us feel at the same time this elevation."[2] What is unusual about this work, however, is that here the sublime, traditionally used to evoke a sense of awe or psychic transport, is combined with a very prosaic surface treatment in order to depict a very ordinary landscape. The rough and extremely diversified paint application strives to emulate the vast sense of dislocation suggested by the painting's composition.

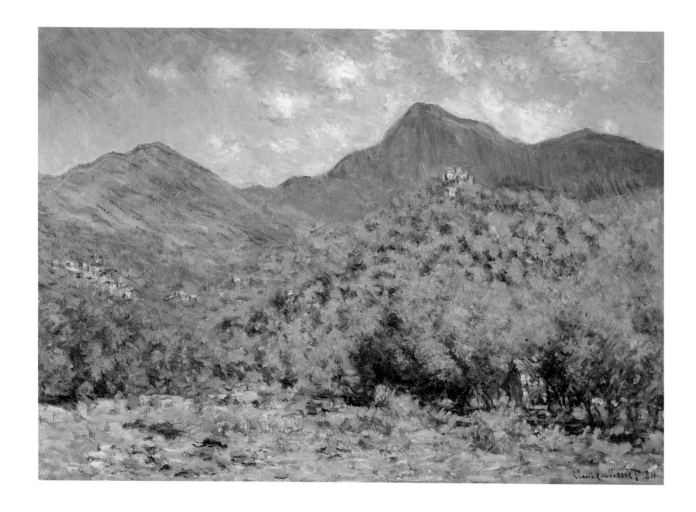

9. Valle Buona near Bordighera, 1884

The Valley of Sasso

The Valley of Sasso, Blue Effect, 1884.

25 ⅝ x 36 ¼ in. (65 x 92 cm)

Private Collection [W. 859, Plate 10]

The Valley of Sasso, Bordighera, 1884.

25 ¼ x 31 ½ in. (64.2 x 80.1 cm)

San Francisco Museum of Modern Art, Bequest of Mr. James D. Zellerbach [W. 861, Plate 11]

The Valley of Sasso, Sun Effect, 1884.

25 ⅝ x 32 in. (65 x 81 cm)

Musée Marmottan, Paris [W. 862, Plate 12]

The Valley of Sasso, Bordighera, 1884.

25 ⅝ x 32 in. (65 x 81 cm)

Private Collection [W. 863, Plate 13]

This group of five works (including *Olive Trees and Palm Trees, Valley of Sasso*, location unknown, unillustrated, W. 860) offers a clear demonstration of Monet's Mediterranean as an utterly unfamiliar environment, fraught with a sense of the bizarre and packed with a profligacy of interwoven exotic plants—citrus trees, lianas, palm trees, and so forth. These trees and vines are formed by a dense web of nervous lines of color, an abundance of brushmarks of all shapes and in all directions. This is one of the most unpicturesque motifs chosen by Monet in Italy: these pictures are marked by a total absence of any "touristic" appeal; the cube-shaped stone shed, for instance, eaten up by the surrounding lianas and vines, is conspicuously banal. The perspective is blocked by the descending mountain on the left and by the hill that teems with vegetation on the right. Despite (or perhaps because of) their provocative lack of well-known or visually arresting details, these paintings foreground Monet's unique debauchery of paint. It is most likely with such paintings in mind that he told his wife that he found nature even crazier than his art: the pictorial effect of his empathy with this wild segment of landscape was that Monet could let go of all inhibitions. Monet would not find himself so liberated pictorially again until he started his *Water Lilies* series, in which he would immerse himself in a wholly natural environment and would allow the pictorial patterns of the paint surface to be dictated by the forms of the all-encompassing pond surface.

In the Mediterranean, Monet resorted to two different procedures with regard to his choice of subjects. He would either choose culturally or historically significant subject matter (such as Venice itself or the Villa Etelinda in Bordighera), which he would then "designify" by his pictorial practices, or, as in this case, he would choose seemingly insignificant views, with no landmarks, no points of particular interest, no recognizable cultural artifacts, nothing to "designify." Here, it is the agitation of the brush on the canvas and the unusual vantage point that are so disorienting.

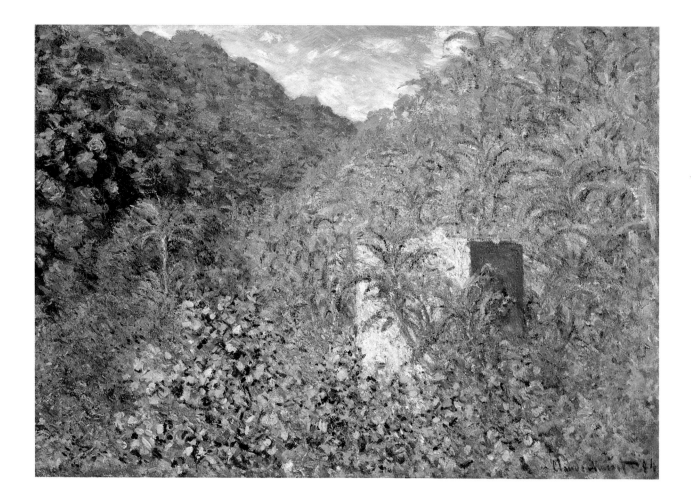

10. The Valley of Sasso, Blue Effect, 1884

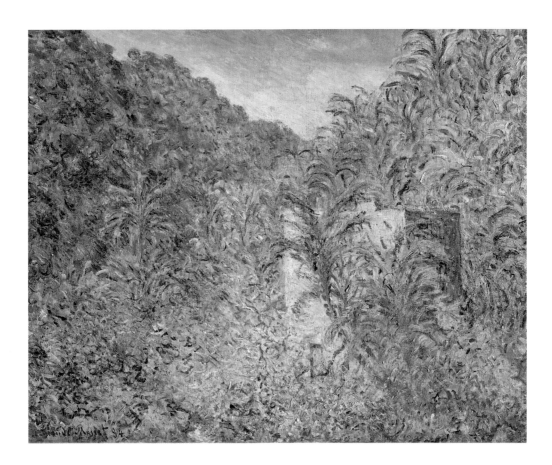

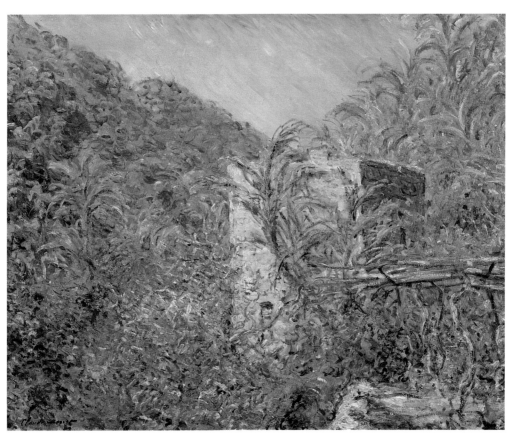

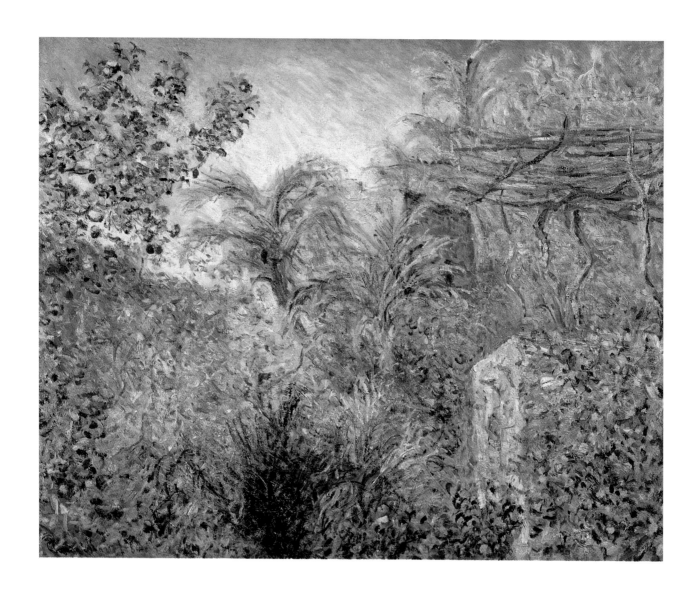

11. The Valley of Sasso, Bordighera, 1884
12. The Valley of Sasso, Sun Effect, 1884
13. The Valley of Sasso, Bordighera, 1884

Olive Trees

Evoking the floral abundance of Monet's *Water Lilies* series, the Belgian poet Emile Verhaeren wrote, "Oh! beautiful vegetal violence, mad abundance, tight weave of colors and lights! A congestion of flowers, grasses, shoots, branches." These words are particularly apt to suggest the reality that Monet grappled with in this group of works. The five paintings of olive trees, including *Study of Olive Trees, Bordighera* (location unknown, unillustrated, W. 871), have never been exhibited together, nor have they been reproduced in color. Plate 16 was, however, given by Monet to Octave Mirbeau, indicating that the series held particular interest for the critic.

In this group of works the artist adopts an unusual vantage point: he immerses himself in his subject and paints beneath the trees. In this way, Monet pays a discreet tribute to the nineteenth-century tradition developed by the Barbizon artists of representing the forest interiors. Earlier in his career, Monet had attempted this type of representation with such works as the group of large "tableaux" depicting the so-called *Pavé de Chailly* (1864–65).[3] This group, however, embodies a different approach to the theme in that no perspectival device leads the observer's gaze out of the grove. Here Monet is purely interested in the effects of light as it comes through the silver-colored leaves of the trees, the shadows cast by the gnarled and twisted forms of the trees on the soil, and the chromatic contrasts between the silvery pale-blue tonalities of the leaf-filtered light and the crimson, ruddy ground of clay it falls upon.

These are the only works by Monet in which the viewer is entirely surrounded. A few months later, back in Giverny, Monet started his famous water garden. Nearly fifteen years later, his *Water Lilies* series would resume some of the themes: the notion of a self-contained natural space that takes over the whole surface of the canvas and acts as a cocoon, completely absorbing the artist's gaze into that space and negating the laws of perspective.

88

Study of Olive Trees, 1884.
28¾ x 23⅝ in. (73 x 60 cm)
Courtesy Marc Blondeau, S.A., Paris [W. 868, Plate 14]

Grove of Olive Trees in the Moreno Garden, 1884.
25¾ x 32⅛ in. (65.5 x 81.5 cm)
Private Collection [W. 869, Plate 15]

Olive Trees in Bordighera, 1884.
23⅝ x 28¾ in. (60 x 73 cm)
Private Collection [W. 870, Plate 16]

Grove of Olive Trees in Bordighera, 1884.
25⅝ x 32 in. (65 x 81 cm)
Private Collection [W. 872, Plate 17]

Under the Lemon Trees, 1884.
28¾ x 23⅝ in. (73 x 60 cm)
Ny Carlsberg Glyptotek, Copenhagen [W. 873, Plate 18]

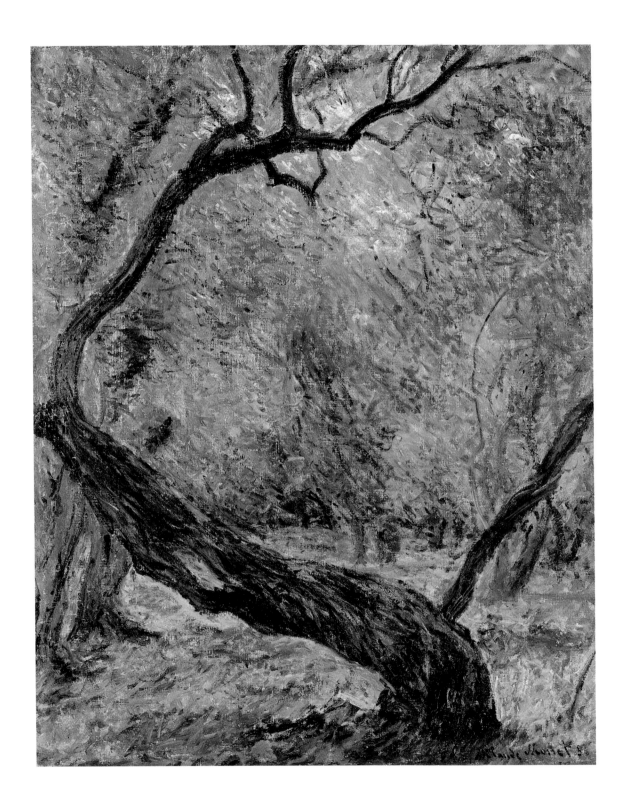

14. Study of Olive Trees, 1884

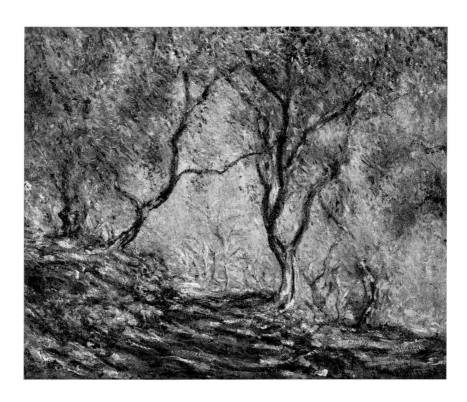

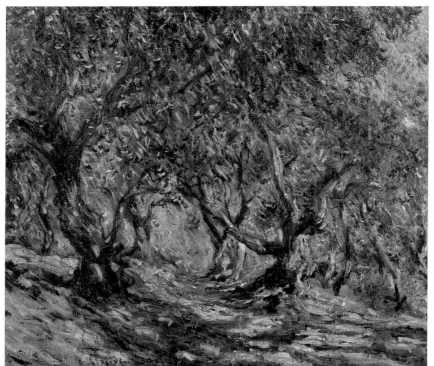

15. Grove of Olive Trees in the Moreno Garden, 1884

16. Olive Trees in Bordighera, 1884

17. Grove of Olive Trees in Bordighera, 1884

18. Under the Lemon Trees, 1884

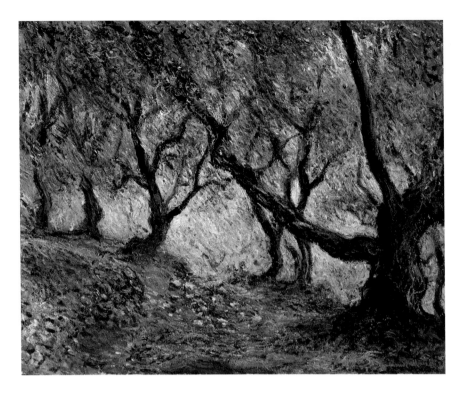

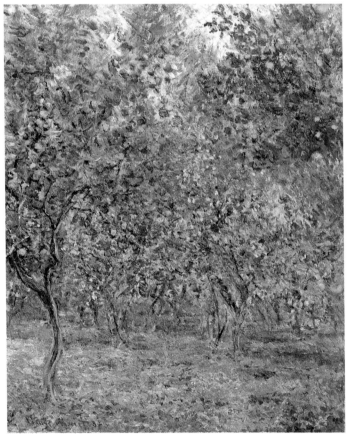

Palm Trees:
Inside the Moreno Garden

Gardens of Bordighera, 1884.

28¾ x 36¼ in. (73 x 92 cm)

Norton Museum of Art, West Palm Beach, Florida
[W. 865, Plate 19]

Garden in Bordighera, Impression of Morning, 1884.

25¾ x 32 in. (65.5 x 81.5 cm)

Formerly collection Otto Krebs, Holzdorf; now at the
State Hermitage Museum, St. Petersburg [W. 866, Plate 20]

Small Country Farm at Bordighera, 1884.

29⅛ x 36⅜ in. (74 x 92.4 cm)

The Joslyn Art Museum, Omaha, Nebraska;
Joslyn Endowment Fund [W. 874, Plate 21]

Palm Tree in Bordighera, 1884.

24⅛ x 29⅛ in. (61.3 x 74 cm)

Private Collection [W. 876, Plate 22]

Monet was often tempted by what seemed impossible. When he arrived in Bordighera, he was told of a magnificent garden where hundreds of rare species of palms grew. But access to the public was restricted. Monet spared no efforts, writing to every contact he could think of to gain access to the garden. In fact, thanks to the proper introduction, he was given a very warm and generous welcome by the owner, Francesco Moreno, who, according to Monet, owned almost all of Bordighera. In this group, Monet does not represent just what a tourist guide deems worthy: the palm tree was indeed the emblem of Bordighera, and was unavoidably featured on all the postcards. More complex than a tourist postcard, the artist's mind here selects the most difficult, most inaccessible point so that his representation will remain outstanding, both in what is represented and in the ways it is represented. This attitude recurred later in Antibes, where Monet sought access to a spot protected by the military for intelligence reasons, and in Venice, where he wanted to use the balcony of a palazzo that was closed to the public.

Before the palm trees, Monet found no need to "designify" his motif, since the trees lent themselves so admirably to his pictorial research: their pure effusion of colors and unkempt shapes organized the structures of the compositions. The turret of the Santa Maria Maddalena Church seen from the Moreno garden (Plates 19 and 20) and the farm (Plate 21) gives a measure to the vast scale of these palm trees, which visually dominates everything. The paintings of groves of palm trees culminate with a sort of portrait of a lone palm (Plate 22). The explosive fishbone structures of this single tree push the limits of Monet's chromatic boundaries. In the way that this wild tree stands on its own, like a disjointed giant, it is tempting to see a projection of the artist himself. This picture was very likely the last painted by Monet in Bordighera.

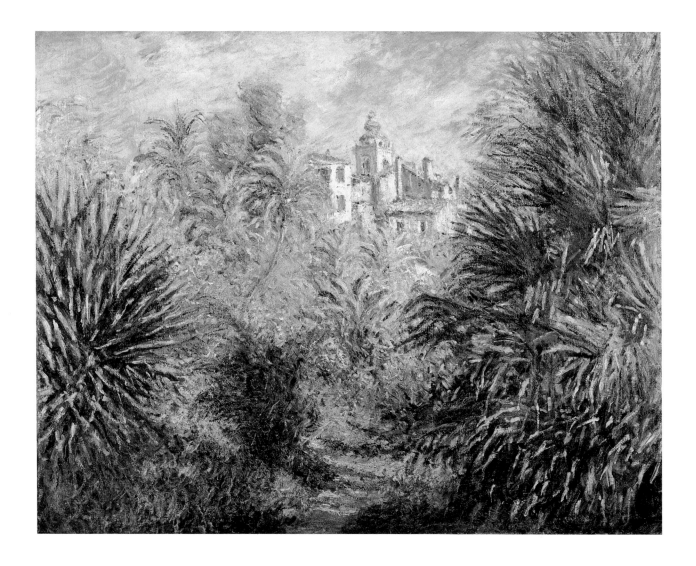

93

19. Gardens of Bordighera, 1884

94

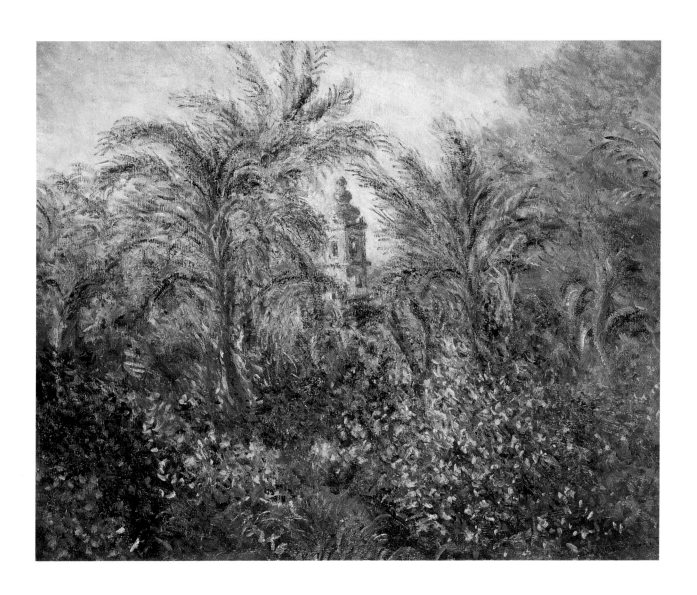

20. Garden in Bordighera, Impression of Morning, 1884
21. Small Country Farm at Bordighera, 1884
22. Palm Tree in Bordighera, 1884

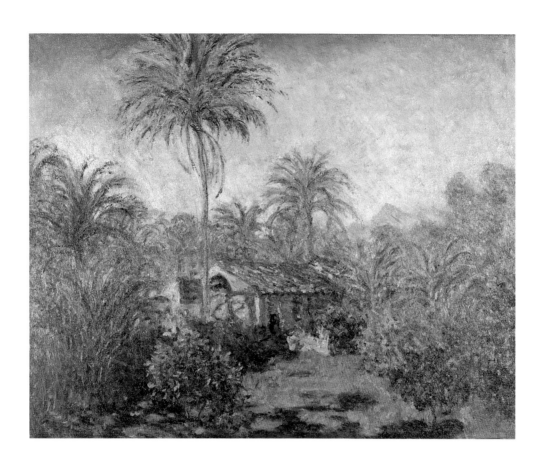

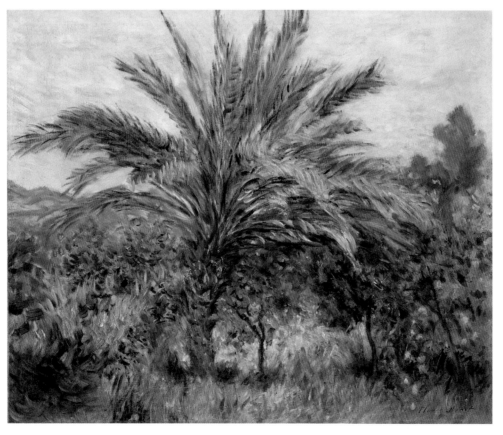

Outside Bordighera: The Alps

Palm Trees at Bordighera, 1884.

25½ x 32 in. (64.8 x 81.3 cm)

Lent by The Metropolitan Museum of Art, New York,
Bequest of Miss Adelaide Milton de Groot (1876–1967), 1967
[W. 877, Plate 23]

View of Ventimiglia, 1884.

25⅝ x 36⅛ in. (65.1 x 91.7 cm)

Glasgow Museums: Art Gallery and Museum, Kelvingrove
[W. 878, Plate 24]

View Taken near Ventimiglia, 1884.

25⅝ x 32 in. (65 x 81 cm)

Private Collection [W. 879, Plate 25]

The Valley of the Nervia, 1884.

26 x 32 in. (66 x 81.3 cm)

Lent by The Metropolitan Museum of Art, New York,
Theodore M. Davis Collection, Bequest of Theodore M. Davis, 1915
[W. 881, Plate 26]

The Valley of the Nervia with Dolceacqua, 1884.

25⅝ x 32 in. (65 x 81 cm)

Private Collection [W. 885, Plate 27]

The Dolceacqua Castle, 1884.

36¼ x 28¾ in. (92 x 73 cm)

Musée Marmottan, Paris [W. 883, Plate 28]

Dolceacqua, 1884.

28¾ x 36¼ in. (73 x 92 cm)

Courtesy Marc Blondeau, S.A., Paris [W. 882, Plate 29]

Bridge at Dolceacqua, 1884.

25⅝ x 32⅛ in. (65 x 81.6 cm)

Sterling and Francine Clark Art Institute, Williamstown, Mass.,
Gift of Richard and Edna Salomon [W. 884, Plate 30]

Monet was a tremendous walker; he made excursions throughout the alpine countryside around Bordighera every time the weather would allow it. This group of eight works (to which must be added *The French Seacoast Seen from Bordighera*, Private Collection, unillustrated, W. 880) indicates the density and the rapidity of Monet's work during these promenades. Even if these works seem more inclined toward the conventional "views" of the tourist guides (or the postcard industry), his approach remained systematic, relentless, and exhaustive. The Alps appear here as a quiet, domineering presence, interacting spatially with the palm trees, the sea, and the plateau behind Bordighera. After studying the seacoast and the crestline of the Alps, he turned his gaze inland, looking at Dolceacqua from the Nervia Valley and finally focusing closely on the "two wonderful motifs" provided by the ruins of the medieval fortress of the Doria family (Plates 29 and 30), offset with the fragile, collarbone-like structure of the rib-vaulted bridge.

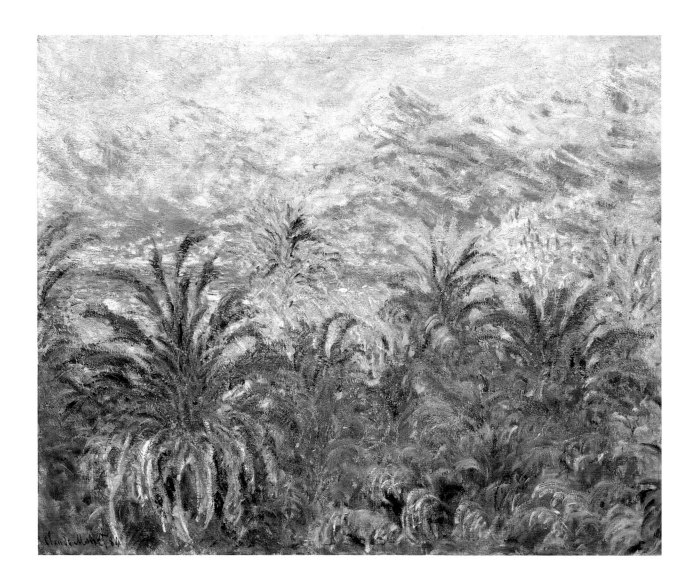

97

23. Palm Trees at Bordighera, 1884

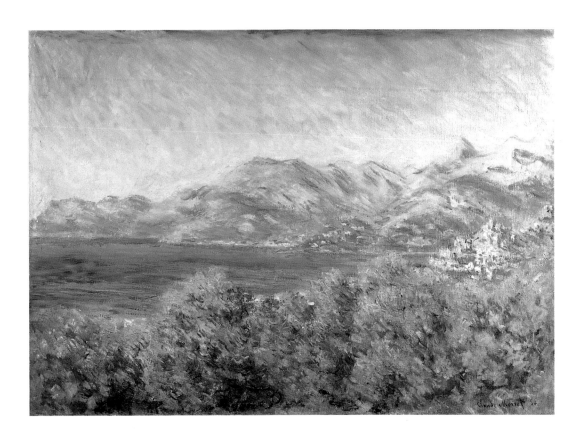

98

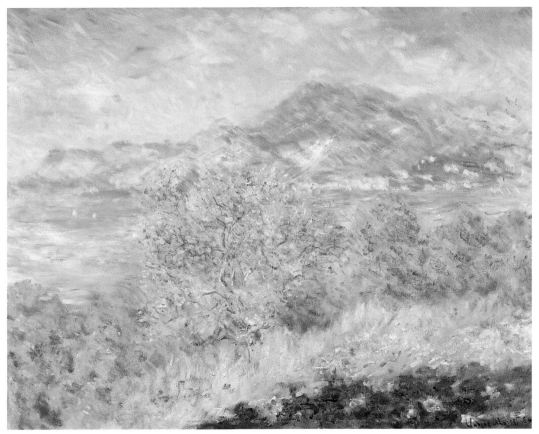

24. View of Ventimiglia, 1884
25. View Taken near Ventimiglia, 1884

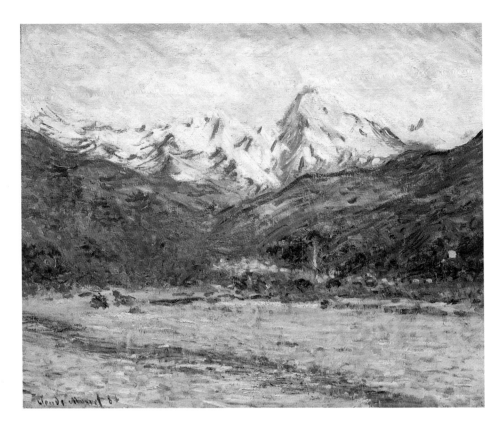

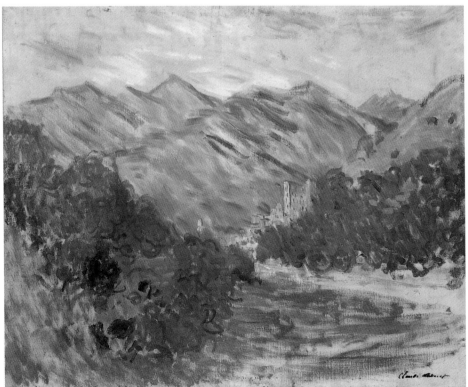

26. The Valley of the Nervia, 1884
27. The Valley of the Nervia with Dolceacqua, 1884

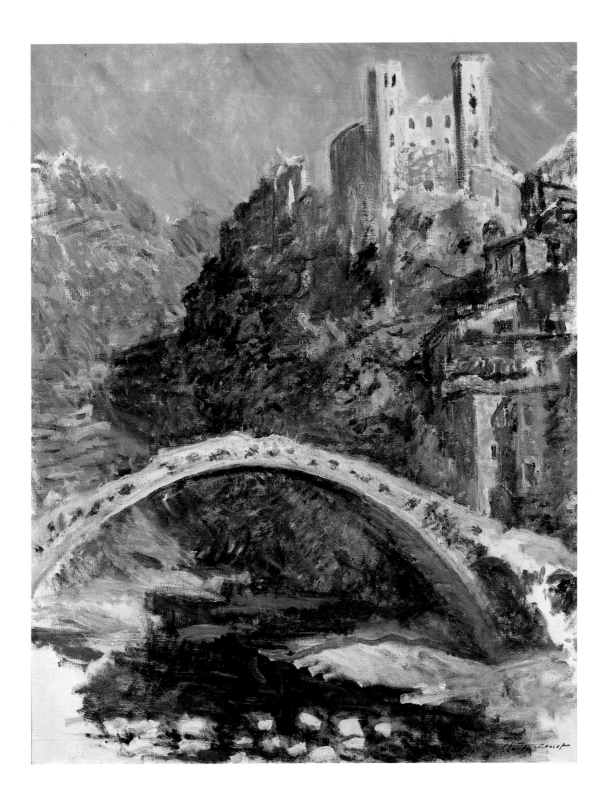

28. The Dolceacqua Castle, 1884
29. Dolceacqua, 1884
30. Bridge at Dolceacqua, 1884

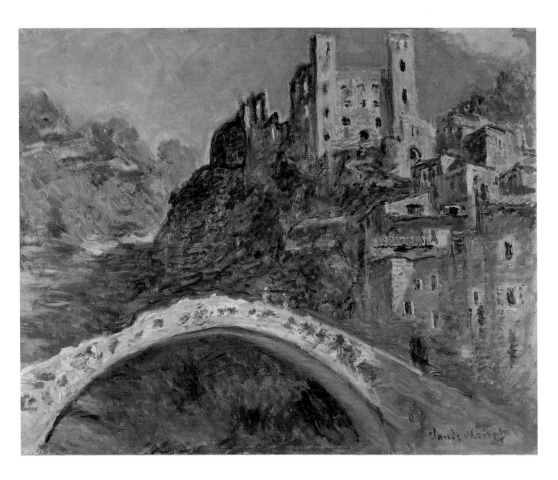

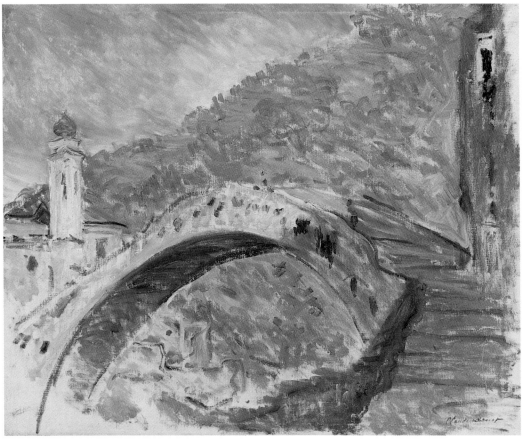

Painting Indoors

When the weather was bad, Monet often painted indoors. These three works, atypical among his Mediterranean oeuvre, are a result of such "bad weather" sessions in Bordighera. The portrait has recently been identified as the English painter Arthur Burrington or one of his friends.[4]

102 **Portrait of an English Painter, Bordighera,** 1884.

20½ x 16¼ in. (52 x 41 cm)

Tel Aviv Museum of Art, Gift of Mrs. Fernand-Halphen, Paris, 1949 [W. 886, Plate 31]

Orange Branch Bearing Fruit, 1884.

20⅞ x 15 in. (53 x 38 cm)

Private Collection, [W. 887, Plate 32]

Lemons on a Branch, 1884.

25⅝ x 21¼ in. (65 x 54 cm)

Private Collection [W. 888, Plate 33]

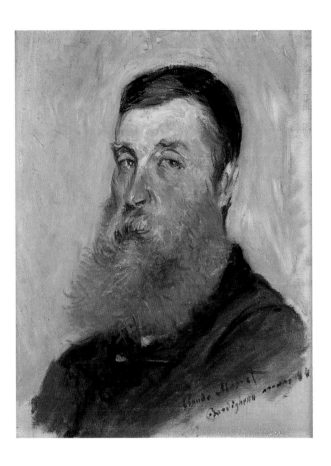

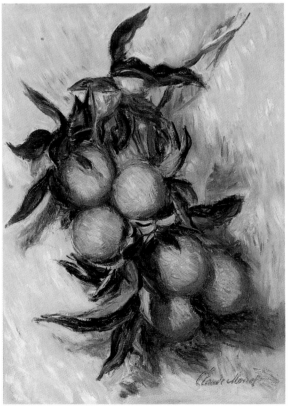

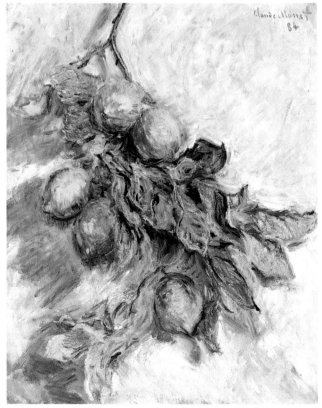

31. Portrait of an English Painter, Bordighera, 1884

32. Orange Branch Bearing Fruit, 1884

33. Lemons on a Branch, 1884

Monte Carlo and
The Red Road, Menton

Having completed his first group of works in Italy, Monet headed north, planning to stop off for a few days in Menton to undertake a few motifs. Since he had visited these sites earlier with Renoir, and on regular occasions from Italy, on his own, he believed they would give him fewer difficulties than Bordighera. The principal difference between these works and those executed in Italy is that in the Italian works the sea plays a very limited role; here, back on the French coast, in contrast, the sea, which Monet referred to as "quite definitely his element," is omnipresent. Each of these four works also represents the curious rock formation known as the "Dog Head" (Tête de Chien), which dominates Monte Carlo.

Coastal Road at Cap Martin, near Menton (Plate 35) is by far the largest work by Monet depicting a Mediterranean motif. As with *The Villas in Bordighera* (Plate 8), however, it was not executed outdoors but in Monet's Giverny studio. Still, its overall composition is faithful to the other paintings in this group, and it displays the same audacious and energetic brushwork. The lighting exposure is similar to that in the Stedelijk painting, though the tonalities of the larger canvas show more reserve and harmony.

Monte Carlo Seen from Roquebrune, 1884.

25 ⅝ x 32 in. (65 x 81 cm)

Scott M. Black Collection [W. 892, Plate 34]

Coastal Road at Cap Martin, near Menton, 1884.

54½ x 71 in. (138.5 x 180 cm)

Private Collection [W. 891, Plate 35]

The Corniche of Monaco, 1884.

29½ x 37 in. (75 x 94 cm)

Collection Rijksmuseum, Amsterdam, on long-term loan to the Stedelijk Museum, Amsterdam [W. 890, Plate 36]

The Red Road near Menton, 1884.

25 ⅝ x 32 in. (65 x 81 cm)

Private Collection [W. 889, Plate 37]

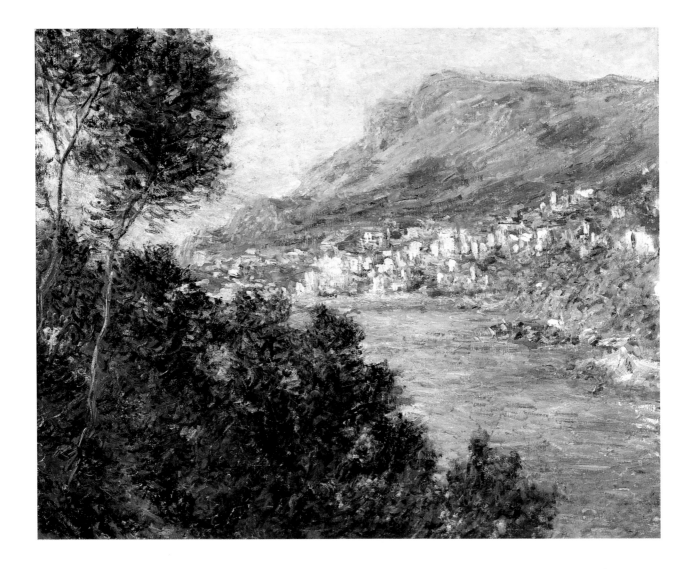

34. Monte Carlo Seen from Roquebrune, 1884

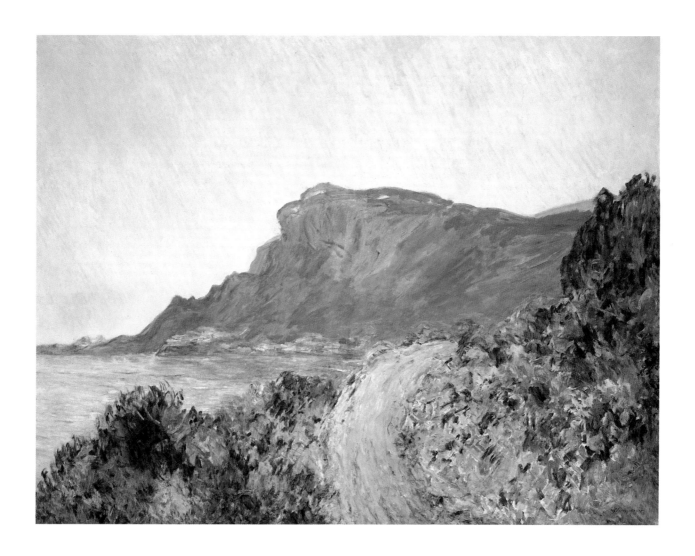

35. Coastal Road at Cap Martin, near Menton, 1884

36. The Corniche of Monaco, 1884

37. The Red Road near Menton, 1884

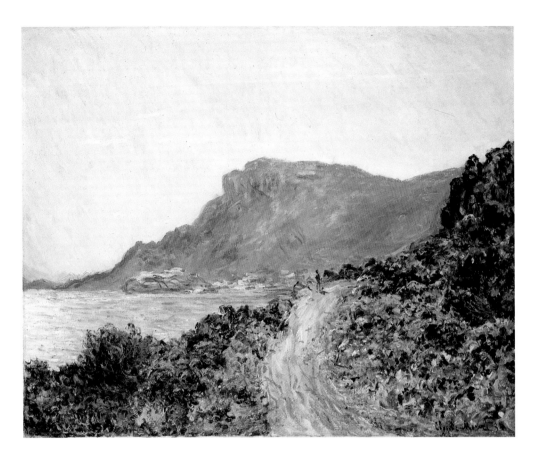

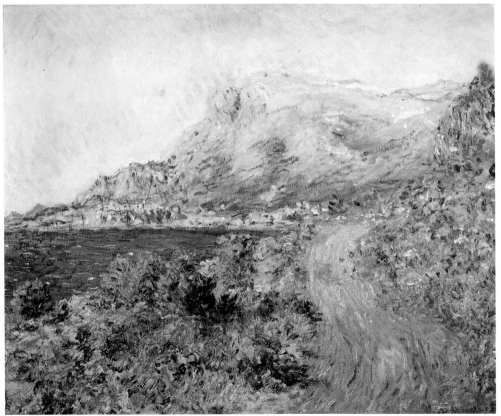

Cap Martin

These two works are very close. As in the paintings of the Dog Head, Monet has resorted to the principle of serialization to produce strikingly different images that draw upon the same motif. *Cap Martin, near Menton* (Plate 38) displays the mountainside in bright sunlight, whereas *Cap Martin* (Plate 39) depicts the same mountain in a darker mood. All the works depicting Menton and its surroundings offer very strong contrasts of colors: the brilliant hues of the earth on the paths have the intense tonality of a piece of meat, announcing, on some level, the art of Munch, or of some of the German Expressionists.

108

Cap Martin, near Menton, 1884.

26½ x 32⅛ in. (67.2 x 81.6 cm)

Lent by Museum of Fine Arts, Boston,
Juliana Cheney Edwards Collection 25.128 [W. 897, Plate 38]

Cap Martin, 1884.

25⅝ x 32¼ in. (65 x 82 cm)

Private Collection [W. 896, Plate 39]

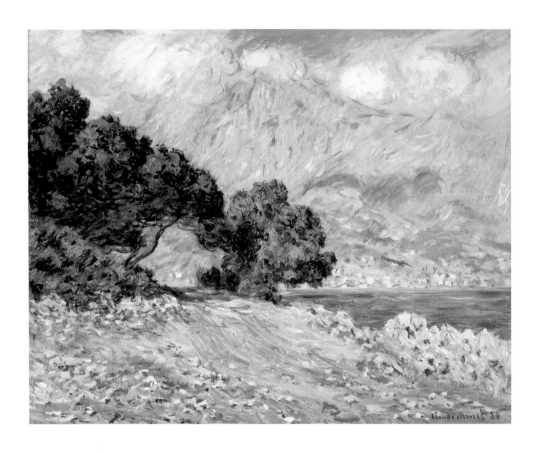

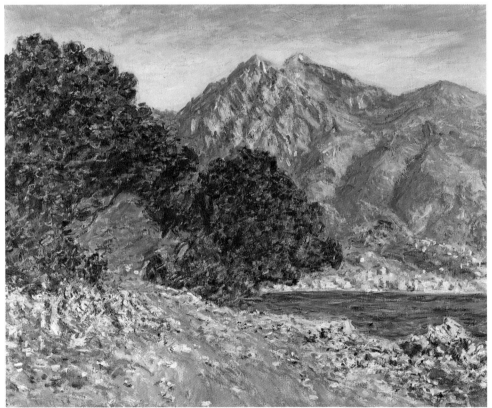

38. Cap Martin, near Menton, 1884
39. Cap Martin, 1884

Rocks and Sea

Here, Monet hones his pictorial imagination on a reduced register of themes. It is sheer visual interaction between elements, taken in their bare simplicity, that is of interest to him. Drawing upon the same serial principle, water, rocks, and vegetation are depicted as they change their appearances with shifts in weather and light.

As in previous groups, the contrast between the various elements in these works is stronger when the sunlight is dimmer: the larger canvas, which depicts an overcast sky, employs stronger contrasts of color and tonalities than the slightly smaller canvas, which shows the same scene in bright light.

There is about these works a sense of directness, a forthrightness in the treatment and the selection of the motifs, that demonstrates the confidence Monet developed during his ten-week southern trip. These works, painted both in Italy and France, are important not only because they anticipate the forthcoming series of Antibes but also because they seem to enlarge upon what is acceptable in Monet's art. Here, Monet goes further than Monet.

110

Cap Martin, 1884.
26¾ x 32¼ in. (68 x 82 cm)
Musée des Beaux-Arts de Tournai [W. 893, Plate 40]

Cap Martin, 1884.
28¾ x 36¼ in. (73 x 92 cm)
Private Collection [W. 894, Plate 41]

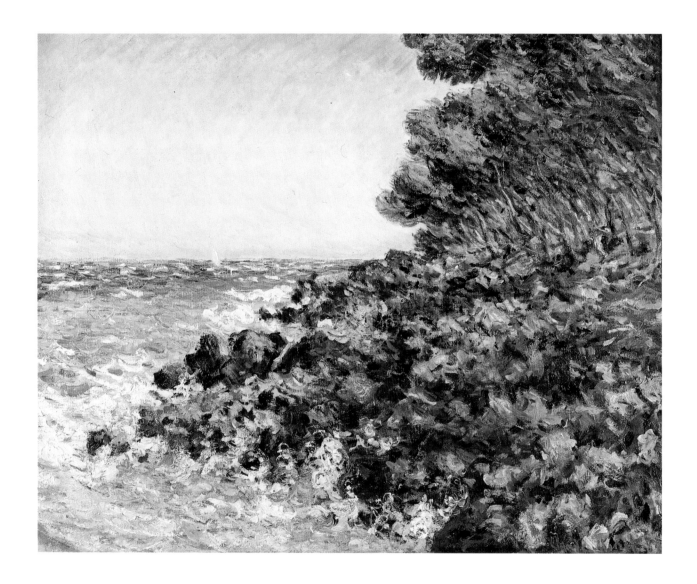

40. Cap Martin, 1884

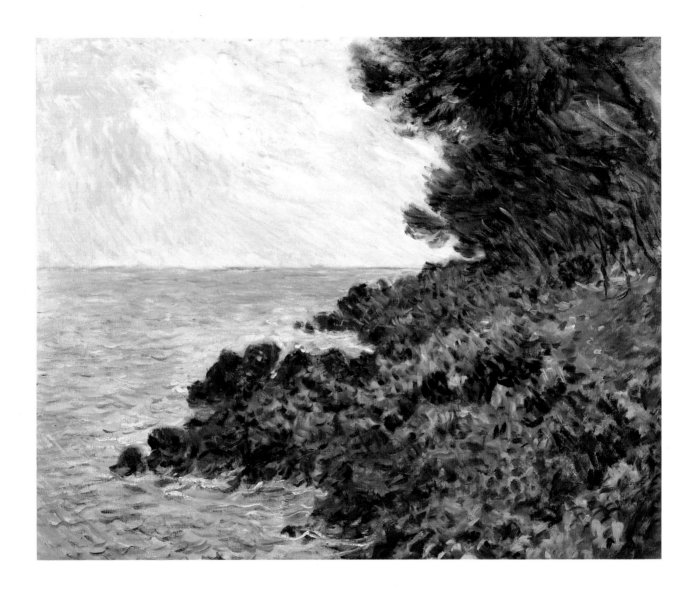

41. Cap Martin, 1884

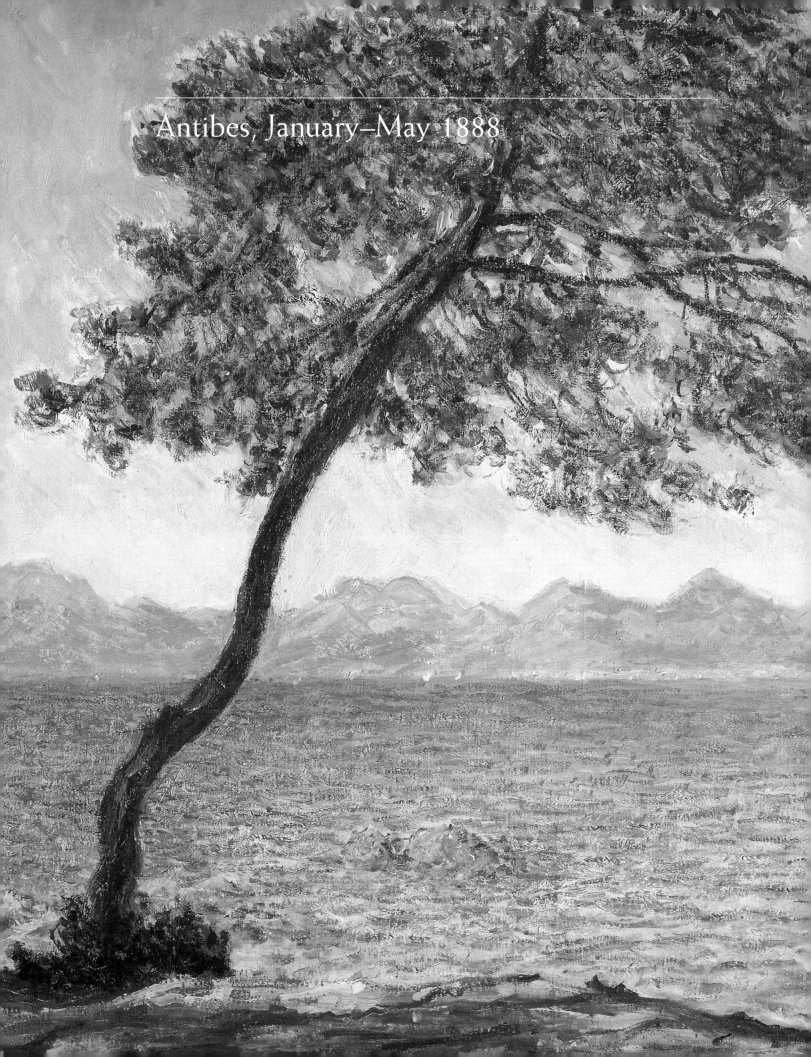

Rocks and Sea II

Monet's Antibes series shuttled between the site-specific to the utterly unspecified and almost unidentifiable. Only two of the paintings have motifs that can be identified, as they were by Wildenstein: Plate 47 depicts the sea and a reef that can be seen from the tip of Bacon Island, and Plate 45 depicts three fingers of rocks that go into the sea, on the west side of Cap d'Antibes. Apart from these paintings the scenes could almost be anywhere. Indeed, these works are similar to the pair of very rough works executed at Cap Martin (Plates 40 and 41), in which Monet examined the interaction of sea, rocks, and trees. Here, however, Monet pushes his experiment a step further by reducing the pictorial dialogue to only two elements—the sea and rocks—as he had notably done between 1884 and 1886, during his Belle-Ile campaign. Three of these paintings (Plates 42–44) are virtually identical in composition and format.

The "Big Blue" in Antibes, 1888.

23 ⅜ x 28 ¾ in. (60.5 x 73 cm)

Oeffentliche Kunstsammlung Basel, Kunstmuseum, Dr. h.c. Emile Dreyfus Foundation [W. 1182, Plate 42]

The Sea in Antibes, 1888.

25 ⅝ x 32 ¼ in. (65 x 82 cm)

Von der Heydt-Museum Wuppertal [W. 1183, Plate 43]

The Mediterranean, 1888.

23 ⅞ x 27 ⅝ in. (60.5 x 70 cm)

Private Collection [W. 1184, Plate 44]

The Mediterranean (Cap d'Antibes), 1888.

28 ¾ x 36 ¼ in. (73 x 92 cm)

Columbus Museum of Art, Bequest of Frederick W. Schumacher [W. 1185, Plate 45]

Seashore on the Mediterranean, 1888.

28 ¾ x 36 ¼ in. (73 x 92 cm)

Private Collection [W. 1186, Plate 46]

The Sea and the Alps, 1888.

25 ⅝ x 36 ½ in. (65 x 92.5 cm)

Private Collection, Switzerland [W. 1179, Plate 47]

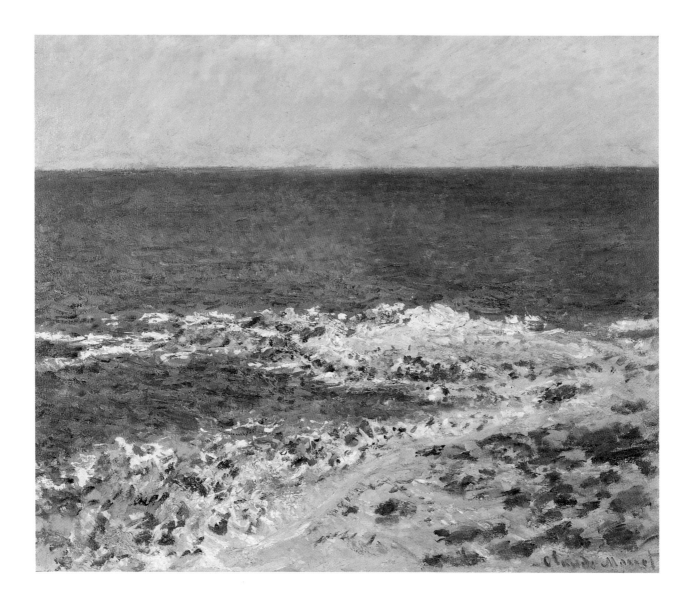

42. The "Big Blue" in Antibes, 1888

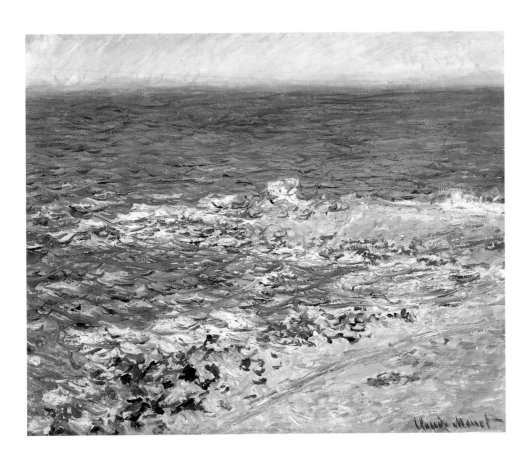

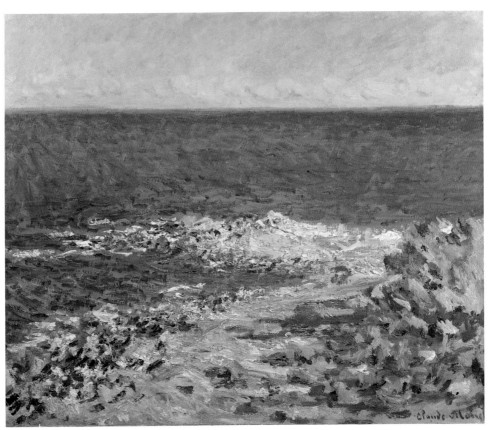

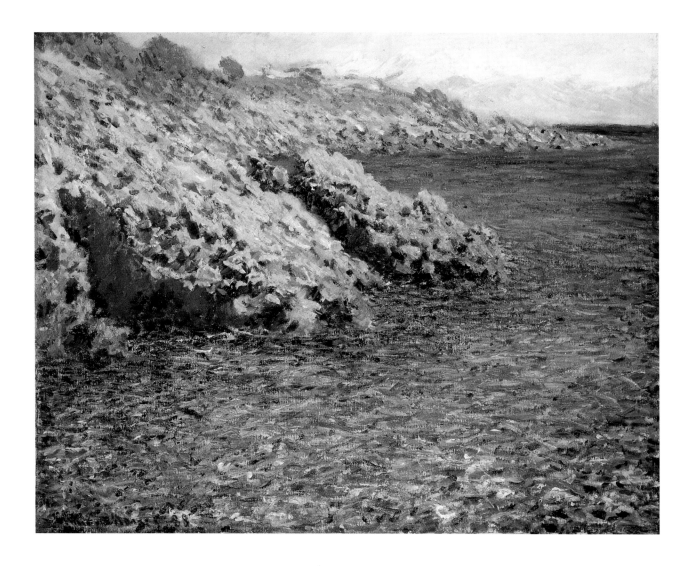

43. The Sea in Antibes, 1888
44. The Mediterranean, 1888
45. The Mediterranean (Cap d'Antibes), 1888

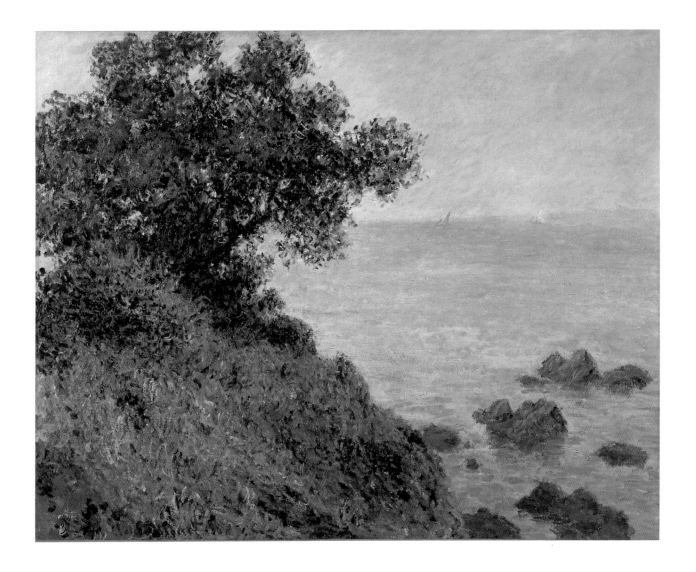

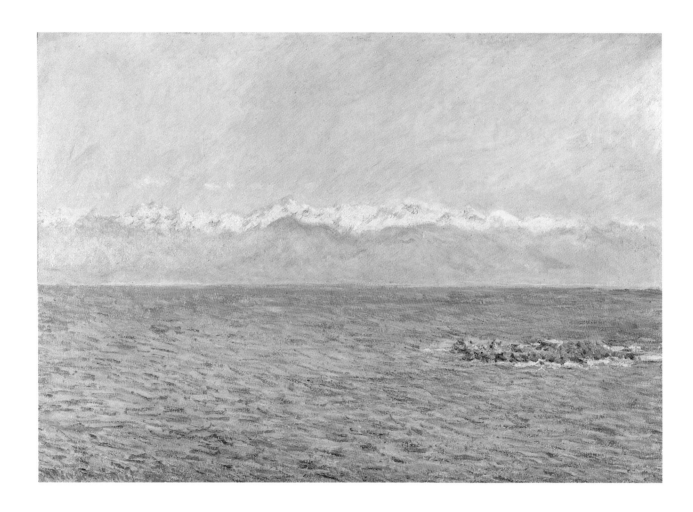

46. Seashore on the Mediterranean, 1888
47. The Sea and the Alps, 1888

The Fort of Antibes and the Bay

Old Fort at Antibes (I), 1888.

26 x 32½ in. (66 x 82.5 cm)

Lent by Museum of Fine Arts, Boston,
Gift of Samuel Dacre Bush 27.1324 [W. 1158, Plate 48]

The Old Fort at Antibes (II), 1888.

25¾ x 32 in. (65.5 x 81 cm)

Museum of Fine Arts, Boston,
Anonymous gift 1978.634 [W. 1161B, Plate 49]

The Castle in Antibes, 1888.

32 x 45⅞ in. (81 x 116 cm)

Private Collection [W. 1163, Plate 50]

Antibes and the Maritime Alps, 1888.

23⅝ x 28¾ in. (60 x 73 cm)

Private Collection, Switzerland [W. 1162, Plate 51]

Antibes, 1888.

25⅝ x 32 in. (65 x 81 cm)

Private Collection [W. 1160, Plate 52]

The Bay of Antibes, 1888.

25⅝ x 32 in. (65 x 81 cm)

Private Collection [W. 1161, Plate 53]

Monet's correspondence with Alice rarely mentions the themes he tackled in Antibes or the order of them. One exception occurs early on, when he describes this motif: "a small fortified town, baked to a golden crust by the sun, standing forth from beautiful blue and pink mountains, and the eternally snow-capped chain of the Alps."[5] Monet also described his difficulties in capturing the widely different effects: "It is so bright, so pure with this pink and blue, that the slightest touch of paint that is not right looks like a stain of dirt."[6] Indeed, the differing effects of this series are dramatic—from the bright picture of a dazzling sea surface painted in turquoise, emerald, and cobalt blue (Plate 48), to a moody picture that seems to have absorbed mud among its pigments (Plate 51).

This group of six works demonstrates that Monet has started to develop his serial procedure into a system: the layout and format are nearly identical in all of these works (Plate 51 is slightly smaller and Plate 50 slightly larger). Yet the variation between these works is considerable. Monet clearly had begun to realize the effect of nonreiterativity as a series of single links on a chain. This series is reduced to the bare essentials: the architecture of the fort, the town of Antibes protruding into the bay, and the Alps. We already saw how present the mountains were in a particular section of the Bordighera campaign (see above, Plates 23–27). Throughout the Antibes campaign, the Alps occupy a prominent place. Distant and yet seemingly tangible, they are a sign of both eternity and, with their ever-changing snow-capped crests, the ephemeral—the two quintessential driving forces of serial practice.

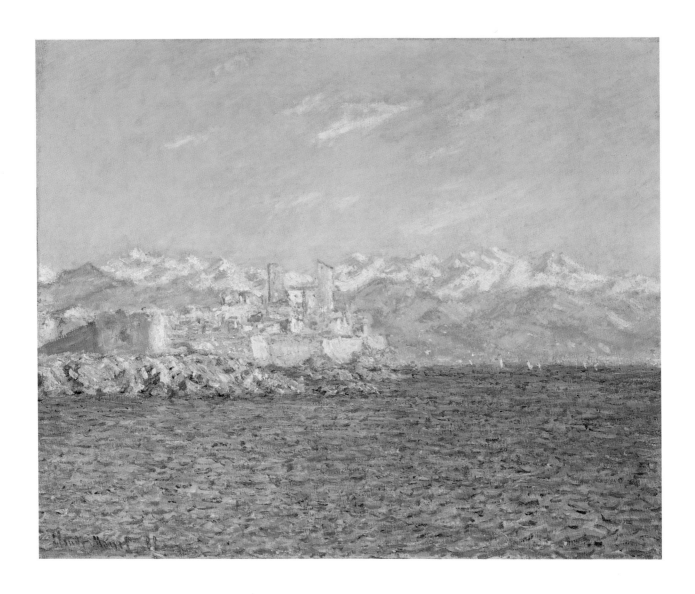

48. Old Fort at Antibes (I), 1888

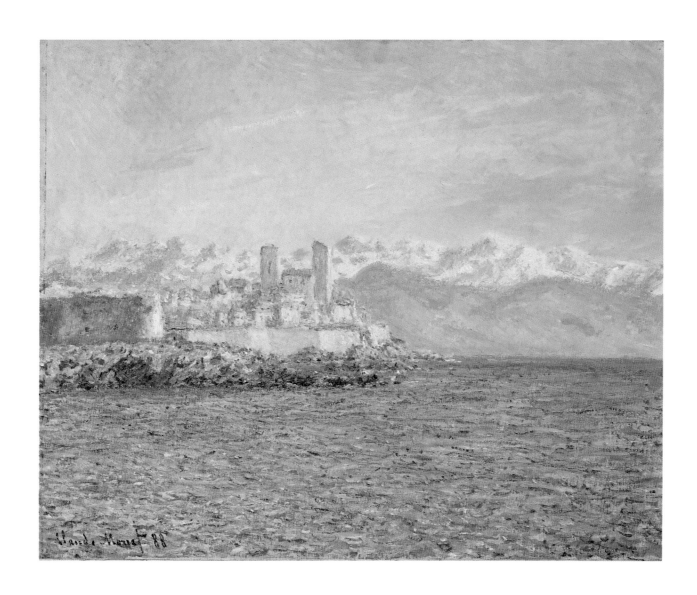

49. The Old Fort at Antibes (II), 1888
50. The Castle in Antibes, 1888
51. Antibes and the Maritime Alps, 1888

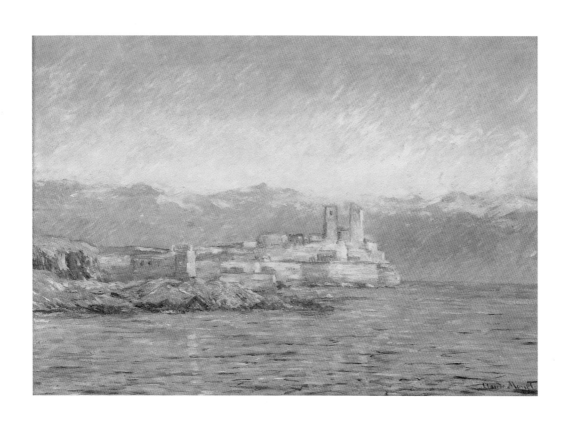

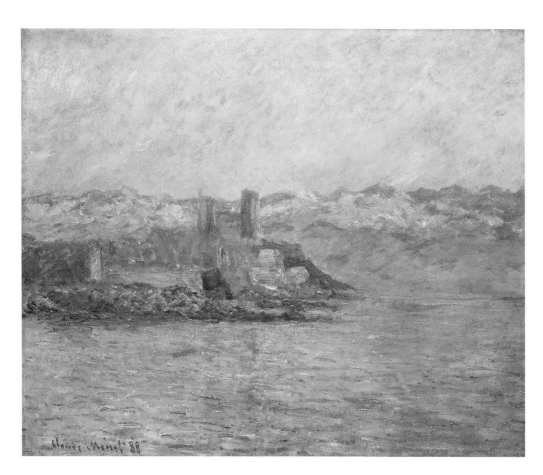

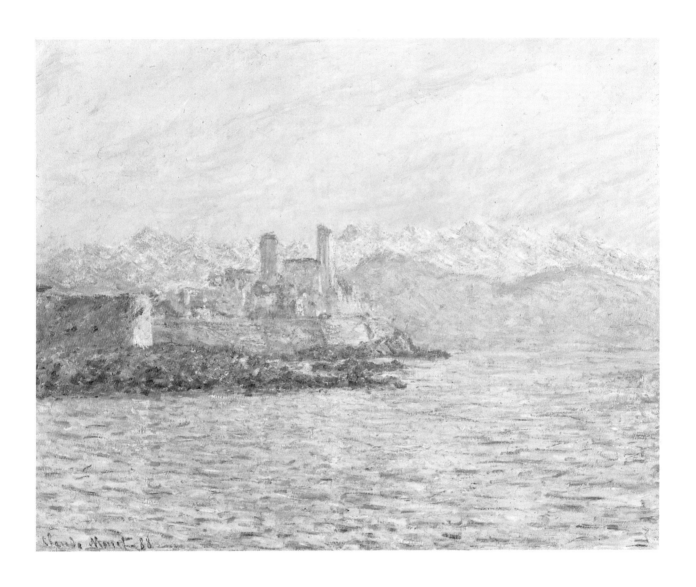

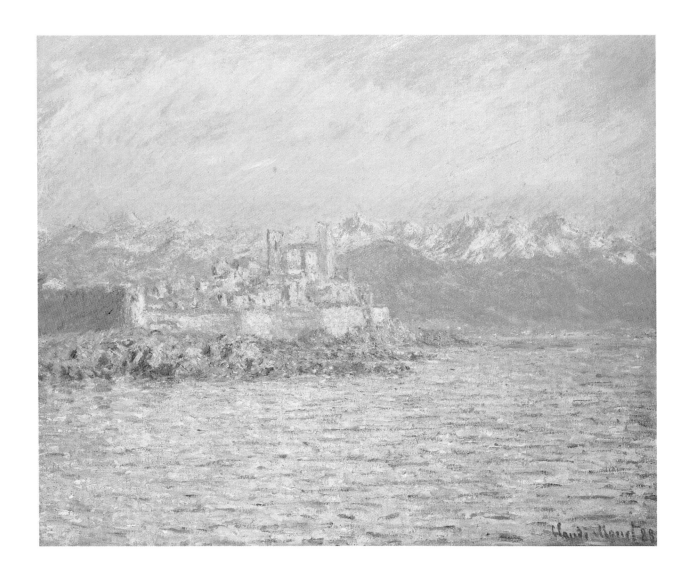

52. Antibes, 1888
53. The Bay of Antibes, 1888

Antibes Seen from La Salis

126 **Antibes Seen from La Salis,** 1888.
25 ⅝ x 36 ¼ in. (65 x 92 cm)
Yasuji Hatano, Tokyo [W. 1167, Plate 54]

Antibes Seen from La Salis, 1888.
28 ⅞ x 36 ¼ in. (73.3 x 92 cm)
*The Toledo Museum of Art, Purchased with
funds from the Libbey Endowment,
Gift of Edward Drummond Libbey [W. 1168, Plate 55]*

Antibes Seen from La Salis, 1888.
25 ⅝ x 36 ¼ in. (65 x 92 cm)
The Wohl Family [W. 1169, Plate 56]

Morning at Antibes, 1888.
25 ⅞ x 32 in. (65.7 x 82.2 cm)
*Philadelphia Museum of Art, Bequest of
Charlotte Dorrance Wright [W. 1170, Plate 57]*

These four works were executed from the so-called Gardens of La Salis, on the edge of the Plateau de la Garoupe.[7] From there, the tower of the Grimaldi Castle once hid the view of Antibes Cathedral, although today the panorama from the site—now a residential housing tract—is dramatically different. Here again, Monet has painted Antibes against the backdrop of the Alps, floating on the Mediterranean. Here, however, the town is framed by a group of trees in the foreground.

Three of the four pictures represent a morning effect (Plates 54, 56, 57): indeed, the group of four works can be ordered according to the progression of hours through the day. In the earliest (Plate 56), the dawn light is still too low to reach the trees, whereas in the next (Plate 54) the tips of the branches and the foliage are starting to be illuminated. The sun is up in the Philadelphia painting (Plate 57) and in the Toledo work (Plate 55) it is clearly afternoon. Although it is interesting to establish the temporal sequence of these works, I do not think this was Monet's chief concern. Rather, it seems that Monet was more intent on studying the plastic and chromatic interactions between the pictorial elements. The series can be divided into two sets: in Plates 54 and 56, the foliage is not yet fully exposed to the sun and is given a particular prevailing color—mauve/purple (in Plate 54) or dark blue-green (in Plate 56)—that gives the rest of the picture a striking visual coherence; in the other two (Plates 55 and 57), there are numerous different hues that interact with each other, accentuating the chromatic contrasts throughout each work. Especially in the Toledo painting, many different pigments (golds, pinks, greens, yellows, and even some blues) are used to create a rich mosaic of colors from which an undeniable sense of unity and cohesion is paradoxically derived. The dominating color of each element finds its echo, less pronounced, in some other element of the picture. There is, for instance, a trace of the golden/pink contrast in the trees repeated in the lit-up facades of the town, and the sides of the buildings in the shade are painted with some of the same pigments found in the sea. Monet's formula was to use endless variations and pictorial contrasts to create rich webs of harmonies, contrasts, and echoes, which these four pictures admirably demonstrate.

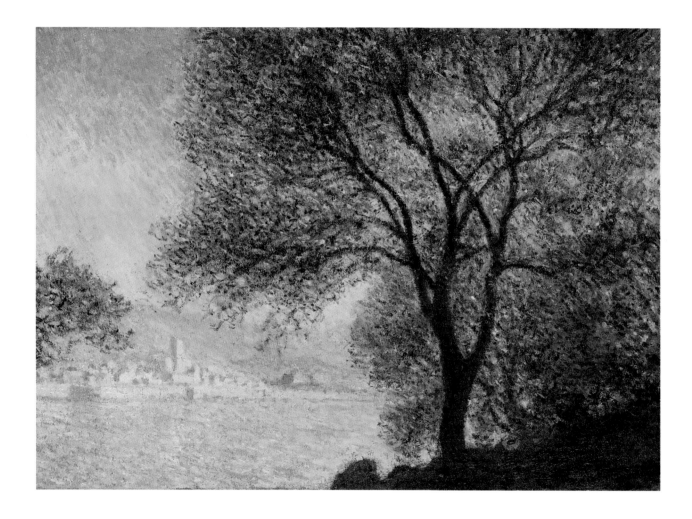

54. Antibes Seen from La Salis, 1888

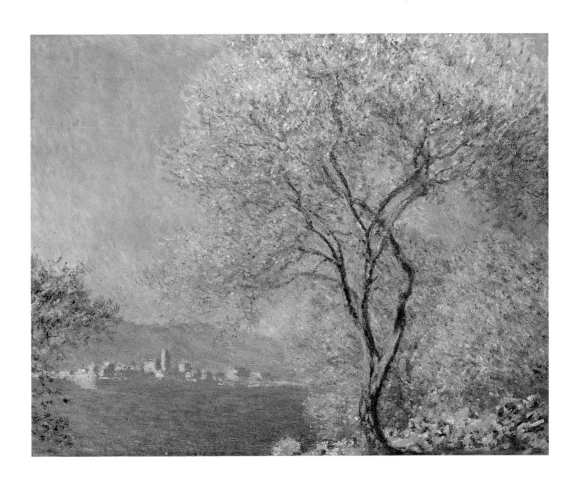

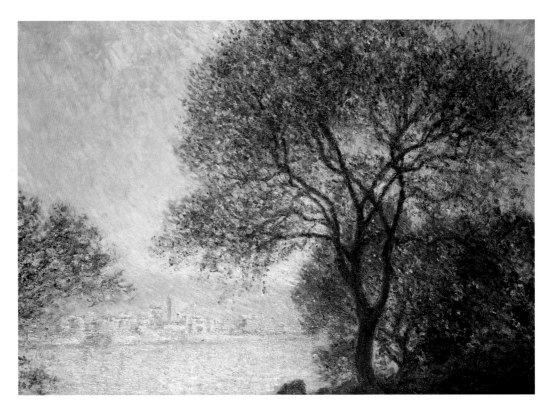

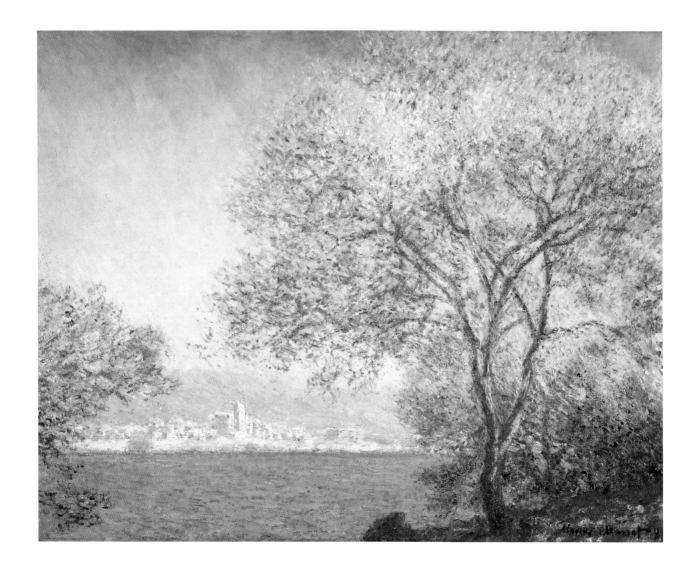

55. Antibes Seen from La Salis, 1888
56. Antibes Seen from La Salis, 1888
57. Morning at Antibes, 1888

The Gardener's House

In this painting the orientation has shifted to the west and the tower of the Antibes Cathedral appears to the left of the Grimaldi Castle. Monet executed a second version of this painting (W. 1166), but its current location is unknown. This view was painted in afternoon light, as was *Antibes Seen from La Salis* (Plate 55). The choice of a conspicuously prosaic motif (a gardener's shed) set against the awesome Alps is provoking, and both recalls *The Valley of Sasso* series, in Bordighera, Plates 10–13, and announces some of the procedures Monet was to use in Venice (for instance, the juxtaposition of the awesome silhouette of Santa Maria della Salute with the lines of *pali*, the mooring poles, in Plates 73–78).

130 **Gardener's House at Antibes,** 1888.

25 ⅝ x 36 ¼ in. (65 x 92 cm)

The Cleveland Museum of Art, Gift of Mr. and Mrs. J. H. Wade, 1916.1044 [W. 1165, Plate 58]

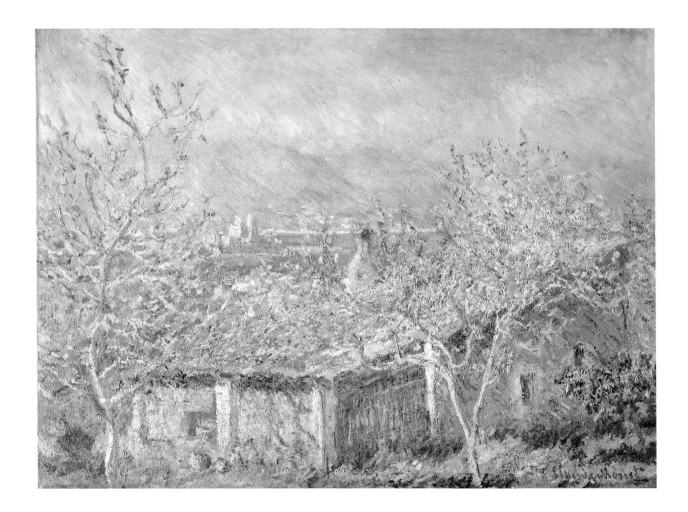

58. Gardener's House at Antibes, 1888

Antibes Seen from Further East

Antibes Seen from the Plateau Notre-Dame, 1888.
25 ⅞ x 32 in. (65.7 x 81.3 cm)

Lent by Museum of Fine Arts, Boston,
Julia Cheney Edwards Collection 39.672 [W. 1172, Plate 59]

Antibes Seen from the Plateau Notre-Dame, 1888.
25 ⅝ x 36 ¼ in. (65 x 92 cm)

Private Collection [W. 1171, Plate 60]

The Gulf of Antibes, 1888.
25 ⅝ x 36 ¼ in. (65 x 92 cm)

Private Collection [W. 1173, Plate 61]

Antibes Seen from the Cape, Mistral Wind, 1888.
25 ⅝ x 32 in. (65 x 81 cm)

The Steven and Dorothea Green Collection
[W. 1174, Plate 62]

On his second sojourn to the Mediterranean, when tackling an identifiable site, Monet resorted to two complementary procedures: he either focused on one given theme to create sets of pictorial variations or he shifted his vantage point laterally to sweep across the horizon line.

The mountains are here given a prominent position. In *Antibes Seen from Plateau Notre-Dame* (Plate 60) especially, they dominate every element of the scenery and seem to dictate the chromatic harmonies and contrasts. The purples, blues, and pinks of the stone, heightened and offset by each other, echo throughout the canvas: they are reiterated in the deep, azurine blue surface of the sea; in a few mauve clouds; in the surface of the ground; and in the quivering blue leaves of the shaded tree. The Boston painting, by comparison, is chromatically much more suffused and discreet.

Shifting his vantage point eastward, Monet then delineated the coast of the Mediterranean facing Antibes (Plates 61 and 62). The artist also suddenly introduced a new element in these two works: the wind. The intense southern mistral bends tree branches and vegetation and sends up choppy whitecaps, as represented in these paintings. Monet's friend, Guy de Maupassant, had recently published a description of his own Mediterranean experiences, and this is how he described the wind:

What a character the wind is to sailors! They talk about it as of a man, of an all-powerful ruler, sometimes terrible, sometimes charitable. . . . It is we who know him better than our fathers and our mothers, this terrible, invisible, changeable, cunning, treacherous, ferocious person. We love him and we fear him, we know his tricks and his rages, which the signs in the sky and the sea slowly teach us to forecast.[8]

More than any other painter, Monet understood these sensations of the wind in the south of France. Like Maupassant, he knew that the mistral imposes on all "the mysterious, religious, never-ending fear of the wind, and respect for its power." In *Antibes Seen from the Cape, Mistral Wind* (Plate 62), Monet created a veritable portrait of that power.

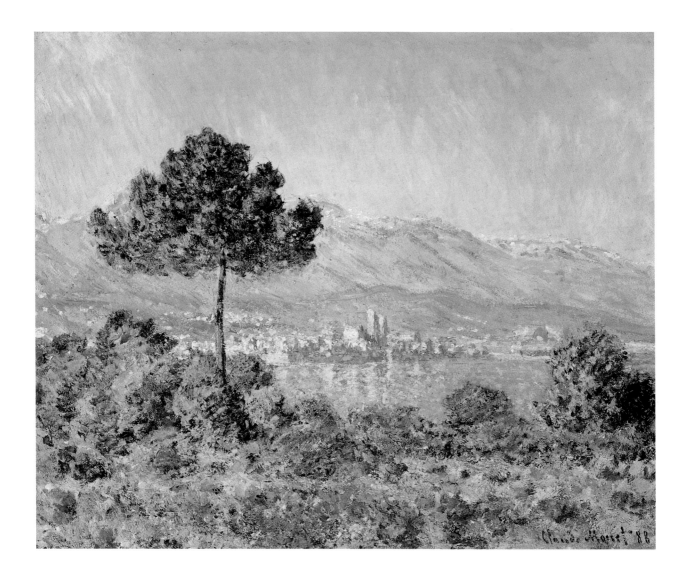

59. Antibes Seen from the Plateau Notre-Dame, 1888

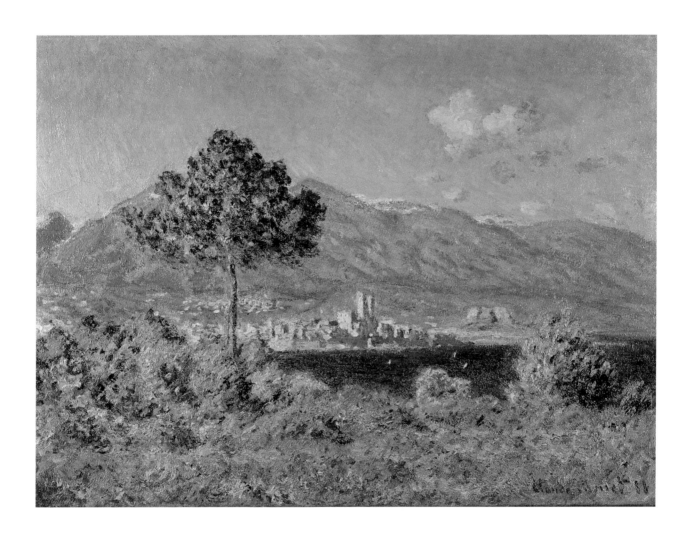

60. Antibes Seen from the Plateau Notre-Dame, 1888
61. The Gulf of Antibes, 1888
62. Antibes Seen from the Cape, Mistral Wind, 1888

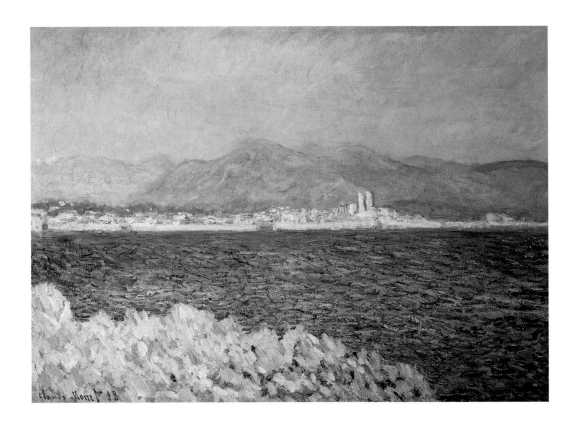

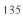

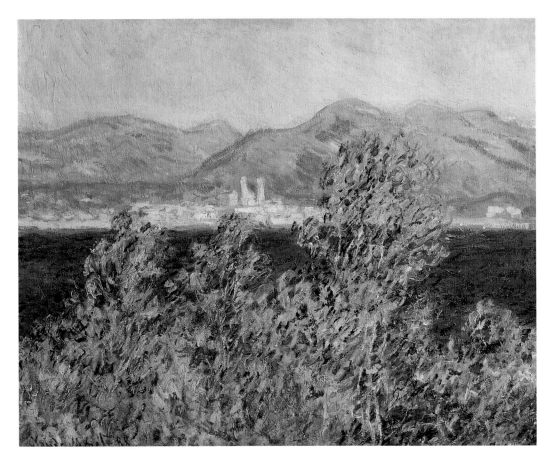

Further Outside Antibes

In this group of three works, Monet shifts his vantage point, moving further east, losing sight altogether of the town of Antibes. These works are remarkably similar in size, format, composition, and definition of the motifs. While the Hill-Stead painting (Plate 63) represents the vegetation, the mountains, and the sea with equal intensity, the other two paintings give preeminence to one element over another. In the Boston painting, where the mistral-blown vegetation again animates the scene, the mountains in the background look almost as though they have been effaced. These same mountains regain their presence in *The Alps Seen from Cap d'Antibes* (Plate 65). The pink shades of the mountainside are echoed in the trees and grass in the foreground; the pale sea, on the other hand, appears weakened by this set of chromatic rhymes.

136 **View of the Bay and Maritime Alps at Antibes**, 1888.

25 x 31 in. (63.5 x 78.7 cm)

Hill-Stead Museum, Farmington, Conn. [W. 1175, Plate 63]

Cap d'Antibes, Mistral, 1888.

26 x 32 in. (66 x 81.3 cm)

Lent by Museum of Fine Arts, Boston,
Bequest of Arthur Tracy Cabot 45.542 [W. 1176, Plate 64]

The Alps Seen from Cap d'Antibes, 1888.

25⅝ x 32 in. (65 x 81 cm)

Private Collection, Courtesy Galerie Schmit, Paris
[W. 1177, Plate 65]

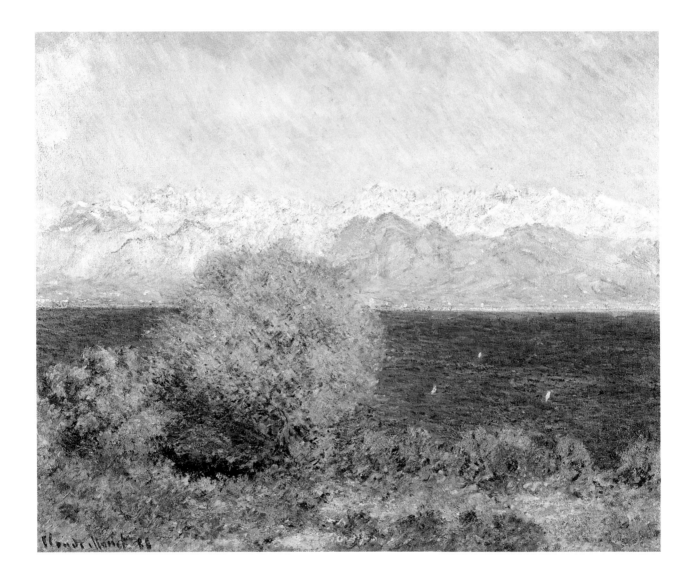

63. View of the Bay and Maritime Alps at Antibes, 1888

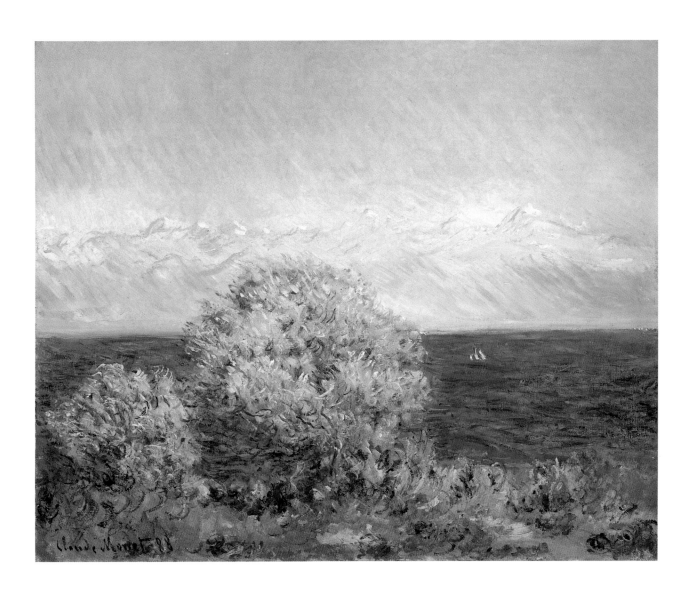

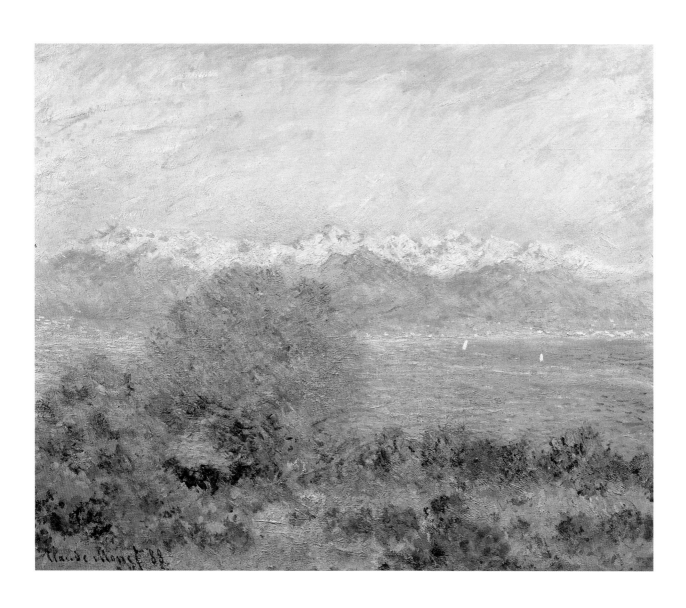

64. Cap d'Antibes, Mistral, 1888
65. The Alps Seen from Cap d'Antibes, 1888

Trees and the Sea

Beach in Juan-les-Pins, 1888.
 28¾ x 36¼ in. (73 x 92 cm)
 Acquavella Galleries, Inc. [W. 1187, Plate 66]

Trees by the Seashore, Antibes, 1888.
 28¾ x 36¼ in. (73 x 92 cm)
 Private Collection [W. 1188, Plate 67]

140

Juan-les-Pins, 1888.
 28¾ x 36¼ in. (73 x 92 cm)
 Private Collection [W. 1189, Plate 68]

Pine Trees, Cap d'Antibes, 1888.
 28¾ x 36¼ in. (73 x 92 cm)
 Private Collection [W. 1190, Plate 69]

Under the Pine Trees, Evening, 1888.
 28¾ x 36¼ in. (73 x 92 cm)
 *Philadelphia Museum of Art, Gift of F. Otto Haas
 [W. 1191, Plate 70]*

Antibes, 1888.
 25¾ x 36⅜ in. (65.5 x 92.4 cm)
 *Courtauld Institute Galleries, London,
 The Samuel Courtauld Trust [W. 1192, Plate 71]*

At Cap d'Antibes, 1888.
 25⅝ x 36¼ in. (65 x 92 cm)
 Private Collection [W. 1193, Plate 72]

These seven works are undoubtedly some of the most powerful and resonant that Monet painted by the Mediterranean. They are bound more by their subject—pine trees on a beach—than by their setting. Indeed, the setting varies: the first subgroup (Plates 66–68) portrays a grove of trees on the beach of Juan-les-Pins, not far from the Chateau de La Pinède, where Monet stayed. A second group (Plates 69 and 70) represents the grove that at the time extended from the end of Golfe Juan to Cap d'Antibes; it no longer exists. The last two works (Plates 71 and 72) were also painted near La Pinède, the location being recognizable by the distinctive crestline of the Alps in the background.

The whole group possesses a uniquely systematic structure, not unlike the composition of a poem or sonnet: there are two pairs of two paintings (Plates 67 and 68 and 69 and 70) plus one on its own (Plate 66) that depict several trees, and finally a pair of paintings that depict single trees. Again, Monet's serial procedure is evident. Each pair of paintings (67–68 and 69–70) depicts a group of trees in almost identical arrangements, and all five works depicting an arrangement of several trees are of the same size (73 x 92 cm). The pair of works depicting a single tree (71–72) are also the same size (65 x 92 cm). Thus this group demonstrates a uniquely cohesive plan; the works could not be separated from one another any more than the lines of a poem could be. With seven paintings, distributed into three pairs of almost identical motifs plus one motif on its own, the structure of the group follows this rhythm: a-a / b-b / c d-d. This offers an interesting analogy with the basic structure of a quatrain and a tercet in a sonnet. Whether Monet had the sonnet structure in mind when he painted this series or not, his close relationship with Mallarmé sheds revealing light on this impressive group of works.

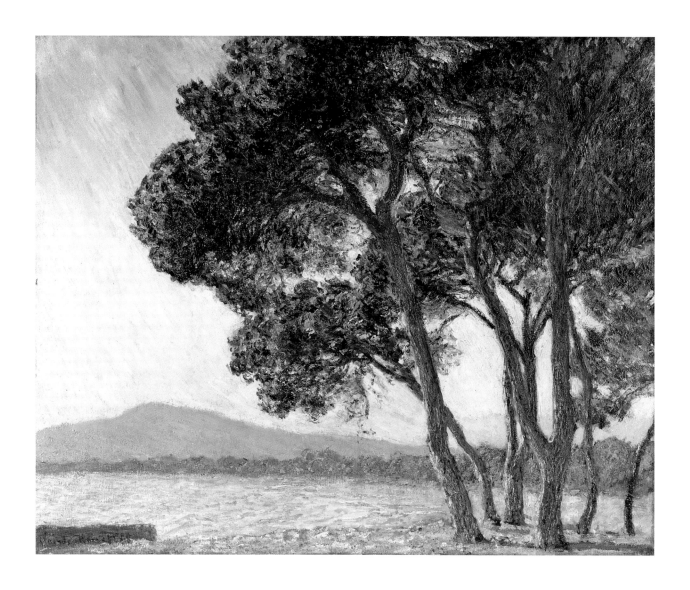

66. Beach in Juan-les-Pins, 1888

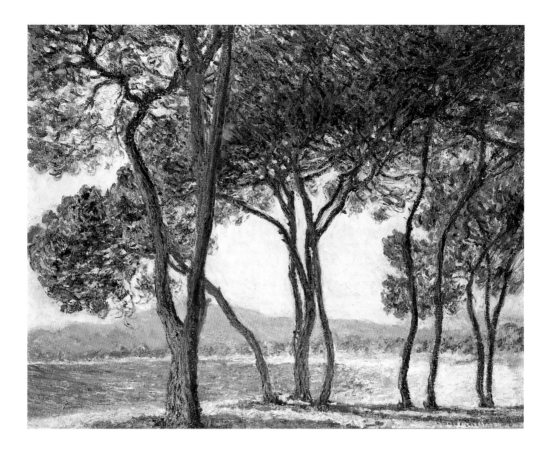

142

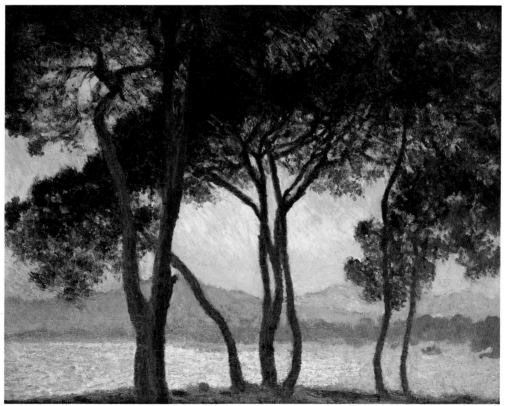

67. Trees by the Seashore, Antibes, 1888
68. Juan-les-Pins, 1888

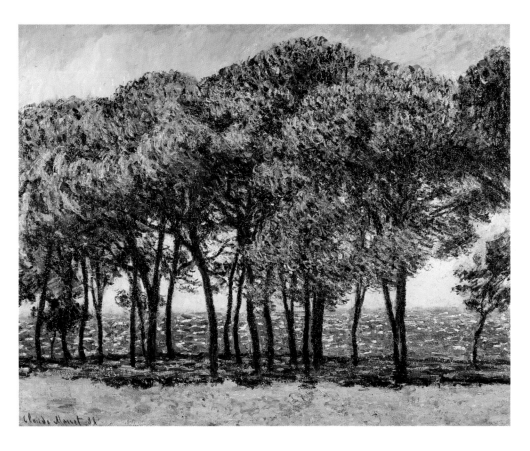

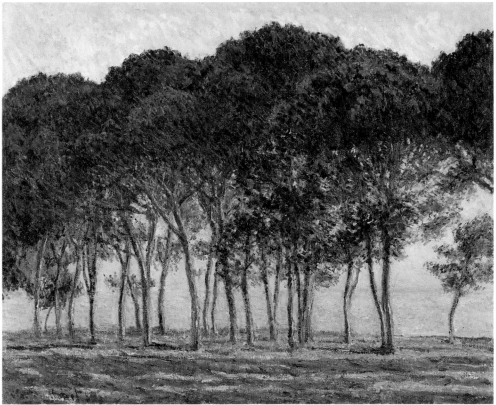

69. Pine Trees, Cap d'Antibes, 1888
70. Under the Pine Trees, Evening, 1888

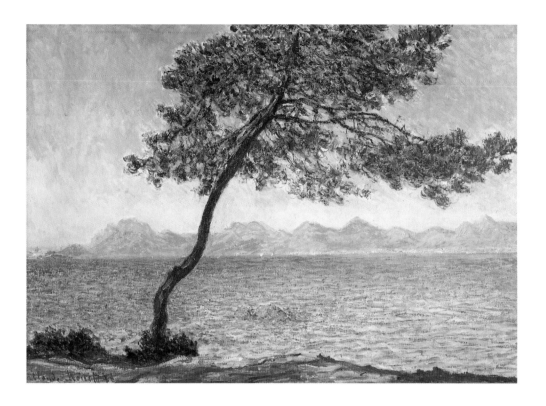

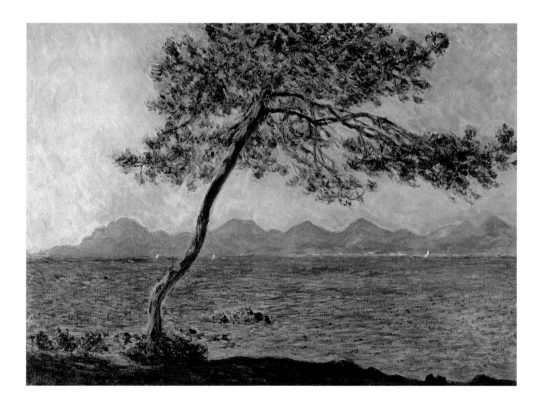

71. Antibes, 1888
72. At Cap d'Antibes, 1888

The Grand Canal

The Grand Canal, 1908.

28¾ x 36¼ in. (73 x 92 cm)

Lent by Museum of Fine Arts, Boston,
Bequest of Alexander Cochrane 19.171 [W. 1738, Plate 73]

The Grand Canal and Santa Maria della Salute, 1908.

28¾ x 36¼ in. (73 x 92 cm)

Private Collection [W. 1740, Plate 74]

The Grand Canal, Venice, 1908.

28¾ x 36¼ in. (73 x 92 cm)

The Fine Arts Museums of San Francisco,
Gift of Osgood Hooker, 1960.29 [W. 1736, Plate 75]

The Grand Canal, 1908.

28¾ x 36¼ in. (73 x 92 cm)

Private Collection [W. 1737, Plate 76]

The Grand Canal, 1908.

32 x 36⅜ in. (81.2 x 92.4 cm)

Private Collection, Tokyo [W. 1741, Plate 77]

The Grand Canal, 1908.

28¾ x 36¼ in. (73 x 92 cm)

Private Collection [W. 1739, Plate 78]

More than twenty years after returning to Giverny from the Mediterranean shores of Antibes, Monet traveled for the last time to the Mediterranean world, to visit Venice. Although the landscape on the shores of the Adriatic was considerably different from the landscape he had experienced on the Ligurian shores in his two previous trips to the Mediterranean, these places were linked together for him, emotionally, pictorially, and even formally. When one compares this group of six views of Santa Maria della Salute to the last group of pine trees in Juan-les-Pins (Plates 66–72), it is clear that Monet has used a similar compositional device: a set of vertical axes (trees or *pali*—vertical wooden poles, where the gondolas are moored) establish a link between what can be seen across the sea and the viewer's vantage point. In fact, *Beach in Juan-les-Pins* (Plate 66) is almost a mirror image of these Venetian views; its pine trees form a dancing rhythm at the right of the composition, whereas in these representations of the Grand Canal, the *pali* are pushed to the left.

This is unquestionably one of Monet's most systematic series. The six canvases are almost exactly the same dimensions (73 x 92 cm); the layout of the motif is virtually identical in all, and each of the canvases was painted at the same time of day, probably in the afternoon. The fact that Monet chose to represent the tide changes that cover and uncover the steps of the Palazzo Barbaro-Curtis is not incidental: Monet deliberately emphasizes that we are on the sea ("his element"), not on fresh water. Establishing in advance the conditions of observation and the context of his experimentation, Monet used Venice as another pictorial laboratory, gauging changes in the "envelope" (the indefinable Venetian "haze") under identical circumstances. There are two typically Venetian effects that animate these views of Santa Maria della Salute: the filtering haze either heightens the colors of the prism, almost setting them alight, or, on the contrary, it dampens them and unites them in a sort of muffled monotonous harmony. In the first group of works are Plates 73, 74, and 75; while the other group includes Plates 76, 77, and 78. If the first group displays incandescent tonalities, the second resorts to more evanescent tones, stressing the diaphanous quality of the air in Venice and heightening its rather monochromatic impact. In the 1912 *Venise* exhibition at Bernheim-Jeune's, Monet chose to hang these works by balancing each painting from the first group with one from the second.

146

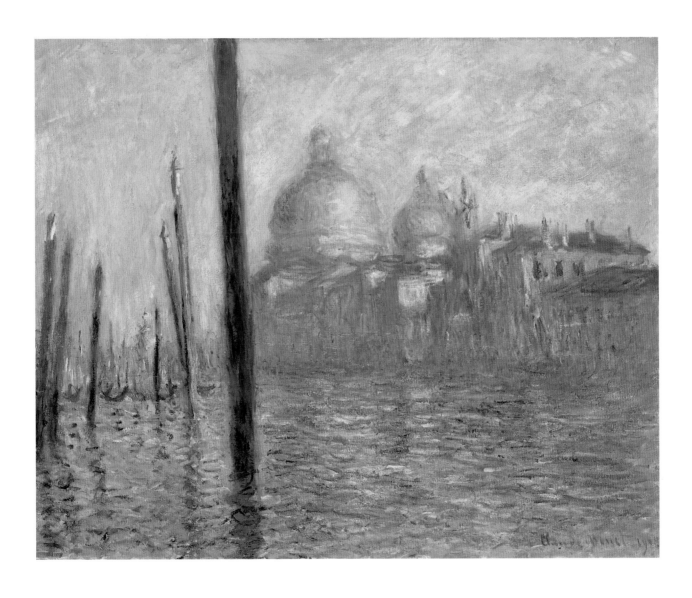

73. The Grand Canal, 1908

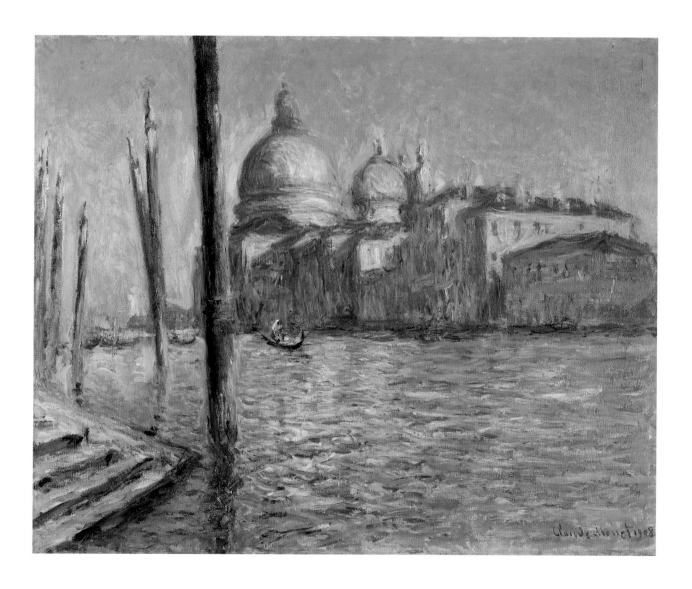

148

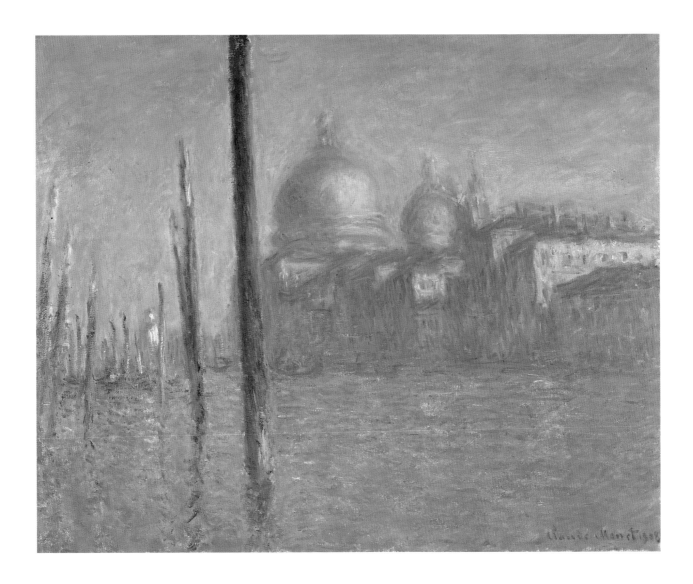

74. The Grand Canal and Santa Maria della Salute, 1908
75. The Grand Canal, Venice, 1908

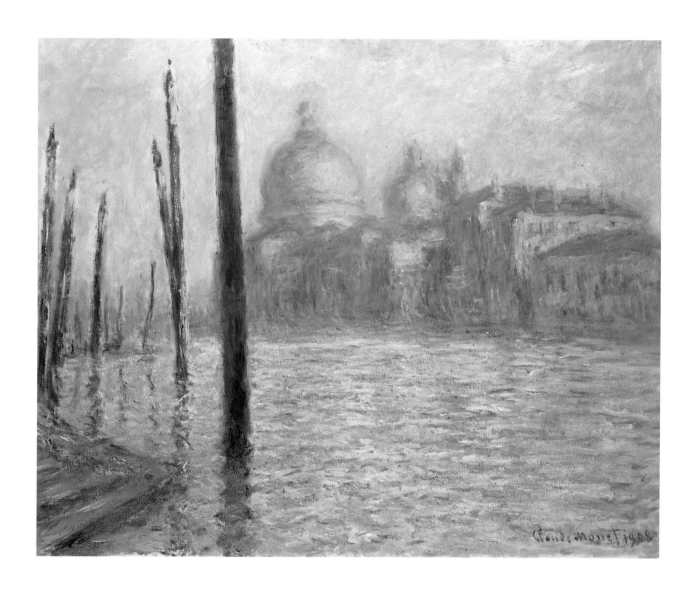

76. The Grand Canal, 1908
77. The Grand Canal, 1908
78. The Grand Canal, 1908

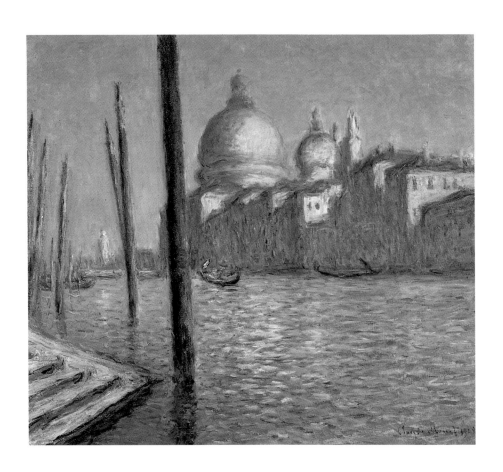

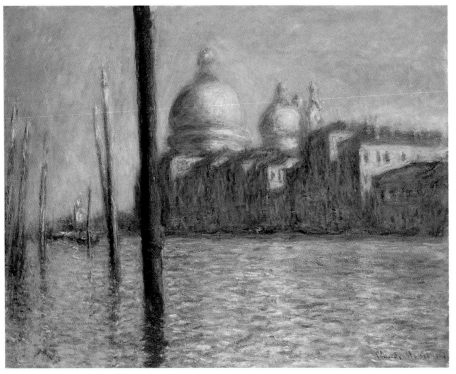

The Doges' Palace Seen from San Giorgio Maggiore

The Doges' Palace Seen from San Giorgio Maggiore, 1908.
25 ⅝ x 39 ⅜ in. (65 x 100 cm)
Kunsthaus Zurich, Donation Walter Haefner
[W. 1751, Plate 79]

The Doges' Palace Seen from San Giorgio Maggiore, 1908.
25 ⅝ x 39 ⅜ in. (65 x 100 cm)
Private Collection [W. 1752, Plate 80]

152

The Doges' Palace Seen from San Giorgio Maggiore, 1908.
25 ¾ x 36 ¼ in. (65.5 x 92 cm)
Picture perished in fire [W. 1753, Plate 81]

The Doges' Palace Seen from San Giorgio Maggiore, 1908.
25 ⅝ x 39 ⅜ in. (65 x 100 cm)
Solomon R. Guggenheim Museum, New York,
Thannhauser Collection, Bequest of Hilde Thannhauser, 1991.
[W. 1756, Plate 82]

Venice: The Doges' Palace Seen from San Giorgio Maggiore, 1908.
25 ¾ x 36 ½ in. (65.4 x 92.7 cm)
Lent by The Metropolitan Museum of Art, New York,
Gift of Mr. and Mrs. Charles S. McVeigh, 1959 (59.188.1)
[W. 1755, Plate 83]

The Doges' Palace, 1908.
22 ½ x 36 ¼ in. (57 x 92 cm)
Private Collection [W. 1770, Plate 84]

This series is the counterpart of the *San Giorgio* series (Plates 87–90) in that it is structured around the mirror image of the group of views of San Giorgio: this view of the Doges' Palace seen from the west end of the island of San Giorgio departs from the more "picturesque" views that inspired the *San Giorgio* series. Here, it is difficult to recognize the details of what is represented. Instead, Monet seems to be interested mainly in the interplay of light, reflections, quivering tremors of the waves of the canal, and, of course, the eternal Venetian haze. The abundance of architectural details that one tends to expect in views of Venice has been somewhat underplayed here, although it has not quite disappeared; it is still possible to recognize the main features of each landmark. Monet's intention is clear: he is de-pictorializing Venice. Venice, the Doges' city, is of no topographical or sentimental interest. Its architectural integrity is of no more or less importance than other pictorial components, such as the haze, the water surface, or the sky. Consider, for instance, the Guggenheim painting (Plate 82): the facades of the Doges' Palace and all of its adjacent buildings are made of the same pigments that make up the water surface and the sky. The resulting impression is that the whole of this reality is almost ethereal—half real, half unreal. But Monet is not a surrealist: this animated fresco, resplendent with contrasts of blues and golds, in which the facade of the Doges' Palace is caught between sky and water, is not enough for Monet: the representation of the real remains unchallenged—hence, the need for the rich, dense, cooling surface of the prominent platform—so odd and empty—which anchors our gaze back on a solid base.

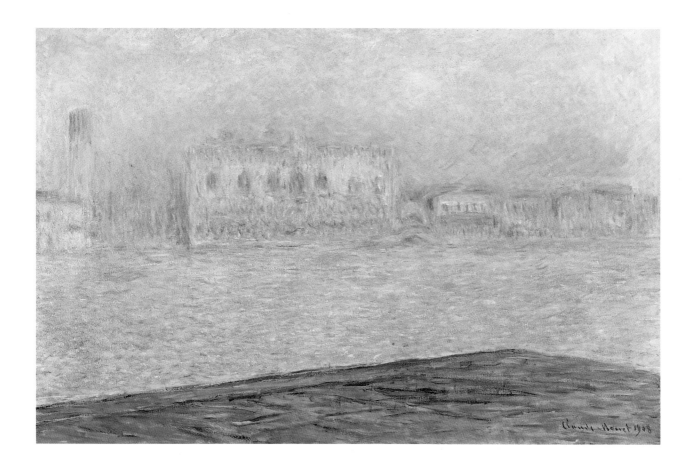

79. The Doges' Palace Seen from San Giorgio Maggiore, 1908

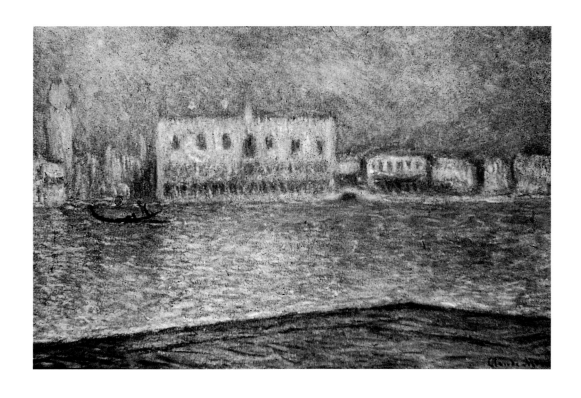

154

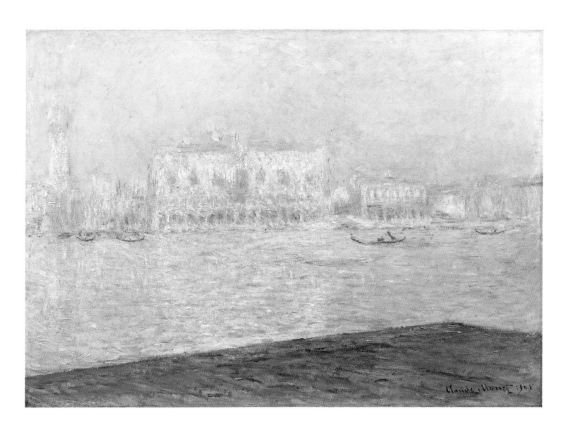

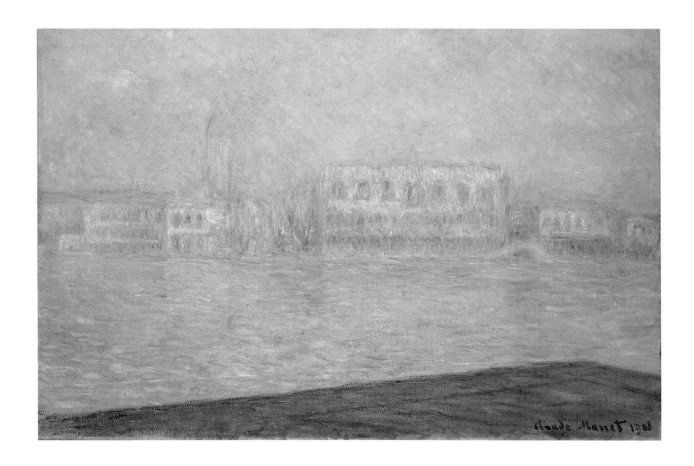

80. The Doges' Palace Seen from San Giorgio Maggiore, 1908
81. The Doges' Palace Seen from San Giorgio Maggiore, 1908
82. The Doges' Palace Seen from San Giorgio Maggiore, 1908

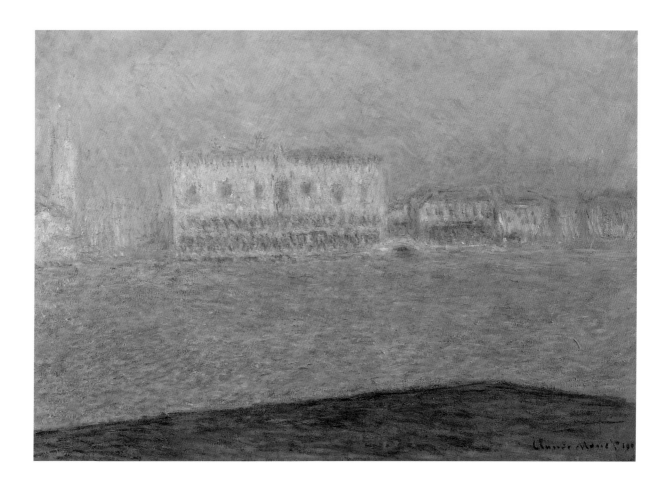

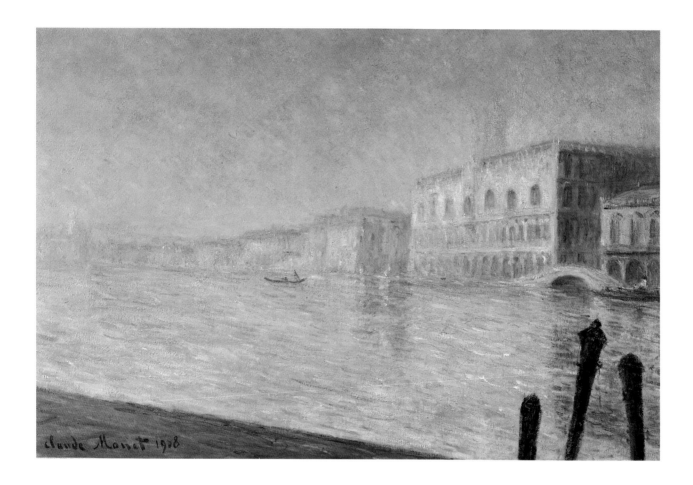

83. Venice: The Doges' Palace Seen from San Giorgio Maggiore, 1908
84. The Doges' Palace, 1908

The Doges' Palace (Close Up)

Monet never spared any effort to create a series of works once he had a concept in mind. Here, Monet painted his subject from a gondola moored in the middle of the canal to obtain the more dramatic close-up effect he desired. One can imagine the difficulties required in having the gondolier resume the same position every day, so that the layout in each painting would be identical. Occasionally, Monet had to give up a whole session because they could not find the right spot. It is extraordinary that under these circumstances Monet was able to achieve as many as three of these compositions.[9] Here, as with the group of views of Santa Maria della Salute, one version is emphatically polychromatic (Plate 86), while the other resorts to a much more subdued and harmonious palette (Plate 85).

158 **The Doges' Palace**, 1908.

28¾ x 36⅓ in. (73 x 92 cm)

Mr. and Mrs. Herbert Klapper [W. 1742, Plate 85]

The Doges' Palace in Venice, 1908.

32 x 39⅝ in. (81.2 x 100.5 cm)

Brooklyn Museum of Art, Gift of A. Augustus Healy 20.634 [W. 1743, Plate 86]

VENICE, OCTOBER–DECEMBER 1908

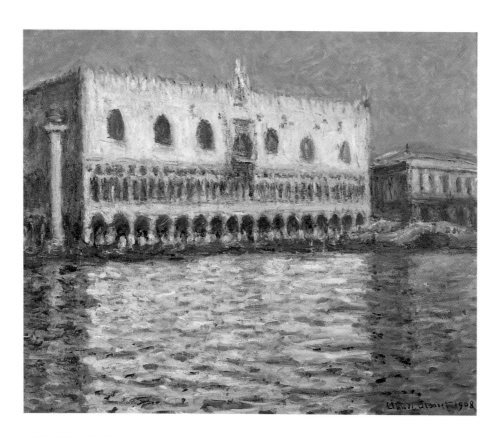

159

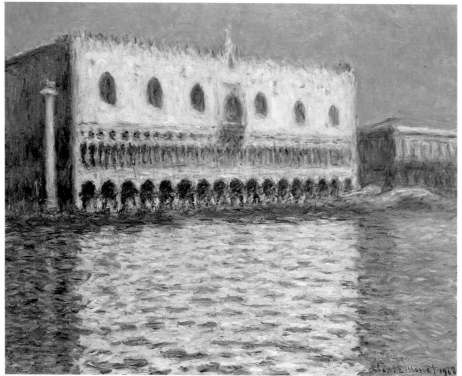

85. The Doges' Palace, 1908
86. The Doges' Palace in Venice, 1908

San Giorgio Maggiore

San Giorgio Maggiore, 1908.

23 ⅜ x 31 ½ in. (60 x 80 cm)

National Museum and Gallery of Wales, Cardiff
[W. 1747, Plate 87]

San Giorgio Maggiore, 1908.

25 ⅝ x 36 ¼ in. (65 x 92 cm)

Private Collection [W. 1748, Plate 88]

San Giorgio Maggiore, 1908.

23 ⅝ x 28 ¾ in. (60 x 73 cm)

Collection of Alice F. Mason, New York [W. 1746, Plate 89]

San Giorgio Maggiore, 1908.

25 ½ x 36 ¼ in. (64.8 x 92 cm)

Indianapolis Museum of Art, The Lockton Collection
[W. 1749, Plate 90]

Monet set up a system of spectacular representations of Venice that intertwined with each other. Monet painted a motif from a particular site and then painted the site from which he had painted the first motif. It is actually impossible to define which series came first: probably both the views of San Giorgio Maggiore and those of the Doges' Palace were developed at the same time. The result is that the two perspectives echo and reverberate. It is difficult to determine exactly the point of observation from which Monet executed these six views.[10] He may very well have painted them without leaving the Hotel Britannia, where he and Alice stayed subsequent to their time at Mrs. Daniel Curtis's palazzo. Monet focused first on one side, then on the other, of the vast Canal, linking the two sides pictorially. This procedure had already been put into practice in Bordighera and Antibes, where the artist would tend to immerse himself in his subject, and would create chains of interrelated motifs that would, as it were, call each other, almost like the sequences of a film. This practice was later developed while working in his new studio in Giverny. In Venice, every facet of the section of the city that caught his imagination gave way to a new series that reflected another.

This group of views of San Giorgio all depict the church on its island exposed under an afternoon effect. Here, the concept that appears to have kindled Monet's serial imagination is one of creating a subtle melodious progression, based on a bitonal opposition of blue-purples versus orange-red hues. The chain begins with Plate 88, with its cold blend of mauve-purple blues, and ends with Plate 89, with its warmer gold-orange-red harmonies. Between these extremes, one can place Plate 87 on the cooler side of the chain and Plate 90 on the warmer side.

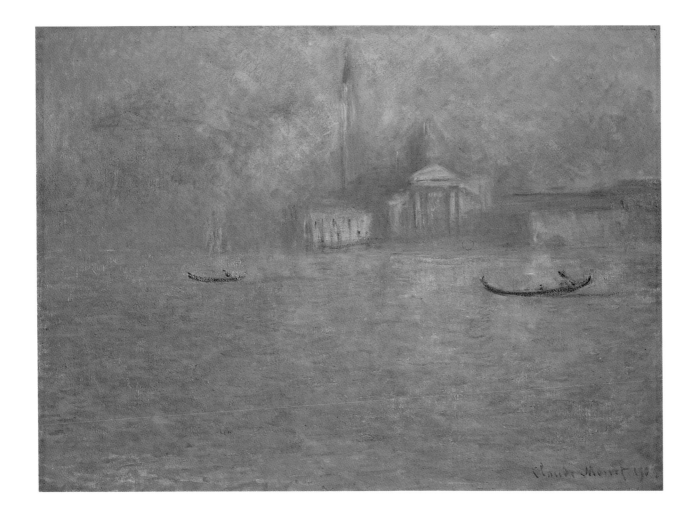

87. San Giorgio Maggiore, 1908

162

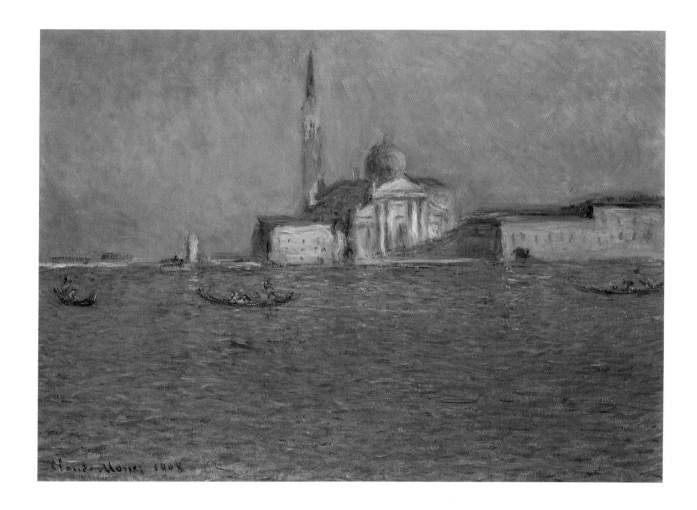

88. San Giorgio Maggiore, 1908

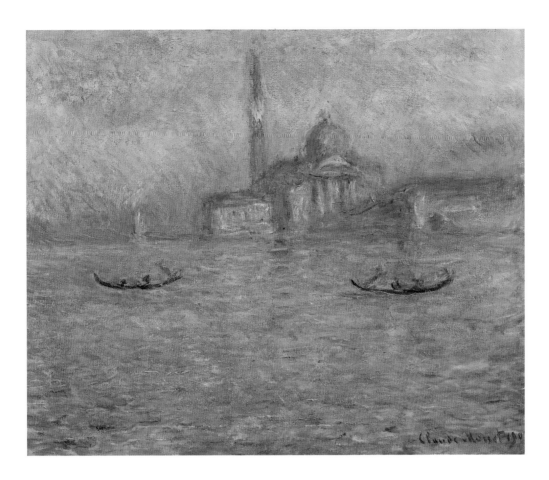

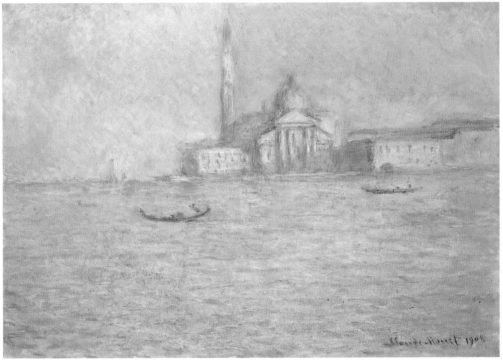

89. San Giorgio Maggiore, 1908
90. San Giorgio Maggiore, 1908

The Palazzi

Palazzo Dario, 1908.

32 x 26 in. (81 x 66 cm)

Private Collection [W. 1758, Plate 91]

Palazzo Dario, 1908.

36 ¼ x 28 ¾ in. (92 x 73 cm)

The National Museum and Gallery of Wales, Cardiff [W. 1759, Plate 92]

Palazzo Dario, 1908.

25 ½ x 31 ⅞ in. (64.8 x 80.7 cm)

The Art Institute of Chicago, Mr. and Mrs. Lewis Larned Coburn Memorial Collection, 1933.446. [W. 1757, Plate 93]

Palazzo Dario, 1908.

22 ⅛ x 25 ⅝ in. (56 x 65 cm)

Drue Heinz [W. 1760, Plate 94]

Palazzo Contarini, 1908.

28 ¾ x 36 ¼ in. (73 x 92 cm)

Private Collection [W. 1766, Plate 95]

Palazzo Contarini, 1908.

36 ¼ x 32 in. (92 x 81 cm)

Kunstmuseum Saint Gallen, acquired by the Ernst Schürpf Foundation [W. 1767, Plate 96]

Palazzo da Mula, 1908.

24 ½ x 32 in. (62 x 81 cm)

National Gallery of Art, Washington, Chester Dale Collection [W. 1764, Plate 97]

Palazzo da Mula, 1908.

25 ⅝ x 36 ¼ in. (65 x 92 cm)

Private Collection [W. 1765, Plate 98]

These eight views of various Venetian palaces constitute the largest ensemble of pictures by Monet on a given theme, even though it can be argued that these comprise three subseries (four of the famous Dario, two of the Contarini, and two of the da Mula). The series as a whole is not only very imposing but it also goes further than any other pictures Monet did in Venice in reversing the Venetian pictorial tradition. These paintings are absolute antitheses to the Vedutist seascape tradition. The sky, the horizon line, and the architectural details of these splendid dwellings are reduced to two or three elements: the facade of a palazzo, the water surface, and, in all but two pictures (Plate 97 and 98), a sliver of sky. Most noteworthy, however, is the fact that the facade is no more important than the water surface that sustains it. The result is sober and overwhelming. Each "effect" or representation is surprisingly close to the other; the range of pigments is quite limited. Yet Monet performs a sort of pictorial dance, where every step, though different from the previous one, is also dependent upon it and resembles it. This series offers a rich display of subtle pictorial nuances.

Even more so than in other series executed in Venice, here every variation counts, since the pictorial components have been so drastically reduced. Monet therefore used the format of his canvases to inject a certain variety: only two Dario paintings (Plates 93 and 91) are of nearly the same size, but even in that case one is horizontal and the other vertical; the two Contarini pictures are of different formats (the vertical one is the sublime Saint Gallen picture, which is the largest of the Palazzi series); and the two Palazzo da Mula paintings are both horizontal, although also of different sizes.

In all likelihood, Monet found a certain kinship between the very ornate facades of the palazzi and his own manner of painting. The richly decorated Palazzo Dario facade, for instance, shone with encrusted gems and could not help but suggest to Monet the metaphors of sparkling diamond and the glitter of gold used by critics of his work in Antibes to suggest the richness of his Mediterranean views. (He was referred to by Camille Mauclair as "the jewel-setter of emerald seas within strands of gold."[11]) Monet had no interest in "imitating" the glorious aspects of these rich facades; his goal was to rival them pictorially, to create an image in pigment that would be as rich as the facades were in stone. This was perhaps Monet's ultimate challenge while in Venice.

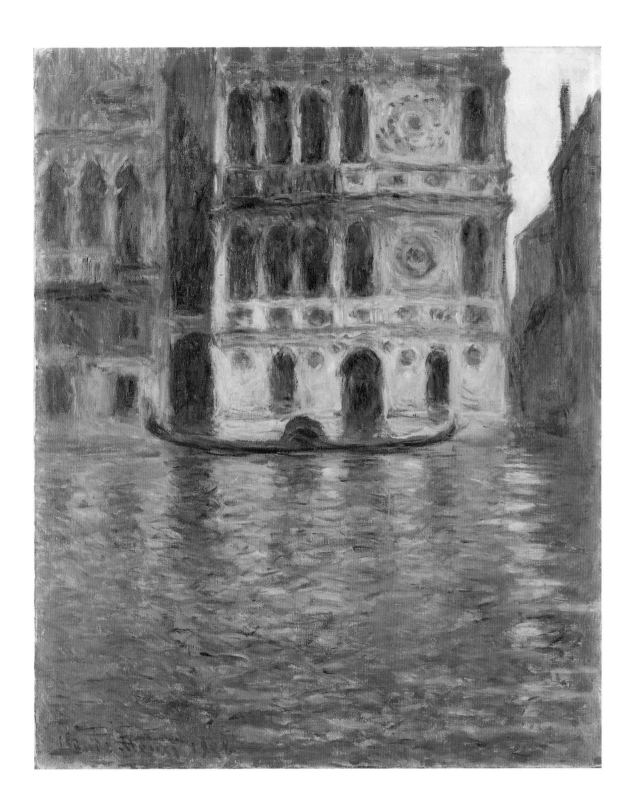

91. Palazzo Dario, 1908

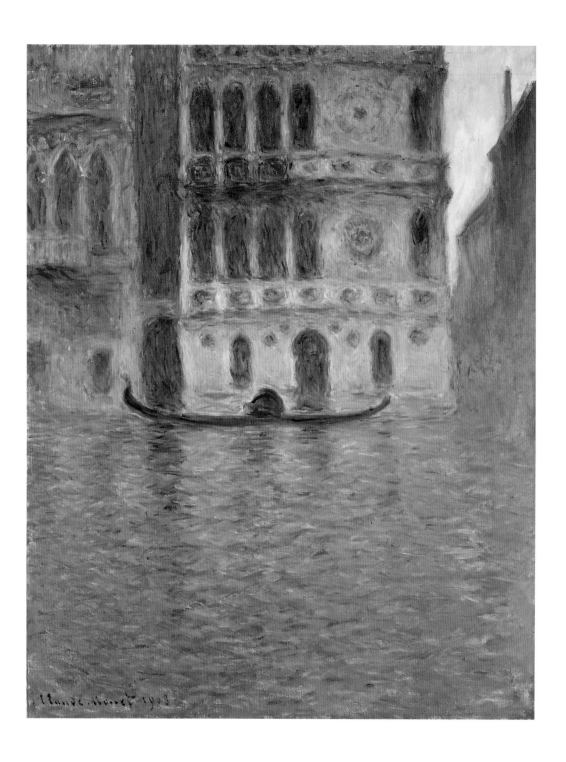

92. Palazzo Dario, 1908
93. Palazzo Dario, 1908
94. Palazzo Dario, 1908

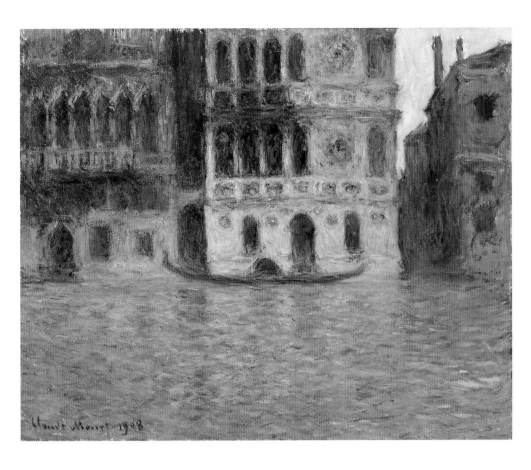

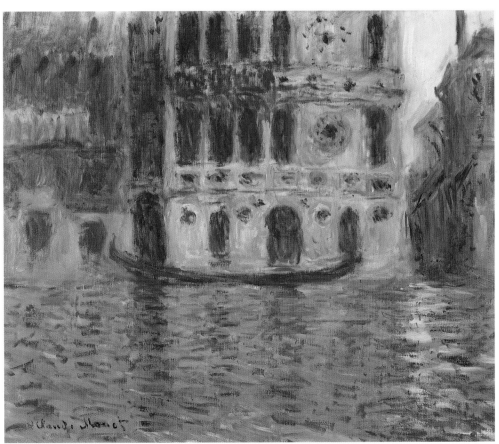

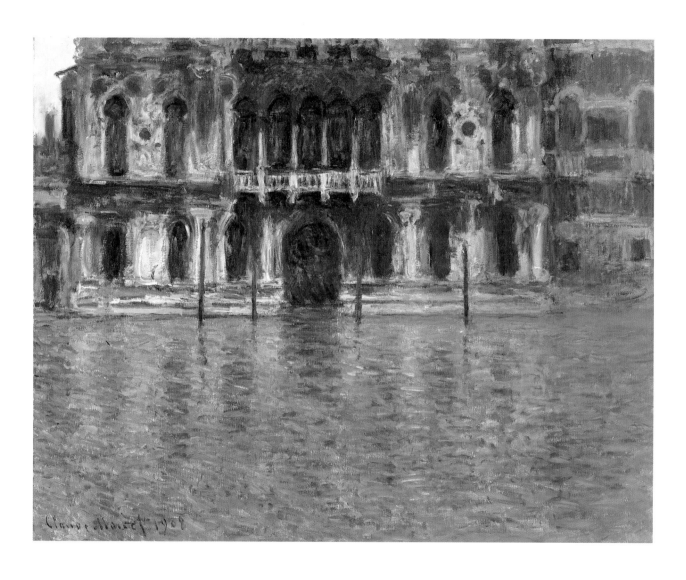

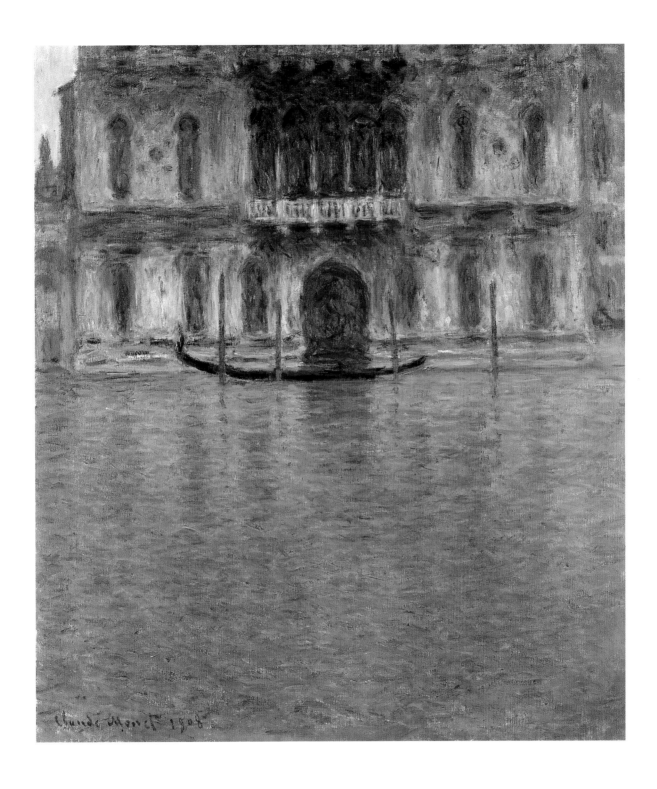

95. Palazzo Contarini, 1908
96. Palazzo Contarini, 1908

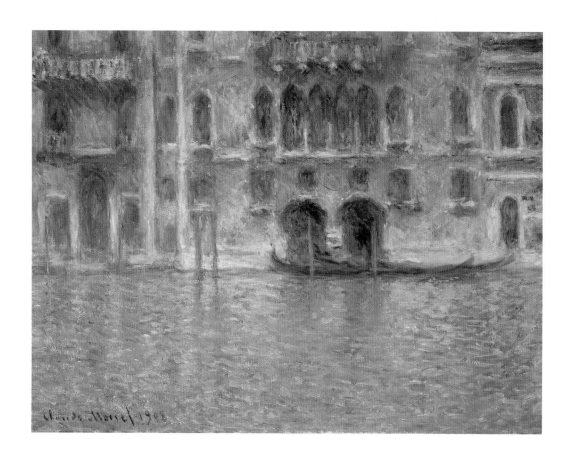

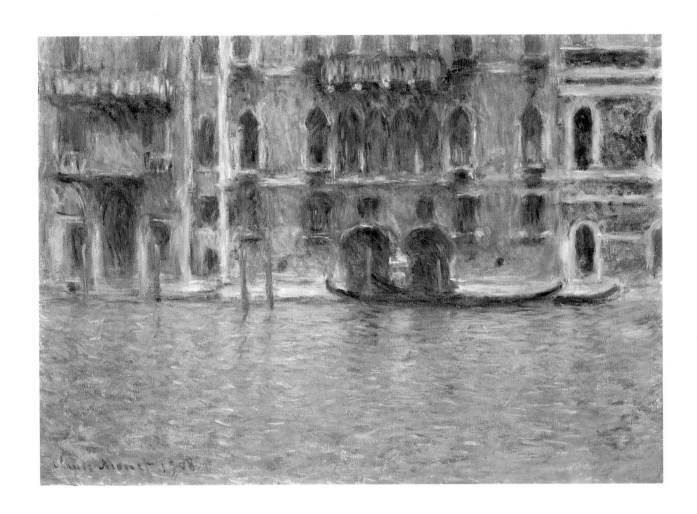

97. Palazzo da Mula, 1908
98. Palazzo da Mula, 1908

Monet's Last Paintings in Venice

Rio della Salute, 1908.

32 x 25 ⅝ in. (81 x 65 cm)

Private Foundation, Baltimore [W. 1761, Plate 99]

Rio della Salute, 1908.

32 x 25 ⅝ in. (81 x 65 cm)

Private Collection [W. 1762, Plate 100]

Rio della Salute, 1908.

39 ⅜ x 25 ⅝ in. (100 x 65 cm)

Private Collection [W. 1763, Plate 101]

San Giorgio Maggiore by Twilight, 1908.

25 ⅝ x 36 ¼ in. (65 x 92 cm)

National Museum and Gallery of Wales, Cardiff [W. 1768, Plate 102]

Twilight, Venice, 1908.

28 ¾ x 36 ¼ in. (73 x 92 cm)

Bridgestone Museum of Art, Ishibashi Foundation, Tokyo [W. 1769, Plate 103]

Gondola in Venice, 1908.

32 x 21 ⅞ in. (81 x 55 cm)

Cliché Ville de Nantes, Musée des Beaux-Arts, Nantes [W. 1772, Plate 104]

The Red House, 1908.

25 ⅝ x 32 in. (65 x 81 cm)

Galerie Rosengart, Lucerne [W. 1771, Plate 105]

The group of paintings of Rio della Salute was among the last that Monet undertook in Venice. Alice refers accurately to a group of three views with two motifs: in Plate 99, Monet actually stood closer to the facade of the house with balconies; as a result, the facade appears higher in the picture, creating a composition that is more compact. These works certainly stand out among Monet's entire Venice production; they also recall another group of three pictures executed by Monet in Bordighera depicting a bridge linking up two sides of a valley in the Alps (Plates 28–30). More so than any other group, the Rio della Salute series emphasizes one's perception of Venice from within its meandering canals as they cut through the awesome slabs of erect architecture on each side.

In the twilight views of San Giorgio (Plates 102 and 103), Monet seems less afraid to reconcile sheer pictorial bravura with traditional Venetian imagery—sunsets evoke in most of us deep romantic associations. Yet, here again, things are not so simple. Monet created *two* sunsets, very close indeed to one another, but *not* identical. In the Tokyo painting, the layout has been modified to accommodate its greater height, and the two works also play on the different gestural and physical procedures in the application of paint, even though the pigments—the balance of hues and tones—are remarkably close. This is certainly one of the most interesting pairs of works within Monet's entire oeuvre, suggesting that while reality may appear to repeat itself, its pictorial representations *never* do.

Gondola in Venice is about the unending nature of Monet's pictorial task. While Alice had finally convinced her husband to leave, and they were ready to go back to Bordighera, Monet caught sight of this isolated gondola and decided to stop everything to portray it. This was a paradoxical decision, since his gondolas were generally sketched in the background and given relatively little importance. *This* gondola embodies two propositions inherent in Monet's painting throughout: it keeps surprising us and it never ends!

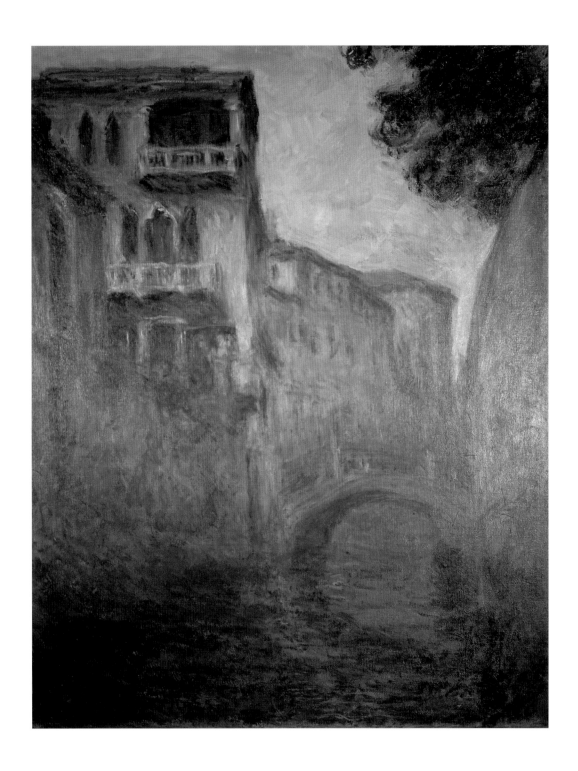

99. Rio della Salute, 1908

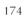

174

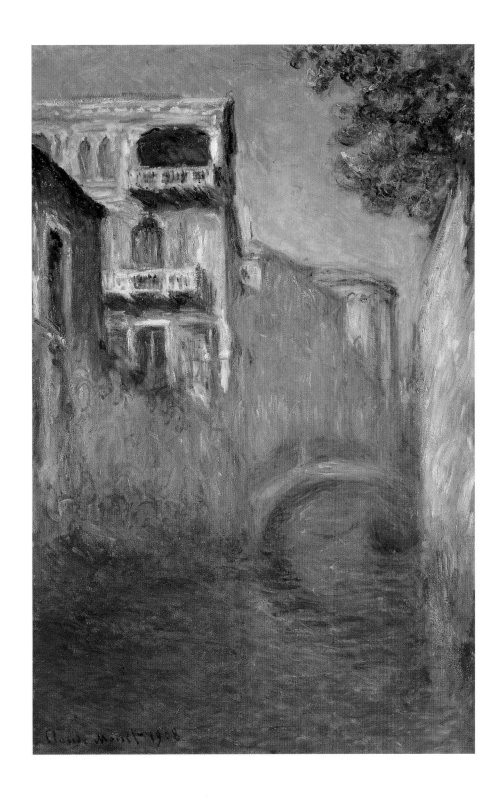

100. Rio della Salute, 1908
101. Rio della Salute, 1908

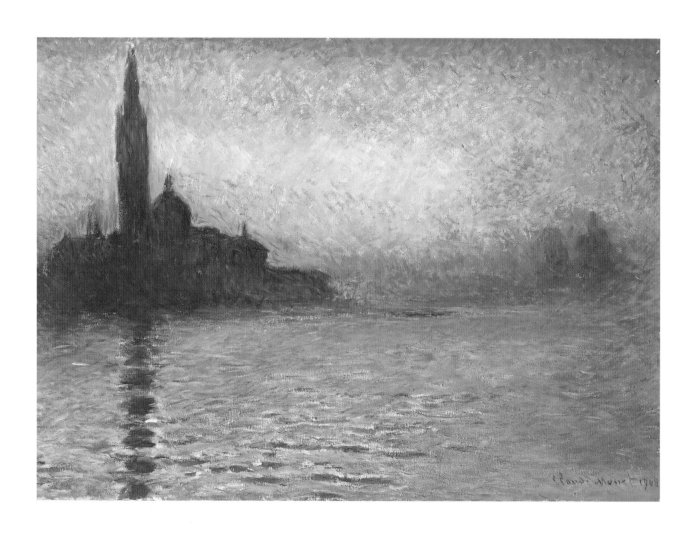

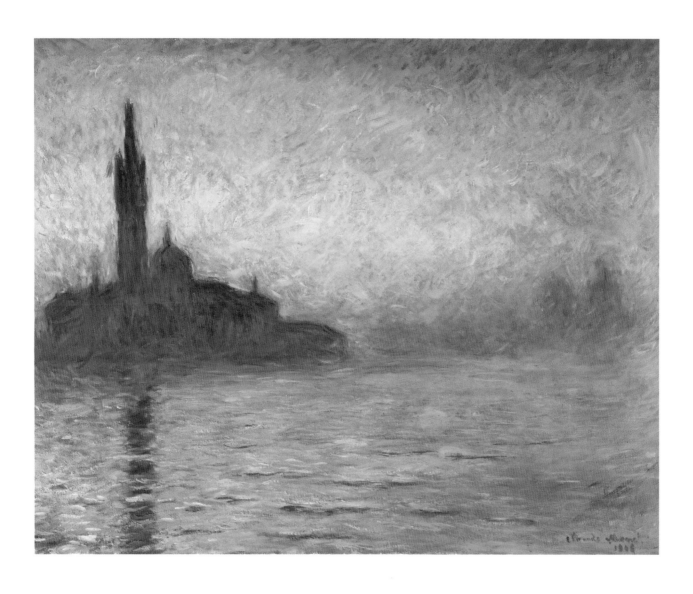

102. San Giorgio Maggiore by Twilight, 1908
103. Twilight, Venice, 1908

104. Gondola in Venice, 1908
105. The Red House, 1908

In Venice, Monet was not interested in the slightest in recording the passage of time. On the contrary, for him, time seems to have stopped in Venice, the flux of time virtually congealed on the surfaces of his canvases. To play upon the very suggestive expression that Virginia Spate used as a subtitle for her monograph on Monet, *The Color of Time*,[12] one could say that Monet paints the "color of timelessness." By his insistence on painting each version of a given motif at the very same time of day, Monet refused to deal with the very essence of time: its passage. This was a radically anti-Impressionist position. By the same token, Monet created a representation of Venice that was quite faithful to the cliché "In Venice, one feels as though one has come to the end of time." Indeed, Claude and Alice Monet cultivated this experience during their stay in Venice, gliding through the canals from dawn to dusk, happily ignoring time. Every day when he went back to his motifs, the clock was set back: time did not change and history did not happen. There is something perverse about adopting this attitude in Venice, of course. In Monet's paintings of Venice, he ahistoricizes one of the sacrosanct centers of the European cultural and architectural tradition. Indeed, Monet happily ignored what went before him, insisting that no predecessor had ever been able to understand or paint Venice. For Monet, Venice could not be the mirror of history, it could only be the mirror of his soul—or its closest equivalent, his palette of colors.

Notes

All citations are fully listed in the Bibliography (p. 186). The most frequent citation, W, stands for Daniel Wildenstein, *Claude Monet: Biographie et catalogue raisonné* (Lausanne, vol. 1 [1840–81], 1974; vol. 2 [1882–86], 1979; vol. 3 [1887–98], 1979; vol. 4 [1899–1926], 1985; vol. 5 [supplement], 1991). In the present volume, Monet's paintings are sometimes cited with their number in Wildenstein's catalogue raisonné, preceded by the initial W. These W. numbers can be correlated with volume plate numbers by seeing the "List of Monet's Works Illustrated" that follows. Letters from Monet to his correspondents are also referred to by their numbers in the above volumes.

INTRODUCTION

1. "Yesterday we admired some superb Tintorettos," Alice Monet wrote to her daughter Germaine Salerou from Venice, October 6, 1908; see Piguet 1986, 28. Piguet presumes that this may be a reference to a visit to the Scuola San Rocco. My thanks here to Charles Stuckey and to Beverly Brown for drawing my attention to other Tintorettos that Monet might have seen in Venice in 1908; a certain number of works, visible to the public today at the Accademia, were in Austria in 1908 and were only returned to Venice in the 1920s. Among the works on view in 1908, none was as spectacular and overwhelming as the huge *Miracle of the Slave* (163¼ x 177⅝ in.), which is most likely one of the works that Alice mentions as having struck Monet. Since, regrettably, Alice does not say where Monet was when he enthused about the Tintorettos, it is also possible that he referred to the *Paradiso* frescoes in the Doges' Palace (this is Stuckey's opinion, communicated to me in conversation).

2. The number of works is based on the data in W: vol. 2 for the 1884 trip to Bordighera and Menton; vol. 3 for the trip to Antibes in 1888; vol. 4 for the trip to Venice in 1908; and vol. 5, the supplement, for additional works, such as *Villa at Bordighera* (W. 2013), which is not reproduced.

3. Nine landscape paintings, executed in Menton, Monaco, and Cap Martin (W. 889–897) can be counted from this short sojourn in the south of France in the spring of 1884; a large reprise of a motif he executed on the coast was painted later in Giverny (W. 891). Additionally, Daniel Wildenstein has identified two more paintings dating to this trip (both views of Monaco, W, vol. 5, nos. 2015 and 2016).

4. W. 1158–1193 and, in W, vol. 5, nos. 2024 (1161B), 2025, and 2026.

5. W. 1736–1772. In a recent telephone conversation, Charles Stuckey pointed out the oddly similar number of canvases for each series: thirty-five, thirty-nine, and thirty-seven. In his opinion, this may have had to do with the prefabricated painting crates, which held a dozen standard canvases. Monet would therefore have left for each trip with three crates, plus a few extra works.

6. Braudel 1995, vol. 1, 17–18. (I was fascinated to find that in his preface, Braudel referred to the Mediterranean as a "character" [as in a novel] — in the same way that some of Monet's critics referred to the Mediterranean light as his main character.) Another example of such a position can be found in Reclus 1990, vol. 1, 126–35. Reclus was a close friend of the Impressionists, and a well-known geographer. In his eyes, the decision to divide the Mediterranean reflected the political interests of the British, who always felt that a unified Italy was a threat to British interests in the Mediterranean.

7. Braudel 1995, vol. 1, 23. This definition given by Braudel offers the important advantage of not reducing the Mediterranean to the sea, proper, but extends the definition to the Mediterranean world, or its basin, and thereby includes the "compact, mountainous peninsulas" that surround this "complex of seas"; in this sense, one could (and possibly should) count Monet's 1904 trip to the Prado in Madrid as belonging to the narrative of *Monet and the Mediterranean*. For according to this definition, Spain and Portugal, together with Morocco, belong to the western Mediterranean world, in the same way as Yugoslavia, Greece, Turkey, and Egypt belong to the eastern part of that same world.

8. Larousse 1866–90. The Larousse dictionary, the most popular standard reference in France in Monet's time, was the French equivalent of Webster's dictionary.

9. For an anthology of recent sociological studies of the development of tourism, parallel with the development of Monet's art in the South, see Corbin 1995, and in particular the contributions by Julia Csergo, "Les métamorphoses du divertissement citadin dans l'Italie unifiée (1870–1915)," and by Alain Corbin, "Les vacances et la nature revisitée (1830–1939)."

10. See Hersant 1988, ix. The bibliography related to French travelers to Italy is vast; among the works that focus on the period related to Monet's stays, several deserve mention: Paloscia 1987; *Voyage (Le)* 1987; Spaziani 1961; Parpagliolo 1928, 1941; and Sénelier (at press).

11. The word "vedutist," for instance, is not mentioned in the Larousse entry. Yet vedutism — the art movement that involved a generation of artists, from Luca Carlevaris to Canaletto, and drew on topographically constructed views (or *vedute*) of Venice — would have shed a critical light on Monet's later Mediterranean project.

12. Monet undoubtedly read reviews of the period in which he was presented as embodying the eminent characteristics of the French genius. Among the most notable examples are: Burty 1883, 3, in which, just before his first trip to Italy, Monet is assimilated to the "génie français"; Jourdain 1889, 517, in which Monet is seen as incarnating the "grandeur de la France"; and Buisson 1899, 70–71, in which the author concludes that the French are becoming "une race artiste."

13. Cézanne to M. de Nieuwerkerke, Paris, April 19, 1866, Cézanne 1976, 103–5.

14. Rosenblum 1989, 273. All three paintings in the May triptych are reproduced.

15. See, for instance, Flor O'Squarr 1882: "M. Claude Monet is exhibiting abominable marines, things that are nameless and unforgivable."

16. For a very good review of the contemporary reception of Impressionism, see Lethève 1959.

17. Burty 1883, 3.

18. At the seventh Impressionist exhibition in 1882, Monet exhibited his largest selection of seascapes ever, with about a dozen paintings of Fécamp. This was his last appearance as an Impressionist artist. In 1886 he refused to contribute any work to the eighth and last Impressionist show. Instead, he exhibited works in the fifth *Exposition internationale* at Georges Petit's. Among the works Monet showed on that occasion were a few views from his 1884 pictorial campaign by the Mediterranean shores.

The 1880s brought a dramatic change in Monet's economic situation. In 1882, the year of the seventh Impressionist exhibition, Paul Durand-Ruel was Monet's unchallenged dealer: out of thirty-five works exhibited that year in the penultimate Impressionist exhibition, almost every single one of these came from Durand-Ruel's own stock. These works were priced between 2,000 and 2,500 francs. At the end of 1882, however, Monet and Camille Pissarro visited the "international" group exhibition at the gallery of Georges Petit, Durand-Ruel's archrival. Petit's space appealed to the Impressionists because of its vast footage (2,700 square feet — a very large space for an art gallery at the time). By the end of the

1880s, Monet was showing more with Petit than with Durand-Ruel.

19. The exact length of Monet and Renoir's stay on the Mediterranean is difficult to establish. It seems, judging from Monet's correspondence, that he intended to spend Christmas in the South and to come back for the New Year (see Monet to Georges de Bellio, December 16, 1883, W, vol. 2, letter 386; and to Durand-Ruel, January 1, 1884, W, vol. 2, letter 387). In a recent conversation, Charles Stuckey pointed out that Monet was almost forced out of Giverny, in order to allow Ernest Hoschedé, the husband of his mistress, Alice, to come and celebrate Christmas with his six children, whom he was seeing for the first time since Alice had left him. In fact, this point also helps to explain Monet's initial decision to go to the Mediterranean. One of his motivations may have been to get as far away as possible from this difficult personal situation.

Regarding the visit with Cézanne, see Cézanne to Emile Zola, Aix, February 23, 1884, Cézanne 1976, 212: "I saw Monet and Renoir who went for a holiday to Genoa in Italy toward the end of December." It is unclear whether Monet and Renoir saw Cézanne in Aix (where he would have come to meet them) or in L'Estaque, where he lived at the time.

20. House 1986, 194 ff.

21. Ibid., 194.

22. For a detailed review of Monet's serial procedure in the 1890s, see Tucker 1989; see also Brettell 1984.

23. House 1986, 194.

24. W, vol. 3, letter 808, January 17, 1888; also cited by House 1986, 196.

25. Todorov 1984, 27, quoting from *Estetika slovesnogo tvorchestva* (The Aesthetics of Verbal Creation) (Moscow, 1979).

26. Ibid., 52.

27. Ibid., 96.

28. Since Monet and Alice were together in Venice in 1908, he had no need to express himself through letters. Alice, however, in her letters to her daughter, often echoed, and even quoted verbatim, Monet's voice.

29. Bakhtin, "Toward a Reworking of the Dostoevsky Book," in Bakhtin 1984, 289.

30. Todorov 1984, 105, quoting from *Estetika slovesnogo tvorchestva* (The Aesthetics of Verbal Creation) (Moscow, 1979).

31. Fried 1996, 45.

32. Todorov 1984, 62.

THE ITALIAN AND FRENCH RIVIERAS

33. See W, vol. 2, letter 383: "In order to succeed in doing these six panels, I have had to erase so many of them, more than twenty, possibly thirty!"

34. Ibid.

35. Stuckey, through the retrospective of the artist's work that he curated for the Art Institute of Chicago, offered a complex and perturbing image of Monet's career and pictorial achievements; see Stuckey 1995. Stuckey is right too in pointing out that Monet's inclination to flirt with neurosis was complementary with his dogged pragmatic sense, as far as organizing his daily life was concerned. For one of the most important recent contributions to Monet studies, drawing on a psychoanalytical approach, see Levine 1994. See also Brettell 1995 and Pissarro 1992, 68–85. More recently, for an application of psychoanalytical (Lacanian) concepts to Monet's work, see Levine 1996, as well as Levine 1986.

36. W, vol. 2, letter 383.

37. The two artists left for the South on December 17 (see W, vol. 2, letter 386) and were back before the New Year. See the letter from Renoir to Durand-Ruel, December 1883, Venturi 1939, 126, and from Monet to Durand-Ruel, W, vol. 2, letter 387.

38. W, vol. 2, letter 388 (Monet's emphasis).

39. W, vol. 2, letter 397.

40. See Levine 1994, especially the chapter entitled "Mirbeau and the Cult of the Self," 89–102.

41. Chateaubriand, *Voyage en Italie* (1827), see Hersant 1988, 87–88.

42. Stendhal, *Rome, Naples, et Florence en 1817*, see Hersant 1988, 114, 116.

43. Sand, *Lettres d'un voyageur* (1857); see Hersant 1988, 350–51.

44. W, vol. 2, letter 388.

45. See Walter and Bessone 1977, 22–28. Garnier was most famous as the designer of the opera house in Paris, which is known as the "Palais Garnier."

46. W, vol. 2, letter 391. The aggravated tone of Monet's letter evinces his strong attachment to his French identity. His feeling of being crowded reflects a certain xenophobia, particularly toward Germans, a bias shared at that time by many of his French contemporaries following the 1870 Franco-Prussian War. The French defeat resulted in the loss of Alsace and Lorraine to the Germans, and the subsequent resentment on both sides of the Rhine spanned the whole French Third Republic (1871–1940).

47. This is the case for all of the Mediterranean paintings; scarcely a trace of the human figure can be found. There are only two exceptions: in one view of *Dolceacqua* (W. 882) a few barely discernible figures can be made out crossing a bridge in the distance; and there is one portrait of an English artist whom Monet met while out walking in the area, on one of those days when the weather prevented him from painting outdoors (W. 886). See Bailey 1995, 55–56, in which the sitter of this previously unknown portrait is identified as Arthur Burrington or one of his friends.

48. W, vol. 2, letter 391.

49. This phrasing, reminiscent of the writing of Guy de Maupassant, raises the issue of the writer's importance for Monet's sojourn in the Mediterranean. See page 43.

50. Liégeard 1887, as quoted in W, vol. 2, 120.

51. W, vol. 2, letter 392.

52. Several are made up of three works (W. 852–854; 855–857 *bis*; 878–880), and some, such as the Sasso Valley series (W. 859–863), or the later *Olive Trees* series done in the Moreno garden (W. 868–872), are composed of as many as five canvases. W. 857 *bis* is mentioned, though not reproduced, in W, vol. 5, no. 2013, 10. The case of this group of works is peculiar, since W. 857 (now on deposit at the Musée d'Orsay, Paris) is of much larger dimensions than other works of Bordighera. It was commissioned by Berthe Morisot after Monet returned, and executed by the artist in Giverny after W. 856, on a larger scale (45 1/4 x 51 1/8 in. [115 x 130 cm] as opposed to 29 x 36 3/8 in. [73 x 92 cm]). Therefore, it cannot be counted as one of the works executed on the Mediterranean proper.

53. W, vol. 2, letter 392.

54. W, vol. 2, letter 395.

55. W, vol. 2, letter 401, dated 1 February.

56. W, vol. 2, letter 416.

57. Ibid.

58. W, vol. 2, letter 419, dated 15 February.

59. W, vol. 2, letter 417.

60. W, vol. 2, letter 394.

61. W, vol. 2, letter 395.

62. W, vol. 2, letter 398.

63. Ibid.

64. W, vol. 2, letter 399.

65. W, vol. 2, letter 402.

66. W, vol. 2, letter 403.

67. See W, vol. 2, p. 118, "The series of the olive trees was executed by Monet inside the Moreno garden from February 7 onward."

68. See W, vol. 2, letter 391.

69. W, vol. 2, letter 407. On February 7, Monet immediately started something new at Moreno's gardens, presumably the picture now in the Norton Museum of Art, West Palm Beach, Florida (W. 865), while continuing to work on old motifs that he hoped to complete soon.

70. For another account of Monet's nightmares while he was painting the Rouen Cathedral, see Pissarro 1990, 18. Monet relates his dream to Alice saying, "This usually never happens to me. I slept a night filled with nightmares: the Cathedral would crash on top of me, it would appear either blue or pink or yellow" (Monet to Alice, April 3, 1892, W, vol. 3, letter 1146). One can infer from this letter that his Bordighera campaign and his campaign in front of the Rouen Cathedral were among his most tormenting pictorial experimentations.

71. W, vol. 2, letter 409.

72. W, vol. 2, letter 413.

73. W, vol. 2, letter 415.

74. Ibid.

75. Ibid.

76. W, vol. 2, letter 416.

77. W, vol. 2, letter 422.

78. W, vol. 2, letter 424.

79. W, vol. 2, letter 422. The letter encloses photographs of the village of Dolceacqua, which he describes with these words: "The place is superb…there is a bridge there that is a jewel of lightness."

80. W, vol. 2, letter 426.

81. W, vol. 2, letter 431.

82. W, vol. 2, letter 432.

83. W, vol. 2, letter 436.

84. W, vol. 2, letter 438.

85. W, vol. 2, letter 441.

86. W, vol. 2, letter 444.

87. W, vol. 2, letter 445.

88. W, vol. 2, letter 449.

89. W, vol. 2, letter 459.

90. W, vol. 2, letter 460.

91. W, vol. 2, letter 462.

92. W, vol. 2, letter 463.

93. W, vol. 2, letter 465.

94. W, vol. 2, letter 472.

95. W, vol. 2, letter 474.

96. W, vol. 2, letter 476.

97. W, vol. 2, letter 477.

98. W, vol. 2, letter 481.

99. W, vol. 2, letter 485.

ANTIBES

100. For a discussion of the prevalent role of trains in the development of Impressionism, see Clark 1985, 148–73; and Herbert 1988, 219–29. From a sociological vantage point, see also Dauzet 1948. For a study on this subject, with particular reference to Monet, see Tucker 1982, 57–87. See also Cagliardi 1987, and the exhibition catalogue, Los Angeles 1984.

101. W, vol. 3, letter 805.

102. Harpignies, a contemporary of Boudin, was not overly sympathetic toward the Academy. In his earlier days he had been one of the "Refusés" of 1863. Later, he had established a career as a landscape painter in the manner of Corot. He had traveled to Italy, first in 1853 and subsequently from 1863 to 1865. By the 1880s, however, he had gained official "recognition" — he was made a knight and an officer of the Legion of Honor — something Monet always eyed with suspicion.

103. W, vol. 3, letter 812.

104. W, vol. 3, letter 809.

105. W, vol. 3, letter 810.

106. W, vol. 3, letter 811.

107. W, vol. 3, letters 814 and 821. See also W, vol. 3, 6. Monet obtained this authorization through the help of Jules Castagnary, one of the pioneering champions of the Impressionists and, by then, an influential politician.

108. W, vol. 3, letter 816.

109. W, vol. 3, letter 824.

110. Ibid.

111. W, vol. 3, letter 825. Monet was planning a two-man exhibition with Rodin under the direction of Georges Petit. His work and Rodin's would be exhibited together for the first time. With this goal in mind, Monet wanted to create "beautiful things to show."

112. W, vol. 3, letter 826.

113. W, vol. 3, letter 827.

114. W, vol. 3, letter 829.

115. W, vol. 3, letter 830.

116. W, vol. 3, letter 833.

117. W, vol. 3, letter 834.

118. W, vol. 3, letter 836.

119. W, vol. 3, letter 842.

120. W, vol. 3, letter 844. In fact, the prices fetched by his paintings were not too bad. Boussod & Valadon, the gallery headed by Theo van Gogh, bought many of his works.

121. W, vol. 3, letter 843.

122. W, vol. 3, letter 848.

123. W, vol. 3, letter 852.

124. W, vol. 3, letter 858.

125. W, vol. 3, letter 859.

126. W, vol. 3, letter 860.

127. W, vol. 3, letter 865.

128. Ibid.

129. W, vol. 3, letter 867.

130. W, vol. 3, letter 871.

131. W, vol. 3, letter 872.

132. W, vol. 3, letter 874.

133. W, vol. 3, letter 877.

134. W, vol. 3, letter 883.

VENICE

135. Quoted in Stuckey 1995, 240.

136. Mary Young Hunter, the spouse of a well-to-do coal mine owner, was a friend of Rodin (for whom she had posed) and of Sargent, who introduced her to the Monets. She had immediately struck a friendship with Alice. In the summer of 1908, Hunter was loaned the use of the Palazzo Barbaro by Mrs. Daniel Curtis, a distant relative of Sargent. See Piguet 1986, 23, and W, vol. 4, 60–61.

137. See Piguet 1986, 25. In this important book, the correspondence from Alice Hoschedé (Monet's wife) to her daughter, Germaine Salerou, was first published.

138. Mirbeau 1990, 266.

139. See Schneider's preface to Piguet 1986, 10–11.

140. See Distel and House 1985, 300.

141. Renoir to Durand-Ruel, Naples, November 21, 1881, in Durand-Ruel Godfroy 1995, vol. 1, 15.

142. Conversation between Vollard and Renoir, in Vollard 1989, xv.

143. There are questions as to which work by Renoir was the second painting of Venice exhibited in 1882. Distel and House 1985, 230–31, as well as Isaacson 1984, pl. no. 211, all agree that the two works by Renoir exhibited in the 1882 Impressionist exhibition were the Boston *Grand Canal* and the Williamstown *Doges' Palace*, whereas Isaacson later reidentified the second work exhibited in 1882 as the Kreeger version, less well known, and less often exhibited (see Moffett 1986, 415). Isaacson's second identification was much more convincing, as it was based on one of the contemporary reviews (Jean de Nivelle, *Le Soleil*, March 4, 1882) that suggested that Renoir's view of Venice looked as though there had been "a tempest in the Grand Canal" — terms that can much more readily be applied to the Kreeger picture than to the Williamstown painting.

144. Monet may have seen other works that Renoir painted in the South in the artist's studio. Renoir stayed in Naples in January 1882 and went to Algeria in March for six weeks; in Algiers, he painted mainly figures. In fact, certain works from Renoir's Algerian campaign (March and April 1881) are, as pointed out by Charles Stuckey, compositionally comparable to some of Monet's works of the Bordighera period of three years later (Stuckey 1995, 206–7). See, for instance, Renoir's *Algerian Landscape: The Ravin de la femme sauvage* (1881, Musée d'Orsay, Paris) and Monet's subseries of the Valley of Sasso (W. 859–863). One can also compare the latter with Renoir's *Paysage d'Alger* (1881, location unknown), which is shown in Vollard 1989, pl. 164, no. 649 (where it is misdated 1880).

145. Hepp 1882; Silvestre 1882, 150–51. Felix Ziem (1821–1911) was closely associated with the Barbizon painters and also painted extensively in Venice. Adolphe Monticelli (1824–1886), originally from Marseilles, was a student of the Salon master Paul Delaroche and was well known for landscapes of his native region. He later became van Gogh's favorite artist.

146. Renoir to Paul Durand-Ruel, March 1882, in Durand-Ruel Godfroy 1995, vol. 1, 35.

147. This dialogue, indeed, ended in three final steps: Monet's last trip to the South in 1908, his visit to Renoir on his way back, and the final exhibition of his Venetian views in 1912. The correlation between the two artists

was so obvious to Durand-Ruel that he proposed extending his *Exposition de tableaux par Renoir* from April 27 to May 15, 1912, so that the Parisian public could see the Renoir exhibition alongside *Claude Monet: Venise* at Bernheim-Jeune. He wrote to Renoir, "We would have liked to prolong [your exhibition] so that it could be seen at the same time as the Venice views by Monet." Joseph Durand-Ruel to Renoir, May 10, 1912, ibid., vol. 2, 105.

148. Piguet 1986, 25.

149. See W, vol. 4, letters 1861 to 1870.

150. Piguet 1986, 26. A telegram sent by the Monets is reproduced; its message reads: "Bien arrivés hier soir, sommes ravis, baisers, Monet."

151. Ibid., 27.

152. Ibid.

153. Ibid. The word "unrenderable" (*inrendable*) is a neologism, one translation of Monet's idiomatic expression, which might also be translated as "uncatchable" or "ungraspable."

154. Ibid., 28.

155. Ibid., 29.

156. Ibid., 30. A mention of this daily schedule was first published in Paris 1983, 139, and referred to in W, vol. 4, 61, although the quotation of Alice's letter did not carry any date.

157. Ibid., 32–33.

158. W, vol. 4, letter 1861.

159. W, vol. 4, letter 1863 A.

160. Piguet 1986, 35.

161. Ibid., 41.

162. Ibid., 46.

163. Ibid., 47.

164. Ibid.

165. Ibid., 48.

166. Ibid., 50.

167. Ibid., 51.

168. W, vol. 4, letter 1868.

169. W, vol. 4, letter 1869.

MONET'S MEDITERRANEAN AND HIS CRITICS

170. Paris 1885; the two titles from the South were *Au Cap Martin, près Menton* (no. 65), possibly W. 889, and *Vue prise près Vintimille (Italie)* (no. 68), W. 879.

171. New York 1886, an exhibition under the management of the American Art Association of the City of New York.

172. Monet to Durand-Ruel, January 22, 1886; W, vol. 2, letter 650.

173. Brussels 1886; no. 2, titled simply *Bordighera (Italie)*, probably W. 852, and no. 10, *Ferme à Bordighera*, W. 874. On the selection by Monet, see his letter to Octave-Maus announcing the "imminent arrival of ten paintings" — among which were the two views of Bordighera; Octave-Maus 1980, 43.

174. See Paris 1888.

175. See Vincent van Gogh to Theo van Gogh, van Gogh 1959, vol. 2, letter 514, 621.

176. Brussels 1889; the three paintings were titled *Vue du Cap d'Antibes*, *La Mer et les Alpes*, and *La Méditerranée par un temps de mistral* (W. 1174).

177. Paris 1889. The five works were *La Marina, Bordighera*, W. 864; *A Bordighera*, W. 867 (?); *Vallée de Sasso, Bordighera* (any work between W. 859 and 863); *Sous-bois, Bordighera* (any work between W. 868 and 873); and *Vue de Bordighera* (W. 852, 853, or 854?).

178. The first painting, no. 100 in the Georges Petit catalogue, was simply titled *Antibes* (W. 1158–1163?); the others were: *Antibes, vue du Cap, vent de mistral*, W. 1174; *Antibes, vue de la Salis* (two paintings), W. 1167–1170 (?); *Montagnes de l'Esterel, vues de Juan-les-Pins*, W. 1192 or 1193 (?); *Golfe d'Antibes*, W. 1173; *Bords de la Méditerranée, temps gris*, W. 1186; *Antibes vue des jardins de la Salice*, W. 1164; *Antibes, le matin* (?), W. 1165; *Sous les pins, cap d'Antibes: effet du soir*, W. 1191; *La Mer et les Alpes*, W. 1179; *Plage de Juan-les-Pins*, W. 1187; *Sous les pins, cap d'Antibes*, W. 1190; *Maison de jardinier à Antibes*, W. 1166; *Méditerranée par vent de mistral, cap d'Antibes*, W. 1181; *Les Alpes, vues du cap d'Antibes*, W. 1177; *Antibes, vue du plateau Notre-Dame*, W. 1172; and *Au cap d'Antibes, par vent de mistral*, W. 1176.

179. See Paris 1900, 211, nos. 486 (*Les Pins parasols*), and 489 (*Antibes*).

180. See Brussels 1904, no. 103; no. 102 was *La Mer sauvage à Belle-Ile*.

181. See Paris 1910; no. 5 was titled *Les Alpes vues du cap d'Antibes*, and no. 17, *La Vallée de Susso (sic)*. One wonders whether the works were brought closer together during the hanging than they were in the catalogue.

182. Paris 1914, no. 37, *La Vallée de Susso (sic)*, with the same typo as in the Durand-Ruel catalogue; see note above.

183. Brussels 1913, nos. 146–51.

184. See Paris 1921. The Bordighera painting in question is titled *Les Palmiers, Bordighera*, no. 15, and can most likely be identified with W. 875, which had been purchased from Monet by Durand-Ruel and Bernheim-Jeune in December 1920, although this exhibition is not mentioned in the entry for this work in W, vol. 2, 120. The work titled *Pins parasols*, thanks to the fact that it is illustrated in the catalogue, leaves no doubt as to its identification: it is W. 852; the works titled *Antibes* are difficult to identify; the work titled *Cap Martin* (W. 894) was inaccurately placed among the Antibes group, even though Monet worked in Cap Martin on his way back from Bordighera in 1884; the work titled *Baie des Anges* is W. 1178.

185. See Paris 1925; the two works in question were nos. 13 and 44 in the catalogue. Renoir's *Venise* was no. 22.

186. See Berlin 1928, nos. 34, 42, and 66–68.

187. See Paris 1928. The two works in question were nos. 81 and 82 (W. 882 and 1763, respectively). Two more works representing motifs in Venice were also included in the show, one titled *Venise* and the other, *Le Palais Ducal, Venise*, nos. 75 and 76 of the same catalogue.

188. Exemplifying this new contextual approach, devoid of personal or passionate value judgments, was Schapiro 1937, which was in contrast to the publication in English the previous year, Vollard 1936. See Jamot 1932, 3–72, who in his review of the Royal Academy exhibition (London 1932) was already laying down the premises of a contextualist or historicist interpretation of the place of Impressionism — vastly different from the empiricist and personal approach that prevailed until then. See also Francastel 1937, who interprets Impressionism as the pictorial equivalent of the optical discoveries of Helmholtz and Chevreul.

189. See Paris 1931, 77. The four Bordighera works are nos. 73–75 and 86; the two Antibes works are no. 84, W. 1164, and no. 85, W. 1161; the Venice work is no. 117, W. 1754.

190. See Paris 1935, nos. 47 and 48.

191. See Paris 1940; the catalogue title translates as "Send a Parcel to Your Soldiers." The three works from Bordighera were nos. 13–15.

192. London 1932, 250–55.

193. London 1949.

194. Contemporary and still indispensable, Rewald's *History of Impressionism* (Rewald 1990), which was first published in 1946, epitomized and in many ways pioneered this effort.

195. See London 1949; the three paintings were *The Grand Canal*, no. 254, W. 1736; *Palazzo Dario*, no. 259, W. 1759; and *San Giorgio Maggiore*, no. 262, W. 1747.

196. See Zürich 1952.

197. See London 1954.

198. See Nice 1960.

199. See New York 1969, no. 21. In fact, this painting, which I consider to be very important in the development of Monet's career in the South, has never been reproduced in any art-historical publication, with the exception of Daniel Wildenstein's catalogue raisonné.

200. See Paris 1970.

201. Todorov 1984, 44.

202. Burty 1883, 3.

203. Ibid.

204. See Stuckey 1985, 103; Lostalot's review is reproduced in English, 101–4.

205. This argument — based on presenting Monet as able to paint the invisible elements (waves, radiations, etc.) of the real world — was not infrequent at the time. For another variation on the same theme, see Dalligny 1889, 2–3, where Monet is presented as "the man who pushed to the furthest point his search for the expression not only of the visible field but also of the invisible one."

206. Stuckey 1985, 103–4.

207. Ibid., 104; emphasis mine.

208. See Stuckey 1985, 127.

209. Ibid.

210. Ibid.

211. Ibid.

212. "Claude Monet," *La France*, November 21, 1884, reprinted in Mirbeau 1990, 231.

213. Ibid.

214. Ibid.

215. Geffroy 1887, 1–2.

216. Ibid.

217. Ibid.

218. Ibid.

219. Ibid.

220. Mirbeau 1887, 2.

221. Ibid.

222. Eaque 1888, 2.

223. Ibid.

224. Ibid.

225. Geffroy 1888, 1–2.

226. Ibid.

227. Ibid.

228. Ibid.

229. Ibid.

230. Le Fustec 1889, 3; even though Monet's Impressionism is not "impeccable," Monet produces "works that one has to see and examine seriously. For it is important not to fool ourselves: this art is exerting an increasingly important influence, and one finds its impact expressed in more or less timid ways in every exhibition today."

231. Ibid.

232. Bourgeat 1889, 2.

233. Ibid.

234. About the notion of "excess" applied to Monet's art in the context of the *Monet–Rodin* show, where an important group of Antibes works could be viewed, see also E. de M. 1889, 2, who talks about "exaggeration" and about "the superabundance of life, and the fanaticism of color" in Monet's work there. See also Ernst 1889, 1–2, who describes Monet there as "one of the most personal [painters] of the present time" — which explains, according to the critic, why the artist was such a source of scandals earlier.

235. Eminently illustrated by Félix Fénéon, quoted in Halperin 1970, in which the key word is "objectivité."

236. Illustrated by Aurier 1892, 302–5, where he compares Monet to the Chaldean deity, Baal, who created the sky, the earth, and the gods; Monet is seen as "an exclusive and passionate worshipper of the solar might, within the obscure molehill of our present age." Against the scientists, Aurier claims that

Monet wants "to explain nothing," but satisfies himself "with a few waves of the Mediterranean" to express his adoration of the sun as the "heliotheist" that he is!

237. Burty 1885, 3.

238. Marx 1885, 2.

239. Fourcaud 1886, 2.

240. Wolff 1886, 2.

241. Huysmans 1887, 352.

242. Lostalot 1883, 342–48; Duret 1885.

243. Geffroy 1887, 1–2, who exploits the same themes (truth, subtlety, accuracy) in a later review, Geffroy 1894, 54–95.

244. Fontainas 1898, 159–66 and 278–79.

245. Ferry 1993, 231–32.

246. Bernard 1911, 255–74.

247. Mellerio 1904, 104.

248. Ibid.

249. Ibid.

250. See Geffroy 1912 B, 449. In case the reader had any doubt about the purpose of the article, it is subtitled: "A propos de l'exposition de 29 tableaux de Venise, du 28 mai au 8 juin, galerie Bernheim, rue Richepanse."

251. Ibid.

252. See Mauclair 1905, 49. Highly typical of that position is his historicist approach: every art movement is necessary but each has an end. Therefore, Impressionism and its last survivor, Monet, must also go. "The more one tries to prolong an art movement, the more it rots away in the hands of its creators," Mauclair concludes.

253. Geffroy 1912 B, 449.

254. Ibid.

255. Ibid.

256. Ibid.

257. Ibid.

258. Ibid. These are, of course, double-edged compliments. By suggesting that Monet has just created the *Nightwatch* of his career, there is also an implication that he can only go downward after this. By suggesting that this is Monet's testament, there is an implication that Monet is almost dead. Monet was to live for another fourteen years after the Venice exhibition.

259. Geffroy 1912 A, 1.

260. Ibid.

261. See *Temps (Le)*, 1912, 4.

262. Lecomte 1912, 6, who emphasizes the "reflections [of the Venetian palazzi] in the deep waters," and compares these to the "delicate and fresh songs" of the "mother-of-pearl fleshlike colors of the water lilies."

263. See Mirbeau 1990, 266, which reprints Mirbeau 1912.

264. Ibid.

265. Ibid.

266. Ibid.

267. Ibid.

COLOR PLATES AND COMMENTARIES

1. For a fuller assessment of the cultural and social significance of the Villa Etelinda in the context of the time, see Walter and Bessone 1977, 22–28.

2. See Jaucourt 1969, 567. My thanks to Eileen S. Kahng for drawing this text to my attention, which is discussed in her forthcoming article, "An Appeal to the Real: L'Affaire Greuze and the Genrefication of History Painting."

3. See Tinterow and Loyrette 1994, nos. 119–20 and Fig. 415, 422–23.

4. See Bailey 1995, 55–56.

5. See Monet to Alice Hoschedé, 20 January 1888, W, vol. 3, letter 811.

6. See Monet to Alice Hoschedé, 1 February 1888, W, vol. 3, letter 824.

7. Another version of this subject, *Antibes, Seen from the Gardens of La Salis* (Private Collection, W. 1164), is not illustrated.

8. Maupassant 1995, 27.

9. One of them (W. 1744, unillustrated) was completed in Giverny after the 1912 exhibition, when Monet had the other two "under his eyes." See W, vol. 4, 234.

10. Six paintings of this particular motif, W. 1745–1750, are listed in W, vol. 4, 236–39. Only five were exhibited in the Bernheim-Jeune exhibition; W. 1750 (Private Collection) was not in the exhibition and is not illustrated here. Also unillustrated is W. 1745 (Private Collection).

11. Camille Mauclair to Stéphane Mallarmé, 2 May 1891, quoted in Levine 1994, 147.

12. See Spate 1992.

Bibliography

Aurier 1892
 AURIER, G. Albert. "Claude Monet." *Mercure de France* (April 4): 302–5.

Bailey 1995
 BAILEY, Martin. "Monet's Portrait of an English Artist." *Apollo* (September): 55–56.

Bakhtin 1984
 BAKHTIN, Mikhail. *Problems of Dostoevsky's Poetics.* Ed. and trans. Caryl Emerson. Minneapolis.

Barcham 1977
 BARCHAM, William Lee. *The Imaginary View Scenes of Antonio Canaletto.* New York.

Bataille and Wildenstein 1961
 BATAILLE, Marie-Louise, and Georges WILDENSTEIN. *Berthe Morisot: Catalogue des peinture, pastels, et aquarelles.* Paris.

Berlin 1928
 Claude Monet, 1840–1926. Exh. cat. Galeries Thannhauser.

Bernard 1911
 BERNARD, Emile. "Réfutation de l'impressionnisme." *Mercure de France* (September 16): 255–74.

Bernard 1966
 BERNARD, Claude. *Introduction à l'étude de la médicine expérimentale.* 1865. Reprint. Paris.

Bourgeat 1889
 BOURGEAT, Fernand. "Paris vivant: A la Galerie Georges Petit." *Le Siècle* (June 22): 2.

Bouyer 1893
 BOUYER, Raymond. "Le Paysage dans l'art." *L'Artiste* (March): 206–7, 209.

Braudel 1995
 BRAUDEL, Fernand. *The Mediterranean and the Mediterranean World in the Age of Philip II. (La Mediterranée et le monde mediterranéen à l'époque de Philippe II.)* Paris, 1949, 1966. (English ed. 2 vols. London, 1972. Berkeley, Los Angeles, and London, 1995.)

Brettell 1984
 BRETTELL, Richard R. "Monet's Haystacks Reconsidered." *The Art Institute of Chicago Museum Studies* 11, no. 1 (Fall): 5–21.

Brettell 1995
 BRETTELL, Richard R. "Portrait of the Marriage: Claude Monet and Camille Monet." Lecture at the Art Institute of Chicago, October 1995.

Brettell and Pissarro 1992
 BRETTELL, Richard R., and Joachim PISSARRO. *The Impressionist in the City: Pissarro's Series Paintings.* New Haven and London.

Brussels 1886
 Société des XX. Exh. cat. 1981 ed.

Brussels 1889
 Sixième exposition des XX. Exh. cat. Société des XX. 1981 ed.

Brussels 1904
 Peintres impressionnistes. Exh. cat. La Libre Esthéthique.

Brussels 1913
 Interprétations du Midi. Exh. cat. La Libre Esthétique.

Buisson 1899
 BUISSON, J. "Un Claude Monet de l'exposition Petit." *La Chronique des Arts et de la Curiosité* (February 25): 70–71.

Burty 1883
 BURTY, Philippe. "Les Paysages de M. Claude Monet." *La République française* (March 27): 3.

Burty 1885
 BURTY, Philippe. "Critique d'avant-garde." *La République française* (May 11): 3.

Cagliardi 1987
 CAGLIARDI, Jacques. *Les Trains de Monet ne conduisent qu'en banlieue.* Paris.

Calonne 1889
 CALONNE, Alphonse de. "L'Art contre nature." *Soleil* (supplément) (June 23): 3.

Cézanne 1976
 CÉZANNE, Paul. *Paul Cézanne Letters.* Ed. John Rewald. 4th ed., rev. and enl. New York.

Clark 1985
 CLARK, T. J. *The Painting of Modern Life: Paris in the Art of Manet and His Followers.* New York.

Conisbee 1996
 CONISBEE, Philip, Sarah FAUNCE, and Jeremy STRICK, with Peter GALASSI. *In the Light of Italy: Corot and Early Open-Air Painting.* Exh. cat. National Gallery of Art, Washington, D.C.

Corbin 1995
 CORBIN, Alain, et al. *L'avènement des loisirs, 1850–1960.* Paris and Rome.

Dalligny 1889
 DALLIGNY, Auguste. "Auguste Rodin et Claude Monet à la rue de Sèze." *Le Journal des Arts* (July 5): 2–3.

Dauzet 1948
 DAUZET, Pierre. *Le siècle des chemins de fer en France: 1821–1938.* Fontanay-aux-Roses.

Distel and House 1985
 DISTEL, Anne, and John HOUSE. *Renoir.* London.

Durand-Ruel Godfroy 1995
 DURAND-RUEL GODFROY, Caroline, ed. *Correspondance de Renoir et Durand-Ruel, 1881–1906.* Lausanne.

Duret 1885
 DURET, Théodore. *Critique d'avant-garde (Claude Monet).* Paris.

Duret 1906
 DURET, Théodore. *Histoire des peintres impressionnistes.* Paris.

E. de M. 1889
 E. de M. [Exposition Monet–Rodin]. "Petites expositions." *La Liberté* (June 26): 2.

Eaque 1888
 EAQUE [Paul Robert]. "Claude Monet." *Le Journal des Arts* (July 6): 3.

Eon 1908
 EON, Henry. "Notes d'art — Les Cent pastels: Paysages de Monet et de Renoir." *Le Siècle* (May 31): 2–3.

Ernst 1889
 ERNST, Alfred. "Claude Monet et Rodin." *La Paix* (July 3): 1–2.

Ferry 1993
 FERRY, Luc. *Homo Aestheticus: The Invention of Taste in the Democratic Age.* Trans. Robert de Loaiza. Chicago and London.

Flor O'Squarr 1882
 FLOR O'SQUARR, Charles. "Deux Expositions." *Le National* (March 3): 2.

Fontainas 1898
 FONTAINAS, André. "Claude Monet " and "Art Moderne." *Mercure de France* (July): 159–66 and 278–79.

Fourcaud 1886
 FOURCAUD. "Exposition Internationale à la galerie Georges Petit." *Le Gaulois* (June 19): 2.

Francastel 1937
 FRANCASTEL, Pierre. *L'impressionnisme: Les origines de la peinture moderne de Monet à Gauguin.* Paris.

Fried 1996
 FRIED, Michael. *Manet's Modernism or, The Face of Painting in the 1860s.* Chicago and London.

Galassi 1991
 GALASSI, Peter. *Corot in Italy: Open-Air Painting and the Classical Landscape Tradition.* New Haven.

Gasquet 1988
 GASQUET, Joachim. *Cézanne.* 1921 and 1926. Reprint. Paris.

Geffroy 1887
 GEFFROY, Gustave. "Salon de 1887, VI. Hors du salon: Claude Monet, II." *La Justice* (June 2): 1–2.

Geffroy 1888
 GEFFROY, Gustave. "Chronique: Dix tableaux de Claude Monet." *La Justice* (June 17): 1–2.

Geffroy 1894
 GEFFROY, Gustave. *La Vie artistique,* Troisième série. Histoire de l'Impressionnisme. Paris.

Geffroy 1912 A
GEFFROY, Gustave. "Notre époque: La Venise de Claude Monet." *La Dépêche de Toulouse* (May 30): 1.

Geffroy 1912 B
GEFFROY, Gustave. "Claude Monet." *La Vie* (June 1): 449–50.

Genet 1912
GENET, Henri. "Beaux-arts et curiosité: Les 'Venise' de Claude Monet." *L'Opinion* (June 1): 698.

Gillet 1924
GILLET, Louis. "Après l'exposition Claude Monet: Le testament de l'Impressionnisme." *La Revue des Deux Mondes* (February 1): 661–73.

Gillet 1927
GILLET, Louis. *Trois variations sur Claude Monet.* Paris.

Halperin 1970
HALPERIN, Joan U. *Félix Fénéon: Oeuvres plus que complètes.* Geneva and Paris.

Hepp 1882
HEPP, Alexandre. "Impressionnisme." *Le Voltaire* (March 3).

Herbert 1988
HERBERT, Robert. *Impressionism, Art, Leisure, and Parisian Society.* New Haven and London.

Herbert 1992
HERBERT, James D. *Fauve Painting: The Making of Cultural Politics.* New Haven.

Hersant 1988
HERSANT, Yves. *Italies: Anthologie des voyageurs Français aux XVIIIe et XIXe siècles.* Paris.

House 1986
HOUSE, John. *Monet: Nature into Art.* New Haven and London.

Huysmans 1887
HUYSMANS, Joris Karl. "Chronique d'art— Le Salon de 1887: L'Exposition internationale de la rue de Sèze." *La Revue indépendante* (June): 345–55.

Isaacson 1984
ISAACSON, Joel. *List of Paintings in the Sterling and Francine Clark Art Institute.* Williamstown.

J. A. 1889
J. A. [Jules Antoine]. "Beaux-Arts: Exposition à la Galerie Georges Petit." *Art et Critique* (June 29): 75–77.

Jamot 1932
JAMOT, P. "French Painting—II." *The Burlington Magazine* (January): 3–72.

Jaucourt 1969
JAUCOURT, Chevalier de. "Sublime." In *Encyclopédie ou dictionnaire raisonné des sciences, des arts et des métiers.* 1765. Reprint. New York.

Jourdain 1889
JOURDAIN, Frantz. "Claude Monet: Exposition du boulevard Montmartre." *La Revue indépendante* (March): 513–17.

Jourdain 1895
JOURDAIN, Frantz. "Les Salons: L'Exposition de Claude Monet chez Durand-Ruel." *La Patrie* (May 20): 2.

Jullian 1968
JULLIAN, René. *Les Impressionnistes français et l'Italie.* Publications de l'Institut français de Florence, 1st series. Florence and Paris.

Kronenberger 1996
KRONENBERGER, Dagmar E. *Die Kathedrale als Serienmotiv: MotivKundliche Studien zu einem Bildthema in der Malerei des französischen Impressionismus.* Frankfurt.

Küster 1992
KÜSTER, Bernd. "Monet: seine Reisen in den Süden." Hamburg.

Larousse 1866–90
LAROUSSE, Pierre. *Grand dictionnaire universel du XIXe siècle.* Paris.

Lassaigne 1956
LASSAIGNE, Jacques. *Venice.* Le Goût de notre temps. Geneva, Paris, and New York.

Latour 1909
LATOUR, P. Contamine de. "Les trois manières de Claude Monet." *Le Gaulois du dimanche* (May 15–16): 7.

Lecomte 1892
LECOMTE, Georges. *L'Art impressionniste d'après la collection de M. Durand-Ruel.* Paris.

Lecomte 1912
LECOMTE, Georges. "La Vie artistique— Un radieux poème à la gloire de Venise: C'est l'illustre peintre Claude Monet qui nous en donne la joie." *Le Matin* (June 3): 6.

Le Fustec 1889
LE FUSTEC, Jean. "Au jour le jour: L'Exposition Monet–Rodin." *La République française* (June 28): 3.

Lethève 1959
LETHÈVE, Jacques. *Impressionnistes et symbolistes devant la presse.* Paris.

Levine 1986
LEVINE, Steven Z. "Monet's Series: Repetition, Obsession." *October* 37: 65–75.

Levine 1994
LEVINE, Steven Z. *Monet, Narcissus, and Self-Reflection: The Modernist Myth of the Self.* Chicago.

Levine 1996
LEVINE, Steven Z. "Virtual Narcissus: On the Mirror Stage with Monet, Lacan, and Me." *American Imago* 53, no. 1: 91–106.

Liégeard 1887
LIÉGEARD, Stéphane. *La Côte d'Azur.* Paris.

London 1932
French Art, 1200–1900. Exh. cat. Royal Academy of Arts.

London 1949
Landscape in French Art, 1550–1900. Exh. cat. Royal Academy of Arts.

London 1954
Claude Monet, 1840–1926. Exh. cat. Marlborough Gallery.

Los Angeles 1984
BRETTELL, Richard R., et. al. *A Day in the Country: Impressionism and the French Landscape.* Exh. cat. Los Angeles County Museum of Art, Art Institute of Chicago, and Grand Palais, Paris.

Lostalot 1883
LOSTALOT, Alfred de. "Exposition des oeuvres de M. Cl. Monet." *Gazette des Beaux-Arts* (April): 342–48.

Lyotard 1986
LYOTARD, Jean-François. *Le Postmoderne expliqué aux enfants.* Paris.

Marx 1885
MARX, Roger. "L'Exposition internationale." *Le Voltaire* (May 18): 2

Mauclair 1905
MAUCLAIR, Camille. "La Fin de l'impressionnisme." *La Revue politique et littéraire* (January 14): 49–53.

Maupassant 1995
MAUPASSANT, Guy de. *Afloat. (Sur l'eau.)* Paris, 1888, 1989. (English ed. London and Chester Springs, Penn., 1995. Trans. Marlo Johnston.)

Mellerio 1904
MELLERIO, André. "Correspondance de Belgique: Exposition des peintres impressionnistes à la Libre Esthétique." *La Chronique des Arts* (March 26): 104–5.

Mirbeau 1884
MIRBEAU, Octave. "Notes sur l'art: Claude Monet." *La France* (November 21).

Mirbeau 1887
MIRBEAU, Octave. "L'Exposition internationale de la rue de Sèze." *Gil Blas* (May 13): 2.

Mirbeau 1912
MIRBEAU, Octave. "Les 'Venise' de Cl. Monet." *L'Art Moderne* (June 2): 167–68.

Mirbeau 1990
MIRBEAU, Octave. "Claude Monet: Venise." In *Correspondance avec Claude Monet.* Ed. Pierre Michel and Jean-François Nivet. Tusson.

Moffett 1986
MOFFETT, Charles, et al. *The New Painting: Impressionism, 1874–1886.* Exh. cat. The Fine Arts Museums of San Francisco and the National Gallery of Art, Washington.

New York 1886
Works in Oil and Pastel by the Impressionists of Paris. Exh. cat. American Art Galleries.

New York 1969
Claude Monet. Exh. cat. Richard L. Feigen & Co.

Nice 1960
Peintres à Nice et sur la Côte d'Azur, 1860–1960. Exh. cat. Palais de la Méditerranée.

Octave-Maus 1980
OCTAVE-MAUS, Madeleine. *Trente années de lutte pour l'art: 1881–1914.* 1926. Reprint. Brussels.

Paloscia 1987
PALOSCIA, F., et al. *L'Italia dei grandi viaggiatori.* Rome.

Paris 1885
Quatrième exposition internationale de peinture. Exh. cat. Galerie Georges Petit.

Paris 1888
Dix marines d'Antibes de M. Cl. Monet. Exh. cat. Boussod, Valadon et Cie.

Paris 1889
Claude Monet—A. Rodin. Exh. cat. Galerie Georges Petit.

Paris 1900
Catalogue Officiel illustré de L'Exposition centennale de l'art français. Exposition universelle. Exh. cat. Grand Palais des Champs-Elysées.

Paris 1908
Paysages de Monet et Renoir. Galerie Durand-Ruel.

Paris 1910
Tableaux par Monet, C. Pissarro, Renoir, et Sisley. Exh. cat. Galerie Durand-Ruel.

Paris 1912
Claude Monet, Venise. Exh. cat. Galerie Bernheim-Jeune.

Paris 1914
Le Paysage du Midi. Exh. cat. Galerie Bernheim-Jeune.

Paris 1921
Claude Monet. Exh. cat. Galerie Bernheim-Jeune.

Paris 1925
Oeuvres importantes de Monet, Pissarro, Renoir, Sisley. Exh. cat. Galerie Durand-Ruel.

Paris 1928
Claude Monet (1840–1926). Exh. cat. Galerie Durand-Ruel.

Paris 1931
Claude Monet: Exposition Rétrospective. Exh. cat. Musée de l'Orangerie.

Paris 1935
Claude Monet de 1865 à 1888. Exh. cat. Galerie Durand-Ruel.

Paris 1940
Centenaire de Claude Monet: Exposition au profit du "Colis aux Armées." Exh. cat. Galerie André Weil.

Paris 1970
Claude Monet. Exh. cat. Galerie Durand-Ruel.

Paris 1983
Claude Monet au temps de Giverny. Exh. cat. Centre Culturel du Marais.

Paris 1989
VILAIN, Jacques, et al. *Claude Monet–Auguste Rodin: Centenaire de l'exposition de 1889.* Exh. cat. Musée Rodin.

Parpagliolo 1928, 1941
PARPAGLIOLO, L. *L'Italia negli scrittori italiani e stranieri.* Rome.

Piguet 1986
PIGUET, Philippe. *Monet et Venise.* Preface by Pierre Schneider. Paris.

Piguet (forthcoming)
PIGUET, Philippe. *Ernest Hoschedé, collectionneur et mécène de l'impressionnisme.* Forthcoming.

Pissarro 1990
PISSARRO, Joachim. *Monet's Cathedral: Rouen, 1892–1894.* London and New York.

Pissarro 1992
PISSARRO, Joachim. "Y a-t-il une mélancolie impressioniste?" In *Esthétique et mélancolie.* Orléans.

Py 1899
PY, Michel. "Herbes de la Saint-Jean: Corot, Sisley, Renoir, Monet, Pissarro." *Le Voltaire* (April 23): 3.

Reclus 1990
RECLUS, Elisée. *L'Homme et la terre.* 6 vols. 1905–8. Reprint (vol. 6), *L'Homme de la terre: Histoire contemporaine.* Paris.

Rewald 1990
REWALD, John. *The History of Impressionism.* 4th rev. ed. New York.

Rosenblum 1989
ROSENBLUM, Robert. *Paintings in the Musée d'Orsay.* New York.

Schapiro 1937
SCHAPIRO, Meyer. "Nature of Abstract Art." *Marxist Quarterly* (January–March).

Seiberling 1981
SEIBERLING, Grace. *Monet's Series.* New York.

Sénelier (in press)
SÉNELIER, J. *Voyageurs français en Italie du Moyen Age à nos jours: Premier essai de bibliographie.* Geneva, in press.

Silvestre 1882
SILVESTRE, Armand. "Le Monde des arts—Expositions particulières: Septième exposition des artistes indépendants." *La Vie moderne* (March 11): 150–51.

Spate 1992
SPATE, Virginia. *The Colour of Time: Claude Monet.* London and New York. (U.S. title: *Claude Monet: Life and Work.*)

Spaziani 1961
SPAZIANI, M. *Francesi in Italia, Italiani in Francia.* Rome.

Stuckey 1985
STUCKEY, Charles F., ed. *Monet: A Retrospective.* New York.

Stuckey 1995
STUCKEY, Charles F. *Claude Monet: 1840–1926.* Exh. cat. The Art Institute of Chicago.

Temps (Le) 1912
"Art et curiosité—Une féerie de lumière et de couleur: Venise vue par Claude Monet." *Le Temps* (June 11): 4.

Tinterow and Loyrette 1994
TINTEROW, Gary, and Henri LOYRETTE. *Origins of Impressionism.* Exh. cat. The Metropolitan Museum of Art, New York.

Todorov 1984
TODOROV, Tzvetan. *Mikhail Bakhtin: The Dialogical Principle.* Trans. Wlad Godzich. Minneapolis and London.

Tucker 1982
TUCKER, Paul Hayes. *Monet at Argenteuil.* New Haven and London.

Tucker 1989
TUCKER, Paul Hayes. *Monet in the '90s: The Series Paintings.* Exh. cat. Museum of Fine Arts, Boston.

van Gogh 1959
VAN GOGH, Vincent. *Complete Letters, with Reproductions of All the Drawings in the Correspondence.* 3 vols. 2nd ed. Greenwich, Conn.

Venturi 1939
VENTURI, Lionello. *Les Archives de l'Impressionnisme.* Paris and New York.

Verhaeren 1901
VERHAEREN, Emile. "Art moderne." *Mercure de France* (February): 544–46.

Vollard 1936
VOLLARD, Ambroise. *Recollections of a Picture Dealer.* Boston.

Vollard 1989
VOLLARD, Ambroise. *Pierre-Auguste Renoir: Paintings, Pastels, and Drawings.* San Francisco.

Voyage (Le) 1987
"Traverses." *Le Voyage,* nos. 41–42. Paris.

Walter and Bessone 1977
WALTER, Rodolphe, and Giuseppe E. BESSONE. "Charles Garnier et Claude Monet à Bordighera." *L'Oeil* (January–February): 22–28.

W

WILDENSTEIN, Daniel. *Claude Monet: Biographie et catalogue raisonné.* Lausanne. Vol. 1 (1840–81), 1974; vol. 2 (1882–86), 1979; vol. 3 (1887–98), 1979; vol. 4 (1899–1926), 1985; vol. 5 (additions to previous volumes, drawings, pastels, index), 1991.

Wolff 1886
WOLFF, Albert. "Exposition internationale de 1886." *Le Figaro* (June 19): 2.

Zürich 1952
Claude Monet, 1840–1926. Exh. cat. Kunsthaus.

List of Monet's Works Illustrated

Lenders' List

MUSEUMS

BELGIUM
Musée de Beaux-Arts de Tournai: 40

FRANCE
Musée Marmottan, Paris: 12

GERMANY
Von der Heydt-Museum Wuppertal: 43

GREAT BRITAIN
Courtauld Institute Galleries, London: 71

Glasgow Museums: Art Gallery and Museum, Kelvingrove: 24

The National Museum of Wales, Cardiff: 87, 92, 102

JAPAN
Bridgestone Museum of Art, Ishibashi Foundation, Tokyo: 103

THE NETHERLANDS
Rijksmuseum, Amsterdam, on long-term loan to the Stedelijk Museum, Amsterdam: 36

SWITZERLAND
Kunsthaus Zurich: 79

Kunstmuseum, Saint Gallen: 96

UNITED STATES
The Armand Hammer Collection, UCLA at the Armand Hammer Museum of Art and Cultural Center, Los Angeles: 3

The Art Institute of Chicago: 4, 93

Brooklyn Museum of Art: 86

The Cleveland Museum of Art: 58

Columbus Museum of Art: 45

Dallas Museum of Art: 9

The Fine Arts Museums of San Francisco: 75

Solomon R. Guggenheim Museum, New York: 82

Indianapolis Museum of Art: 90

Joslyn Art Museum, Omaha, Nebraska: 21

The Metropolitan Museum of Art, New York: 23, 26, 83

Museum of Fine Arts, Boston: 38, 48, 59, 64, 73

Norton Museum of Art, West Palm Beach, Florida: 19

Philadelphia Museum of Art: 57, 70

San Francisco Museum of Modern Art: 11

Santa Barbara Museum of Art: 7

Sterling and Francine Clark Art Institute, Williamstown, Massachusetts: 30

The Toledo Museum of Art: 55

PRIVATE COLLECTIONS

Acquavella Galleries, Inc.: 66

Scott M. Black Collection: 34

Courtesy Marc Blondeau, S.A., Paris: 14, 29

The Steven and Dorothea Green Collection: 62

Mr. Yasuji Hatano, Tokyo: 54

Drue Heinz: 94

Mr. and Mrs. Herbert Klapper: 85

Mr. and Mrs. William Wood Prince: 6

Private Collection, Courtesy Galerie Schmit, Paris: 65

Collection of Samir Traboulsi: 1

The Wohl Family: 56

Anonymous Private Collectors: 2, 5, 13, 15, 16, 17, 22, 25, 35, 39, 41, 44, 47, 50, 51, 72, 74, 77, 78, 95, 99, 100

Photo Credits

In most cases the illustrations have been made from transparencies provided by the owners or custodians of the works. Those photographs for which further credit is due are listed below. Numbers in **bold** refer to plate numbers.

© 1993, The Art Institute of Chicago: **4, 93**

© 1995, The Art Institute of Chicago: **6**

Art Resource, New York: Fig. 4

Courtesy Marc Blondeau, S.A., Paris: **16**

Photograph by Ken Burris: Fig. 9

Courtesy Christie's, London: **61**

Courtesy Christie's, New York: **98**

Courtesy A. C. Cooper Ltd.: **69**

© 1996, The Cleveland Museum of Art: **58**

Document Archives Durand-Ruel, Paris: **80**

Courtesy Richard L. Feigen & Co.: **44**

Courtesy Fujii Gallery, Tokyo: **77**

Courtesy Gagosian Gallery, New York: **68**

Courtesy Galerie Larock Granoff: **27**

Courtesy Galerie Nichido, Tokyo: **46, 101**

Courtesy Galerie Schmit, Paris: Fig. 7; **81, 89**

Courtesy Gallery Itsuraku Co., Ltd., Tokyo: **78**

© Glasgow Museums: Art Gallery and Museum, Kelvingrove: **24**

Patrick Goetelen, Geneva: **47**

© The Solomon R. Guggenheim Foundation, New York. Photograph by David Heald: **82**

Rodolphe Haller, Geneva: **5, 100**

Hans Hinz-ARTOTHEK, Munich: **42**

Hans Humm, Bruttisellen: **51, 96**

© 1993 The Indianapolis Museum of Art: **90**

© P. Jean, Musée des Beaux-Arts, Nantes: **104**

© 1996, Kunsthaus Zurich: **79**

Courtesy The Lefevre Gallery, London: **1**

Robert Lorenzson, New York: **2, 25, 84, 85**

© 1989 by The Metropolitan Museum of Art: **23, 26**

© 1996 by The Metropolitan Museum of Art: **83**

Courtesy Mono Art Gallery, Tokyo: **54**

Courtesy The Museum of Fine Arts, Houston: **32**

© 1993 National Gallery of Art, Washington: **97**

© photo Réunion des Musées Nationaux, Hervé Lewandowski: **8**

Courtesy Sotheby's, Geneva: **76**

Courtesy Sotheby's, London: **17**

Courtesy Sotheby's, New York: Figs. 1, 5, 8, 19; **52**

© Sterling and Francine Clark Institute, Williamstown, Mass.: Fig. 20

Courtesy Wildenstein & Co., New York: **10, 13, 22, 35**

Courtesy Wildenstein Tokyo, Ltd. / East West Sigma, Inc.: **91**

Graydon Wood, 1995: **70**